AMERICAN
WORKMAN

AMERICAN WORKMAN

THE LIFE AND ART OF
JOHN KANE

Maxwell King & Louise Lippincott

University *of* Pittsburgh Press

This publication is made possible through the generous support of the Heinz Endowments and the Sheila Reicher Fine Foundation

Published by the University of Pittsburgh Press, Pittsburgh, Pa., 15260

Copyright © 2022, University of Pittsburgh Press

All rights reserved

Manufactured in the United States of America

Printed on acid-free paper

10 9 8 7 6 5 4 3 2 1

Cataloging-in-Publication data is available at the Library of Congress

ISBN 13: 978-0-8229-4704-2

ISBN 10: 0-8229-4704-8

Cover art: John Kane, *Self-Portrait*, c. 1929. Oil on canvas over board. Abby Aldrich Rockefeller Fund, 6.1939. Digital Image © The Museum of Modern Art/Licensed by SCALA/Art Resource, NY.

Cover design: Alex Wolfe

Frontispiece: John Kane, *Turtle Creek Valley, No. 1*, c. 1932–34. Oil on canvas attached to pressed-paper board mounted to a wooden panel with a cradle. Gift of the Estate of Richard M. Scaife, 2015.5. The Westmoreland Museum of American Art.

FOR ALL THE
WORKING MEN AND WORKING WOMEN
WHO HAVE MADE JOHN KANE'S
PITTSBURGH THE VERY REAL, GRITTY, AND
BEAUTIFUL PLACE WE LOVE.

CONTENTS

THE ART *by Louise Lippincott*

PREFACE & ACKNOWLEDGMENTS

T HE AUTHORS WANT TO OFFER A VERY SPECIAL acknowledgment to two writers who preceded them, and who have done so much to preserve the legacy of John Kane and to illuminate the exceptional importance of the American self-taught artist: Marie McSwigan and Leon Arkus. Without the efforts of the journalist McSwigan and the scholar Arkus, the world would little understand or appreciate the exceptional contributions of the industrious Kane.

McSwigan was a Pittsburgh newspaper reporter who was one of the first on the story of John Kane once his work was admitted to the Carnegie International in 1927. As his fame grew, and more and more press from around the country sought a piece of the Kane story, McSwigan was one of the leading writers on the subject. Later, when so many others retreated as the story cooled, McSwigan stuck with it. She became a friend of John and his wife, Maggie, and visited them often. Eventually, she entered a process with Kane through which his life story was captured and recorded for posterity. McSwigan spent many long sessions with the artist and his wife, during which Kane reminisced about his life and McSwigan took notes. The result was *Sky Hooks*, the story of his life, published three and a half years after his death. The work was presented as an autobiography, in Kane's own words. But it was very much the product of McSwigan's talent and dedication, and it preserved Kane's legacy. Every scholar, critic, and writer on Kane since is deeply indebted to McSwigan; many direct quotes from Kane in this volume come from her work. She went on to a successful career as a writer, producing a number of articles and books, including the renowned children's book *Snow Treasure*, later made into a popular movie of the same name.

Arkus was of a later time, and his career was devoted to the world of art. He served as director of the Carnegie Museum of

Art from 1968 to 1980 and is credited with a significant expansion of the museum's galleries and its collection. His appreciation for modern art and the Impressionists transformed the museum with acquisitions of such artists as Mark Rothko, Claude Monet, Edgar Degas, and Henri Matisse; he was knighted by the queen of Denmark in 1974 for his role in bringing Danish art to the United States. At the same time, he fostered regional artists through exhibitions and publications, notably *John Kane, Painter*, a catalogue raisonné that included most of Kane's works, a critical review by Arkus himself, and a republication of *Sky Hooks*. Arkus's attention to the Kane oeuvre brought renewed recognition to the importance of the artist's contributions and ensured their preservation.

Neither of these works—McSwigan's *Sky Hooks* and Arkus's *John Kane, Painter*—is without flaws. Every book, including the one you are reading, will have errors and omissions. But McSwigan and Arkus contributed enormously to the understanding and appreciation of Kane as an artist and a person. We only hope that this volume can continue what they began and add to the comprehension of John Kane's important legacy. Because this is a book about the life and work of an artist, it is most importantly a visual exercise. For that reason, the authors and the editors have wanted to be as ambitious as possible in terms of the selection and presentation of pictures. Not only did we want to be able to reproduce a significant selection of Kane's own works but we wanted to present many other pictures, photos, maps, and postcards that could convey to the reader a faithful portrait of Kane's time and place in America.

All this proved to be quite complicated and expensive—indeed, beyond the typical cost borne by the publisher for pictures. Happily, the University of Pittsburgh Press was able to secure grants from two Pittsburgh foundations—the Heinz Endowments and the Sheila Reicher Fine Foundation—to underwrite the added cost of this ambitious presentation. We, the editors and authors, are grateful to both foundations for these critical contributions. And we are proud of the beauty of the resulting volume

As chance and good fortune would have it, Heinz Endowments vice-president Janet Sarbaugh, an expert in the arts and culture,

was already an early source of encouragement for the collaboration of the two authors on this book. And Sheila Reicher Fine, chair of the board of both the Fine Foundation and the Sheila Reicher Fine Foundation, and a committed community leader in Pittsburgh for decades, has included the Kane project among the many Pittsburgh arts projects she has supported. We thank each of them.

Finally, a word about the artist whose work and life have inspired us to write. It was, at first, the very distinctive and exciting life story of John Kane that captured our interest. But, over time, the beauty of the art he created became the prime motivator of our project, and our appreciation of his creativity and his sensibility deepened our commitment to revitalizing his legacy as an important American artist. That Kane was able to overcome the myriad obstacles in his way, and then to find beauty in so much of the workaday world around him, is inspiring. And he did all this, as he lived his life, with a combined sense of duty and joy. As we have worked on this project, the joy has proven contagious, and we have had the time of our lives fashioning this broad account of the man and the artist, his art and his spirit.

■　　■

In this project we have benefited from the knowledge, advice, assistance, and enthusiasm of many others. Our deepest thanks to friend and colleague Janet Sarbaugh, who suggested this writing partnership as the best way to explore a remarkable man's life and art. For two years we consulted with/pestered numerous experts on regional history, culture, and art who were unfailingly generous with their time and attention: Jane Arkus, Barbara Jones, Anne Kraybill, Andy Masich, Anne Madarasz, Akemi May, Pat McArdle, Charles McCollester, Judy O'Toole, and Tonia Rose. They provided helpful guidance as we got started, and critical guardrails as our project steered in new directions. And a special thanks to Mary McDonough, niece of Marie McSwigan, for her thoughtful stewardship of McSwigan's papers, notes and pictures. Errors of fact and interpretation are entirely our own.

The COVID-19 pandemic has been a blessing and a curse. Plenty of time to think and write, near-zero public access to private

collections, museums, galleries, libraries, and archives. Therefore, our debt is all the greater to the curators, conservators, registrars, gallerists, librarians, and archivists who opened their doors to us when circumstances permitted or who served as our eyes and ears during lockdowns. In particular, we would like to acknowledge the expertise and assistance of Amy Bowman-McElhone, Doug Evans, Susan Friedmann, Kimberli Gant, Steven Holmes, Costas Karakatsanis, Mark Lewis, Emily Mirales, Sylvia Rhor Samaniego, Christina Roman, Matthew Strauss, Elizabeth Tufts Brown, Amy Welch, and the institutions they represent: Canajoharie Library and Museum, Carlow University, Carnegie Library of Pittsburgh, Carnegie Museum of Art, the Cartin Collection, the Chrysler Museum of Art, the Galerie St. Etienne, the Senator John Heinz History Center, the University of Pittsburgh, and the Westmoreland Museum of American Art. Independent scholars Allison Russell and John Shulman contributed essential information about Kane's life and times out of sheer goodness of heart.

As the pandemic waned, regional private collectors opened their homes to us. Jane Arkus, Ellen Brooks, Mark and Catherine Loevner, Patrick McArdle, and Mary McDonough provided immediate access to works and documents in their collections, greatly enriching our experience and the finished product. We thank them for their generosity with their time and their collections.

We have greatly enjoyed working with the team who made this book real. Sandy Crooms at the University of Pittsburgh Press accepted our proposal and press director Peter Kracht thoughtfully encouraged greater ambitions for the book's content and design. Alex Wolfe, John Fagan, and Amy Sherman have made a great difference. Laurel Mitchell, freelance photo researcher and editor, compiled the image files and credits from unconventional sources cheerfully and efficiently. The Heinz Endowments and the Fine Foundation, Pittsburgh organizations with distinguished records of support for regional arts, enabled our effort to represent John Kane's visual world—the places he knew and the pictures he painted—in the most comprehensive ways.

By way of more personal thanks, Maxwell King would like to mention the contributions of two people: Pittsburgh art dealer Pat McArdle, who introduced the author to the Kane saga many years

ago; and Margaret Ann King, Maxwell's wife, whose review of the manuscript and hundreds of helpful observations have markedly improved the work. Louise Lippincott would like to thank her friends and family, especially her son Phil McGuire, for their patience and their many contributions to her understanding of an unusual man and wonderful artist.

THE
LIFE

by Maxwell King

PROLOGUE

FROM THE EARLIEST AGE, JOHN KANE SHOWED an aptitude for drawing and creativity. As a little boy growing up poor in Scotland, he loved school, but sometimes found himself distracted by the need to put down the images that floated in his mind. All his life, as he worked in one craft or another—steelworker, coal miner, bridge builder, painter—he would be captured by an image, and he always felt the need, somehow, right away, to begin getting it down on paper or canvas or board. It was a habit that stuck with him through all his days as an American workman from the 1880s to the 1920s; it started at a very young age, in elementary school in West Calder, Scotland, where he was born.

One of the images that captured him, and drew him away from his schoolwork, was of French and Prussian soldiers, which appeared in the local press during the War of 1870. As his classroom attention drifted, the young Kane began drawing his recollection of the fierce look of the warriors. He became so engrossed in his depiction of the soldiers that he never heard the teacher's cane tapping on the desk at the front of the room. When Kane finally did look up, he found that a number of other students had gathered around him to see what he was creating. And schoolmaster Walker was furious at losing control of his whole class. By the time the boy saw what was happening, it was too late: Kane had to accept his due, a half-dozen whacks to his hand from the schoolmaster's cane.

Kane's devotion to his art, and his skill as an artist, grew through the years after he emigrated to America, even as he made

his living as a workingman who struggled to find enough time to draw and paint. Although he found more and more ways to commercialize his skills, and produced more and more exceptional work, success and renown eluded him. He was always a risk taker, moving frequently and shifting professions to capitalize on the directions taken by the US economy and manufacturing. He was driven, certainly, by his own curiosity and his questing nature, but he was also driven by an escapism fueled by his addiction to drink.

No risk in all of Kane's unsettled life was more audacious than his decision, at the age at which most people are retiring from work, to try to enter his paintings into the most prestigious of American art exhibits: the Carnegie International. Shortly after its founding as the Carnegie Institute Department of Fine Arts, in 1895, the Carnegie Museum of Art in Pittsburgh had embarked on a journey to create an international art exhibit that would attract the best in the world. By the 1920s the annual exhibition—today known as the Carnegie International and held every four years—had become enormously influential in the art world. Many of the world's premier artists—including Mary Cassatt, James McNeill Whistler, Childe Hassam, Edward Hopper, Camille Pissarro, and John Singer Sargent—showed at the exhibition over the years. And such renowned figures as Thomas Eakins, Robert Henri, and Winslow Homer served on the juries that judged admittance of the works of the increasingly exclusive list of artists.

It was in 1925 that self-taught Pittsburgh painter John Kane tried his hand at getting some of his pictures into the exhibit.

No such luck.

Midcareer, Kane had taken his construction-trade skills into a new direction, making his living as a railcar and house painter. Around 1900, when he was working for the Pressed Steel Car Company, manufacturer of railroad cars, he soon became the company's lead painter. And, he reported later, during that time he developed a new passion, a new "love." But it wasn't painting that captured Kane; it was paint itself. "I now became in love with paint," he said, explaining his embrace of the material that enabled him to earn a living and, later, to create beautiful pictures.[1] Kane had been drawing since childhood, but now he turned his love of paint into the colorful art that would make him famous.

The Pittsburgh Press

PITTSBURGH, PA., SUNDAY, OCTOBER 16, 1927.

128 PAGES
LARGEST AND GREATEST
SUNDAY PAPER
ISSUED IN PITTSBURGH

TEN CENTS

CAPTAIN DESCRIBES RESCUE OF RUTH ELDER AND HER PILOT

Words Painted on Deck Gave Flyers Advice As They Circled Ship; Dropping Messages; Benzine Blasts Set Plane Afire

By CAPT. GOOS,

RIVAL FORCES ORGANIZE FOR POLITICAL WAR

Barr Enthused Over Outlook for McGovern; G. O. P. Opens Quarters.

FRENCH SEND REPLY

Note Understood to Ask Tariff Dispute Conciliation.

TRIPLE INQUIRY BEGUN IN CRASH

Three Probes Are Started Into Tragic Death of 18.

CHILD'S SKULL BROKEN IN BEATING, CHARGE

FIND OFFICER DEAD

ONLY PITTSBURGHER ADMITTED TO INTERNATIONAL IS A HOUSE PAINTER

Work of John Kane Likened to That of Rousseau.

By ANN LEE.

'CHANNEL SWIM' WAS FRAUD, ENGLISH WOMAN ADMITS; EDERLE RECORD STANDS

Dr. Logan, Returning Prize to London Paper, Declared She Staged Stunt to Show How Easily Feat Can Be Faked.

SWAM FOUR HOURS; SLEPT REST OF TIME

Breaks News to London Editor After He Reaffirms His Belief That Her Exploit Was Genuine.

PANTHERS WIN; TECH TRAMPLED BY PRESIDENTS

Duquesne Holds Bethany to a 7-7 Tie; Notre Dame Beats Navy.

ASKS OIL TRUST PROBE

League Urges Action Against Standard Oil Companies.

MAN WHO BROKE JAIL 19 YEARS AGO TAKEN

Authorize Ship Bonds.

SAVE SCHOONER CREW

Coast Guard Cutter Rescues Men From Wrecked Ship.

Dies Aged 101

"Auntie Lee," of Youngstown, Ohio, Passes Away, After Brief Illness.

WHO WILL SHARE RUTH'S GLORY?

Ruth a Divorcee

The caption below the full page reads:

The *Pittsburgh Press* broke the story; later, scores of publications joined in to focus on the astonishing success of house painter John Kane in securing admittance for his work to the prestigious Carnegie International art exhibit. Front page of *Pittsburgh Press*, October 16, 1927. Newspapers.com.

He went back to try the International exhibit in 1926, the year after he was first rejected. The jurors said no—in effect, thanks but no thanks. Rebuffed again, Kane might have been forgiven for thinking he was being told that the exhibit was not for a house painter like himself. Still, Kane did get an encouraging letter from Homer Saint-Gaudens, the director of the museum, and that spurred him on.

When the Carnegie jury reviewed entries for the 1927 exhibit, Kane—resolute and relentless—was there with more of his work. And this time, Kane had a bit of luck: one of the jurors was Andrew Dasburg, an artist with a broad perspective and an open mind. Dasburg had studied cubism in Paris, and he had seen the impact of self-taught painter Henri Rousseau's work on artists there and art critics worldwide. Dasburg—perhaps inspired by Pablo Picasso's championship of Rousseau—responded to Kane's work and decided to advocate for this undiscovered artist.

The 1927 Carnegie International, thanks to Dasburg's fine sensibility, included *Scene from the Scottish Highlands*, by John Kane. And the workingman-artist's fame was launched in spectacular fashion, as the press and the world of art collectors responded to Kane's work. Eventually, Kane's work was part of seven Carnegie exhibits and was added to the museum's permanent collection, as well as those of New York's Museum of Modern Art, the Whitney Museum of American Art, the Art Institute of Chicago, and other museums. His work was also collected by some of the country's wealthiest patrons, including William S. Paley, Mrs. Averell Harriman, Dr. Albert C. Barnes, and Mrs. John D. Rockefeller.

So it was that Kane, who had been a laborer in the mills and railroads of Pittsburgh's great industrial era and had been painting portraits and landscapes for years, was suddenly launched into a final career as an American cultural star at the ripe old age of sixty-seven. And this just a few years after Pittsburgh's bosses, Henry Clay Frick, Andrew W. Mellon, and even Andrew Carnegie— the men who had built Pittsburgh's mighty manufacturing machine on the backs of workers like Kane—were spending large sums of money to try to forge second careers as art collectors. This irony was something to which Kane never paid the least bit of attention.

PART I

*Scotland, steel, and the origins of the lifelong wanderings of a master of
many parts. How John Kane came to America from Scotland and began
a long and extraordinarily varied working life, first in coal and coke,
then in steel, railroads, and building, all the while patiently honing his
skills as an artist. And how his risk-taking, seeking nature took him to
many parts of the country and into activities as different as boxing with
professionals and patiently teaching himself the skills of a painter and
an artist.*

A West Calder neighborhood of working-class houses where Kane's parents moved a few years after he was born. *A busy scene in the Happy Land, probably Annan Street, looking east*, n.d. Courtesy Guthrie Hutton / Stenlake Publishing.

A BOY IN SCOTLAND

J OHN KANE'S PARENTS, THOMAS AND BARBARA
Cain (the spelling was changed later in their son's life),
came from one of the most enthralling parts of Ireland:
County Galway, a wild, beautiful landscape that stretches from
rolling farmland in the east to a rugged and striking coastline in
the west. But for all that beauty, Ireland was a nightmarishly grim
location in the 1850s, when the Cains lived there: the Irish Potato
Famine, at its peak in 1847, killed a million people and drove
another million away in a quest for food and work before it ended
in the mid-1850s.

The famine, which began in 1845 when a fungus attacked the
potato fields that most Irish farmers and workers depended on for
food through the long winters, was also known as the "Great Hun-
ger." The food supply had become so dominated by the potato,
introduced into Ireland around the turn of the seventeenth cen-
tury, that the loss of crops was devastating to the Irish people. But
it was made far worse by the behavior of the English landowners.
The farmers in Ireland were all tenant farmers and their country
was ruled ruthlessly by Great Britain. Under the so-called British
Penal Laws, for many years Irish Catholics (most of the native
population, including Thomas and Barbara Cain) were prohibited
from voting or even owning their own land. When the famine
struck, the British landed gentry, owners of most of the farmland
in Ireland, were harsh and unforgiving in their treatment of the
workers. In fact, the British not only kept on exporting much of

the food produced in Ireland to England, they actually increased the amount of food shipped away from the starving masses to provide for English subjects. There are those who consider the grotesque loss of life in Ireland to be one of history's most shocking acts of genocide, perpetrated by the English. Over the years, many Irish and British writers have written withering satires of the inhumane and selfish treatment accorded the Irish people by the English. Great bitterness toward the English is still palpable throughout the Emerald Isle today.

John Kane was born on August 19, 1860, in West Calder, a small mining town in the industrial heartland of Scotland lying between Glasgow and Edinburgh. His parents had moved there from County Galway to escape the devastation of the Great Hunger. Their choice of Scotland rather than England may well have reflected the antipathy toward the English that so many of the survivors of the famine felt, and in choosing their new home they selected a country that shared their skepticism of the English character.

Kane's parents picked the village of West Calder because they thought it a likely place for them to find work. The coal and shale industries in and around West Calder—four coal mines and a dozen shale mines—provided jobs for unskilled workers. In fact, mining was the first job that Thomas Cain took on once the family had moved to Scotland. Barbara Cain—known throughout the region as "Big Babbie"—was a hard worker, too, and after Thomas left the mines and became a day laborer she was often found in the fields working side by side with her husband. She got her nickname, according to her son, because of her expansive and openly friendly nature.

The family's first house was a small, one-room hut with an earthen floor and a thatched roof. Big Babbie was a popular figure in the region—appreciated for her humor, her wisdom, and her big heart—and she drew many visitors who came to her small house for conversation and to get advice on life. Thomas, on the other hand, was more taciturn and dour. His last job was digging ditches in the Catholic cemetery. He got sick in the cold, damp conditions, and, after a long illness, he succumbed when John was

just ten years old. Thomas Cain died before the Catholic cemetery was finished, and so he was buried in the Presbyterian cemetery nearby. He left a widow and six children.

Although John Kane was an inquisitive student who showed artistic talent, he grew up in a working-class culture that valued, more than anything, what a man could earn by his labor. Starting at the age of eight, he spent less and less time in school and more time working in the shale mines. By the age of ten, having lost his father, he and his brothers were at work in the mines full time. Kane continued to draw, and he tried to continue some of his education in the evenings, but he had left the world of his childhood and had become a working person. He later said that there were lots of children like him working in the mines. Children were supposed to be at least twelve years old in order to qualify for work in the mines, but many, like Kane, were younger. "There was a great deal of eye-winking," said Kane of the child labor that was permitted in the mines. The shale oil industry around West Calder—just a dozen and a half miles from Edinburgh, the Scottish capital—was the source of fuel and paraffin for the manufacture of candles.

Though Barbara kept to many of her Irish ways, and was loyal to her homeland, she embraced Scottish culture for her children. She dressed the little boys in kilts and tartan outfits. The boys took to Scotland as well, taking frequent trips out into the nearby countryside for hiking and sight-seeing. Kane joined a group of local boys that formed a band, playing Scotch and Irish folk music—Kane on his beloved flute, joined by two dozen other flutes and fifes, two kettle drums, and a number of other instruments. But strife among members of the group who were of Irish descent—some Protestant and some Catholic—finally broke the band apart. Asked to play "Saint Patrick's Day in the Morning," the Protestant boys refused: "We won't play that piece," they said, according to Kane. "Our fathers said we shouldn't." Kane himself adopted his mother's attitude of tolerance and acceptance, and he also adopted her practice of regular attendance at mass—both habits that stuck with him for much of the rest of his life.

A postcard view of Calton Hill in Edinburgh around Kane's time in Scotland. West Calder was near Edinburgh; Kane and his friends often journeyed into the city, and one of his memories was seeing Calton Hill. The Art Publishing Company, Glasgow. *Calton Hill, Edinburgh*. Color postcard. Author's collection.

In 1872, at the age of twelve, Kane left the mines for a better job in Young's Paraffin Light and Mineral Oil Company, making candles from shale oil. He held the position at the paraffin works for three years, and it had a great influence on his development as a committed skilled worker. "The shale which I had helped extract at the mine I now used in its refined state," said Kane. "It comes out of the mine in thick slices . . . it gives an oil which makes the finest candle grease in the world." Kane later estimated that he made hundreds of thousands of candles through the paraffin company's machine-molding process. This was his first taste of skilled work in a factory, and he took a great sense of pride in it, boasting that "his" candles were shipped all over the world. The journey of John Kane the hardworking

Packing parafin wax lights at the sprawling manufacturing works of Young's
Paraffin Light and Mineral Oil Company, where 12-year-old John Kane
found work. Wicking and packing paraffin wax night lights, Addiewell works.
Courtesy Almond Valley Heritage Trust.

teenager in Scotland to John Kane the proud American working man
had begun.

Kane figured that he was making more working either in the
mines or the candle works in Scotland than he could earn almost
anywhere else, including America. "Since the time I was fifteen
I had heard a lot of talk about coming to America where work
was plentiful and where wages were so high that a man could get
rich in just no time at all," he recalled. "Well, work was plentiful

right there in West Calder. The wages were high, too, for those days." Kane was making forty-five shillings a week, better than the wages of many workers in America. "Living cost less in Scotland than in America, I soon found out. Altogether this talk seemed foolish when one could do so well right in his own country." Still, so many around Kane talked incessantly about America as the land of opportunity that momentum built in the family for a move.

When Barbara remarried in 1875, her new husband, Patrick Frazier, began to make plans for moving everyone to the United States. John's brother Patrick and their cousins the Coyne brothers joined in enthusiastically. In 1879 Frazier left for a job in the Pittsburgh region of Pennsylvania. "When my stepfather sent for me, I didn't want to go to America. I was doing well in my own country and was becoming more and more in love with Scotland all the time," said Kane later. "But Mother thought I ought to go when my stepfather sent for me. And accordingly I went." Though Kane was very reluctant, the draw of America had proven too strong for his stepfather, his brother, and the Coyne brothers, and he decided to head to Pennsylvania to join them. Later, Barbara and his other brothers would come as well.

For the rest of his life, Kane loved and missed his homeland. Though he never did return there, he painted many Scottish themes from memory, sometimes stimulated by photographs. One of them was titled *The Campbells Are Coming*, a depiction of a Highland piper based loosely on Kane's revered older brother Patrick, who was a beloved and influential figure in the artist's life. Patrick had served as a private in the British Army after falling for an old recruiting trick: if a soldier gave a young man a shilling, he was automatically an army recruit because he had unwittingly accepted the king's coin. Patrick fell for it, but John did not. When a soldier chased him and begged him to get a drink with him, John was smart enough to run for his life.

▶ John Kane's 1932 painting, *The Campbells Are Coming*, is in part a tribute to his beloved brother Patrick; like many Kane works, it was drawn from a combination of postcard images and memory. John Kane, *The Campbells are Coming*, 1932. Oil and gold paint on paper over composition board. The Sidney and Harriet Janis Collection. Museum of Modern Art, NY. Digital Image © The Museum of Modern Art/Licensed by SCALA/Art Resource, NY.

68058. (JV) Pipe Major 4ᵗʰ Royal Scots.

Kane's combination of wistful memories of his Scottish homeland and his great pride in his work as an American comes through strongly in recollections from his autobiography, *Sky Hooks*:

For I never went back to my childhood home though I have visited it a thousand times in memory. In America I did almost every kind of work a laboring man can do. I dug coal and helped make steel in one of the

greatest steel plants in the world. I mined coke and sank and blasted shafts for collieries. I laid paving brick. I dug foundations for two great industrial plants. I was a watchman at a railroad crossing for eight years. I helped with the manufacture of steel railroad cars. I was a carpenter and worked on the foundations of two new filtration plants. I was one of a crew that built a beautiful bridge in Pittsburgh. I helped with the erection of the four great rubber factories in Akron, Ohio. But chiefly I was handy with the paint brush. I painted houses, offices, box cars and almost the whole of an amusement park in Pittsburgh. I did almost every kind of work that a man can do.

And he found his calling as an artist.

This painting of the Bessemer Steel Company plant, the work of nineteenth-century artist William C. Wall, portrays a typical Pittsburgh industrial scene from the time of John Kane's arrival in America. William C. Wall, *The Pittsburgh Bessemer Steel Company*, 1884. Oil on canvas, Carnegie Museum of Art, Pittsburgh. Bequest of Charles J. Rosenbloom, 74.7.27. Image courtesy Carnegie Museum of Art, Pittsburgh.

· 2 ·

COMING TO AMERICA

JOHN KANE'S 1880 VOYAGE TO THE NEW WORLD came at just the time that the United States, and most particularly the western Pennsylvania region around Pittsburgh, was claiming its place as the leading manufactory on earth. Pittsburgh's advantages—strong shipping on her three rivers, a growing highway system in the first half of the nineteenth century, and ample supplies of sand, lumber, coal, and, later, oil—all provided western Pennsylvania with the means to evolve a powerful manufacturing base that included iron, tin, brass, steel, other metals, and glass. The region became famous for producing locomotives, ships, armaments and ammunition, and steel rails for the railroads.

The completion of the Pennsylvania Railroad's Main Line from Philadelphia to Pittsburgh in 1854 sealed the deal and soon Pittsburgh's steel industry became the leading, and most profitable, business in the country. The region's famed industrialists—Andrew Carnegie, Henry Clay Frick, Andrew W. Mellon, H. J. Heinz, George Westinghouse, Alfred E. Hunt, and others—became some of the richest men in the nation, and the area around the Pittsburgh neighborhood of East Liberty, where many of these business titans and their lieutenants lived, achieved the status of one of the wealthiest communities in America.

These barons of industry needed workers, of course, and this was what drew Kane and his family to the Pittsburgh region. Thousands of immigrants poured in from Ireland, Scotland, Germany, Hungary, Italy, Poland, Russia, and elsewhere. By 1920 the

population of Pittsburgh had grown an astonishing seven times its size at the beginning of the period of industrialization in 1870. As the barons grew rich, their workers endured long hours, harsh conditions, and increasingly dangerous work conditions. Many of the immigrants were caught up in a long and sometimes brutal labor struggle with the management of the companies where they worked. But it was the work—the abundance of jobs and the opportunity to earn better wages than in many of the places from which the workers came—that drew the tide of immigrants. (Later in the twentieth century large numbers of African Americans moved north to cities like Philadelphia, Chicago, and Pittsburgh, similarly drawn by the hope of employment.) The contingent of Scots-Irish, including one John Kane of West Calder, Scotland, was the first and leading group to come to western Pennsylvania—in fact, many in the ranks of the industrialists, as well as their workers, were Scots-Irish.

In 1880, just before reaching the age of twenty, a strapping and handsome young John Kane headed to America from Glasgow on the cargo and passenger ship Indiana, an early trans-Atlantic steamer made of iron and steel. The Indiana served for thirty-six years, including a journey in which US president Ulysses S. Grant crossed the Atlantic on her two years before Kane was aboard. The Indiana would be shipwrecked on the coast of Mexico over a quarter century after Kane's voyage. The passage for Kane and his cousin Tom Coyne took eighteen days and it was an unusual trip for two reasons: relentless rough weather and the unexpected need to stop in Larne, Ireland, for repairs to be made in the hold of the ship, where ballast had come loose.

The unexpected stop in Ireland gave John an opportunity to visit the birth country of his parents, and he relished it. Tom had grown up in Ireland and gave John a tour around County Antrim and the northeast coast of Ireland. Kane, away from home for the first time in his life, felt a bit self-conscious: "I must have been a comical-looking greenhorn, for sure. I had a regular suit of clothes, of course, of good heavy Scotch woolen. On my head was a little cheese-cutter, a cap with a peak like a chauffeur's, only tilted backward toward the crown like the hats of the union soldiers. I had other garments, just as curious, on board in my

U.S. Steel's Edgar Thomson Works on the Monongahela River around the time Kane's relatives, and later Kane himself, went to work there. Frederick T. Gretton, *Blast Furnaces at Edgar Thomson Steel Works*, 1886. Detre Library & Archives, Senator John Heinz History Center, Pittsburgh.

little tin steamer trunk where I had stowed my flute." This flute from his childhood went everywhere with Kane for his whole life; he got pleasure and took solace from playing it for years to come.

Kane and Coyne were headed ultimately to the mill community of Braddock, just outside Pittsburgh, to join Kane's stepfather and his brother, who had found work in Braddock, most likely at the Edgar Thomson Works. The works had quickly become the major industry along the Monongahela River—known locally as the "Mon"—after it was opened in 1872 by Andrew Carnegie. In one of his many savvy moves as a businessman, Carnegie had named the plant after the president of the Pennsylvania Railroad, to whom Carnegie planned to sell steel rails and other products from the works. It has been a landmark in Braddock for 150 years and is still in operation as part of U.S. Steel Corporation.

Henry Clay Frick's Coke Company achieved such a central place in American manufacturing that venerable magazines like *Harper's* provided an illustrated look at the coke ovens and the workers. W. A. Rogers, *The Workers and Their Dwellings at Pittsburgh Coke Ovens*, 1888. Wood engraving, hand-colored. *Harper's Weekly*, 1888. North Wind Picture Archives/Alamy Stock Photo.

Kane ended up working, in quick succession, for the railroad, in coal mining and the production of coke (a key ingredient in the making of steel), and in the major steel mill in the state. He first found employment quickly in nearby McKeesport, about eight miles up the Mon, as a gandy dancer—one of the section hands responsible for laying and maintaining railroad tracks—with the Baltimore and Ohio Railroad. He liked the work, tamping down rocks between railroad ties, but he was disappointed that his wages were less than he had been making in Scotland.

Kane's major work experience back in Scotland had been as a miner, and soon after his arrival in the New World he gravitated back to that. Kane and another cousin who had moved from Europe to America, Pat Coyne, went to the coal-mining region around Connellsville, about fifty miles to the southeast of Pittsburgh on the Youghiogheny River, a tributary of the Mon. This was and still is coal-mining territory, and one of the biggest industries in the region was the manufacture of coke for use in the production of steel. Instead of going down into the mines, Kane took on one of the jobs "drawing coke" from the abundant coal in the region—a process of turning coal into coke by baking it in ovens to take out all the impurities, rather like turning wood into charcoal. This created a fuel capable of generating the extreme high temperatures needed for mass steel production.

It was also in Connellsville that he began his serious pursuit of a pastime that was to become a staple of his life for years to come: boxing. What may have started as a propensity for barroom brawling quickly became a skill that John was proud of. He became a prizefighter, and his skills in the ring brought him recognition in many of the places where he subsequently lived and worked.

For a time during his sojourn in coal country, Kane worked for Henry Clay Frick, the famous industrialist who started his coke company at the age of twenty and went on to build an enormous fortune in both the coke and steel industries. Frick, who was notoriously antilabor and the author of harsh working conditions for men like Kane, understood the critical role of coke in the fledgling steel industry in western Pennsylvania, and he profited enormously by his foresight. Because coke can create intense heat with very little smoke or effluent, it is essential in the production of steel.

PITTSBURG STREET, CONNELLSVILLE—LOOKING NORTH.

CONNELLSVILLE COKE AND COAL REGION.

This postcard view of Pittsburgh Street in Connellsville, made some years after Kane worked in this coke and coal region of western Pennsylvania, shows the bustling street activity of a prosperous industrial city of the time. *Pittsburg Street, Connellsville—Looking North. Connellsville Coke and Coal Region*, 1906. Postcard. Porter & Co., publisher. Author's collection.

Kane recounts one of the times he encountered Frick, during a labor meeting when Frick was trying to convince a group of miners to go back to work: "Now a young Hungarian in the crowd drew a gun, meaning to shoot Frick, for the feeling ran high against the bosses. But Frick was a pretty strong young man. He jumped down off the steps where he was speaking and snapped the gun out of the Hungarian's hand. 'Here, young fellow, give me that gun,' he said. He went right on with what he had been saying. He hardly interrupted his talk at all."

Kane's admiring account of Frick's courage mirrors another commonly told story about the industrialist: During the famous Homestead Strike outside Pittsburgh in 1892, a Russian-born anarchist, Alexander Berkman, tried to assassinate Frick, who was

employed by Carnegie to manage the Homestead Works. Though he was both shot and stabbed, Frick kept his cool, even dictating some business letters while doctors treated him. Berkman was later arrested and convicted, serving fourteen years in prison for attempted murder. Frick and Carnegie used the bitter and violent Homestead Strike to break the Amalgamated Association of Iron and Steel Workers, and drive unions from the Homestead Works, on the Monongahela near Braddock.

In 1881 Kane moved back from Connellsville to Braddock. His stepfather, Patrick Frazier, had written to Barbara to say it was time for her to come to Pittsburgh to be with him and her son, and that she should bring John's brothers with her. John, of course, was very excited and happy. Frazier had suggested that the time might be right for him to come back to Braddock, to bring the whole family together, and he abruptly quit his job in the coke fields and went to work at Carnegie's Edgar Thomson Works.

On the day Barbara was scheduled to arrive, Kane and his step-father and his cousin Pat Coyne were too eager to wait in Braddock for her to get there. They got on a train headed east and got off in Irwin, about a dozen miles up the rail line, to wait for Barbara's train. "The day she was to arrive I was up at dawn," said Kane later. "Frazier and Paddy and I went to meet her . . . I entered one of the immigrant cars full of greenhorns, and what should I see but a sign in great big letters, 'Mrs. Frazier—Braddock.'" And there was his mother and his three younger brothers, asleep by the sign. When they all got back to Braddock, they had a great family reunion in Frazier's house. "But," said Kane, "when the whistle blew the next morning we were all back at our jobs."

Kane's job now was as a top-filler at the sprawling Edgar Thomson Works, near the house he shared with his stepfather, his mother, and his brother Patrick. "In top-filling, your load is half a ton," said Kane. "You push it on a carrier that has two arms like the handle on a baby carriage. A man would push one of these half-ton charges to the bell, which was what we called the furnace. It took eight charges of ore, two charges of coke and one of limestone to fill the bell." Kane's job was one of the crucial ones in steelmaking, and he had become a part of one of the greatest manufacturing machines in the history of the world.

The close, side-by-side proximity of houses and the mills in Homestead, Pennsylvania, is clearly apparent in this postcard view of the riverfront community from a decade and a half after the famed Homestead Strike of 1892. *View of Homestead and the Mills, Homestead, Pa.,* c. 1910. Color postcard. Robbins & Son, publisher. Author's collection.

· 3 ·

MAKING STEEL

FROM THE TIME JOHN KANE WENT TO WORK AT Andrew Carnegie's Edgar Thomson Works until the aftermath of World War II, western Pennsylvania was the center of the universe when it came to manufacturing steel, other metals, glass products, and other goods. Kane had entered the Pittsburgh workforce just at the birth of the era of huge, spectacular mills along Pittsburgh's three rivers (the Monongahela, the Allegheny, and the Ohio). These mills literally lit up the night sky with the glow of their furnaces, visible for scores of miles. This was, as Boston writer James Parton had written in the *Atlantic Monthly* back in 1868, "hell with the lid off." Later, between the two world wars, airplane pilots could spot the light of Pittsburgh a hundred miles away and be guided into the region by it. It was a powerful center of industrial entrepreneurship, and many great fortunes were made there during this period. Two of the greatest were made by Henry Clay Frick and Carnegie, and Kane had just gone from working for Frick in the coke fields to working for Carnegie in the steel mill.

Both Frick and Carnegie were financed by the third financial titan of the period, banker Andrew W. Mellon, who turned the Mellon National Bank and the Union Trust Co., both headquartered in Pittsburgh, into two of the richest financial institutions in the country. In effect, Mellon was America's first venture capitalist; he pioneered the practice of making private equity investments in companies that showed a promise of great growth. The savvy Mellon made these investments not as loans but as funding for equity

An esteemed Pittsburgh artist from the time, impressionist Aaron Gorson, made numerous portraits of riverfront steel mills luminous in the dark. Gorson, *Night around the Mills*, c. 1909. Oil on canvas. Carnegie Museum of Art, Pittsburgh: Gift of Senator and Mrs. H. John Heinz III, 77.80. Image Courtesy Carnegie Museum of Art, Pittsburgh.

stakes in the companies. And so, as the companies grew, Mellon's investments mushroomed into one of America's greatest fortunes.

Kenneth J. Kobus, a scholar of Pittsburgh and the steel industry, makes a strong case that what gave Carnegie such an advantage over competitors was his use of cutting-edge technology

to improve his manufacturing process. And the other key advantage for Carnegie was his extraordinary business acumen, which enabled him to foresee developing markets. Certainly, Carnegie was the most aggressive adopter of cutting-edge technology in the world of steel, and he saw that the railroads would have to switch from iron rails to steel well before any of his competitors, or even a lot of the railway men themselves. It was a combination of all these factors that made Carnegie the richest man of his time and place.

Another Pittsburgh historian, Charles McCollester, notes that Frick, Carnegie, and Mellon were not creators of new inventions or new products, like Pittsburgh magnates George Westinghouse and H. J. Heinz I were. What the big three of the steel business had in common as a principal source of success and wealth was this: they were intensely ambitious and competitive managers. In McCollester's words, "they were driven, even ruthless, men who were present at a particularly opportune time."[1] McCollester's anger with the barons of industry and their impact on his community derives from his belief, well documented throughout his voluminous history of the Pittsburgh region, that they managed to control all aspects of life in western Pennsylvania. As they exerted more and more control over labor, and dramatically diminished the impact of organized unions, they extended their hegemony to all facets of society: work, commerce, politics, even the environment itself. In so doing, they degraded the existence of working people and the natural world: "The rivers themselves were dark, murky, oil and sludge-filled, garbage-littered waterways cut off by railroad tracks and riverside factories from the drab industrial towns that sprang up upon what once were rich agricultural bottom lands."[2]

Frick, much more than the other two, was considered a relentless foe of labor, and he advanced conditions in each of the enterprises he managed that were as harsh and unforgiving as any in the country. A signature moment in Frick's career was the Mammoth Mine Explosion. Over a hundred men and boys died in the 1891 disaster at this Frick-operated mine outside Pittsburgh. The Mammoth explosion, followed a year later by Frick's role in the terrible Homestead Strike, fueled mounting discontent with

Frick and Carnegie and their companies. Again, from McCollester: "Long hours, low pay, plus unhealthful working and living conditions sparked work stoppages and marches by strikers" throughout Frick enterprises.[3]

Les Standiford, a writer who made a study of the working relationship between Carnegie and Frick, claims that Carnegie observed Frick's methods and became a ruthless negotiator: making cost calculations to drive efficiency, and then simply shoving them down the throats of the workers. His mantra: "Watch the costs, and the profits will take care of themselves." Carnegie's relentless focus on driving down costs was key to his success. He kept a constant downward pressure on his cost basis, and his business became inexorably more profitable. Of course, labor was among his biggest costs, and the workmen paid the price for that. They made as little as $1.50 a day, and, as their hours increased over the years of Carnegie's ownership, their wages were stagnant.

In 1887 Carnegie calculated the savings to his company if the workers at the Edgar Thomson mill were forced to lengthen their workday, even if they were paid somewhat more for the longer day. Against the advice of Bill Jones, his lead manager, Carnegie told workers there that their eight-hour workdays were to become twelve-hour days. "The moment Carnegie's decision was announced, workers at the plant went out on strike. After a conference with Jones, Carnegie announced that the plant would close until the men agreed to return, on his terms, and he held fast for four months, until representatives of the Amalgamated Association of Iron and Steel Workers agreed to negotiate."[4] In the end, the settlement achieved the schedule and the increased profitability Carnegie was seeking. By the time Carnegie and other industrialists were done changing the business, almost all the laborers worked seven days a week, anywhere from eight-hour shifts to as many as sixteen hours a day. Carnegie routinely gave his workers one holiday a year: the Fourth of July; sometimes, but not always, they got Christmas Day, too.

Kane and many of his friends and family members spent years subsisting on bare-bones wages. The workers rarely shared in the prosperity, and Pittsburgh played a key role in creating the so-called Gilded Age or Robber Baron Era in US history. This was

In 1882, the humor and satire magazine *Puck* published this cartoon of a
Knights of Labor picnic, featuring fat-cat industrialists cruelly manipulating
the workers and their families. A sign in the background refers to "Pittsburg
Free Strikers." Joseph Keppler, *Knights of Labor Picnic*, 1882. Color lithograph.
Puck, June 21, 1882, copy in New York Historical Society. Niday Picture
Library/Alamy Stock Photo.

the first sustained period of gross income and wealth disparity in America—a period unmatched until the same level of inequity arose at the end of the twentieth century and the beginning of the twenty-first.

According to another student of the period, Kenneth Warren, "Overall, the massed ranks of the workers—'common labor'—received a comparatively small share of the returns from production. . . . Even more dramatic and depressing than the distribution of the fruits of production was the way in which labor was used, its uncertain employment, everyday working conditions, and the state of the still rapidly swelling mill town communities in which the workers and their families lived. . . . Sometimes the very basis of employment and the life of a community could be swept away by a single decision from upper management." And management, says Warren, was singularly blind to the plight of workers laboring twelve hours a day, seven days a week. This from a board member in 1912: "In my experience of forty years I have never known any one to suffer from over work or long hours of labor."[5]

The numbers of accidents, injuries, and deaths skyrocketed as Carnegie and his associates drove the enterprise toward higher productivity. Fully 20 percent of the deaths a year in the Pittsburgh region tracked to Carnegie's works in the 1890s. As exciting and lucrative as it was, it was a dangerous industry in which to work, and hundreds were maimed or killed each year, including friends and relatives of Kane himself. According to historian S. J. Kleinberg, writing of Pittsburgh working conditions,

metal processing was dangerous work with high accident and death rates. Families lived with the uncertainty of the breadwinners' return home from the day's toil. Molten metal spattered the millhands. Unstable piles of iron billets stood everywhere. Hot floors burned feet through wooden-soled shoes. Molds and furnaces exploded. The machinery had no protective guards. The noise deafened or impaired millworkers' hearing; the heat sapped their strength. Standing next to a hot furnace all day stirring iron, guiding it through the rolls, carrying it, dumping materials into blast furnaces, and pouring steel into molds drained workers, especially during the summer, when the mills resembled infernos.[6]

The interiors of the mills—bright, hot, intense, fiery—were a source of fascination to Americans; here, *Harper's* magazine provides an 1886 wood-engraving view of the workers on the floor of a Bessemer steel plant. Charles Graham, *Making Bessemer Steel at Pittsburgh—The Converters at Work*, 1886. Library of Congress, LC-USZ62-108121

Kleinberg notes that "almost two-fifths of the workers involved in accidents were laborers, many of whom worked in the iron, steel, and railroad industries. These industries, then, accounted for approximately four-fifths of the total accidental and violent deaths among adult men."[7]

What's more, according to Kleinberg: "Most victims of industrial mishaps were young family men. Crystal Eastman's study of work accidents for *The Pittsburgh Survey* (an ambitious sociological study of the city funded by the Russell Sage Foundation in New York) found that 69 percent of those who died as a result of such fatalities were between the ages of 21 and 40. . . . The men most likely to be injured or killed in mill accidents were precisely those who had young families to support and no one else who could shoulder their burdens."[8]

For Kane, this was personal. He and his family members spent far more time working for the railroads that served the mills than the mills themselves. And so their mishaps were railroad mishaps: in 1898 one of his brothers, Simon Frazier, was killed working as a brakeman for the Baltimore & Ohio Railroad; a year later, Patrick Cain lost his arm in a Pennsylvania Railroad industrial accident.

The harsh conditions for workers in the mills, the mines, and the other works around Pittsburgh led to investigative journalism after the turn of the twentieth century and finally culminated in *The Pittsburgh Survey*, the voluminous research report on living and working conditions in the Pittsburgh region. Published in six volumes between 1909 and 1914, *The Pittsburgh Survey* changed mass opinion about industry and the wealthy industrialists whose mansions were dotted across the region. It is considered a landmark of the great reform era that characterized the first half of the century and became known as the Progressive Movement. Its documentation of dangerous and overwhelming demands on the labor force around Pittsburgh—all of which were reported during the height of Kane's time as a workingman and artist—set a new standard for such sociological work and helped change conditions. A great deal of the popular support that eventually enabled the labor movement to make significant social progress, in Pittsburgh and across the nation, came about because of the work of the writers of the *Survey*.

A 1908 Pittsburgh neighborhood view, with smoke from the stacks of the mills obscuring the air in daytime, created by artist Joseph Stella to illustrate the groundbreaking study of living and working conditions that was published as *The Pittsburgh Survey*. Joseph Stella, *Painter's Row as It Stood in the Spring of 1908 (Pittsburgh)*, 1908. Charcoal on laid paper mounted on board. Hood Museum of Art, Dartmouth: Purchased through the Miriam H. and S. Sidney Stoneman Acquisition Fund, 2019.16

And John Kane, in the early 1880s, was right in the middle of it, in one of the most hazardous jobs in industry. According to Kobus, top filling in a steel mill was the single most dangerous job in one of the most dangerous professions in the world. Sixty percent of the fatalities in the mills occurred to top fillers. Kobus includes this account of an accident that killed eight men and critically injured eight others while they were clearing a jam from the top of a furnace: "The sheet of flame which issued from the

top of the furnace struck the men who were scattered about it, and blew them in all directions. One man was thrown over one of the elevators, and his body, striking a car below, was cut in two. Others were burned beyond recognition, and could be identified only by their clothing or by physical peculiarities."[9] The mixture Kane described as top-filling the furnace gave off a great deal of smoke, huge bright flames, and gas. Sometimes a worker would pass out from the gas. "Two top-fillers would be up on the platform around the bell," said Kane. "There was a speaking trumpet up there. If one of the two was overcome the partner would call down the tube, 'Partner gassed. Send up another man.'" The gassed worker was taken down from the platform to recover. Then, back to work.

In typical fashion, Kane made light of the hazard and hardship of the work and focused on the wages. Eventually, he tired of the relentless grind of working for Carnegie and Frick, decided that the sparse wages of the Carnegie enterprises could be improved upon elsewhere, and found better-paying places to sell his labor. He and a coworker from the coke fields, Joe Baker, learned that there might be good opportunities in Alabama, where there was a developing coal-mining and steelmaking industry. The prospect of work in the mining field—with which he was quite familiar—and better wages in a growing enterprise appealed to Kane.

Since coming to America, Kane had become prone to moving on from one thing to another. Almost on a whim, he would pull up stakes and change jobs, or change locales, or both. This was a reflection of Kane's peripatetic nature, to be sure. All his life, he showed a willingness to leave jobs or even family to pursue what he perceived as new opportunities. It also reflected the temperament of a hard-drinking, hard-living workman in late nineteenth-century America, with its strong culture of individuality and independence.

And so, in the fall of 1885, Kane and Baker hopped a freight headed south. It was on this ride that Kane developed one of his favorite "tall stories," the tales he later shared with the newspaper writer and author Marie McSwigan, who helped him write his autobiography. Kane was a naturally talented storyteller, and his skill shows through in this account of the time he "rode 130 miles on a mule in a night." According to this story, Kane and

Baker were riding on top of a freight car in the dark, the weather cold, windy, and rainy. Both men were suffering from the weather, and Kane decided to drop down into the car itself, which held a herd of mules, braying and milling about. "Well, the mules and I went back and forth the length of the car a few more times. They stamped a bit and stampeded back and forth, time after time. Then I put out my hand and touched one that didn't shy away. 'That's my mule,' I told myself, 'Here is one that is used to a man.'" Kane slept on the back of the mule for 130 miles, all the way to Birmingham, and for years liked to confound listeners with the puzzle of how he could have ridden a mule such a long distance in one night.

He and Baker found good jobs working at a coal mine in Warrior, Alabama, in the north-central part of the state. And it was here that he came back again to the very first love of his life: drawing and painting. During his off hours from the mine, Kane took to heading out into the countryside to look for beautiful settings—first to enjoy their beauty, and then, increasingly often, to use his skill to turn them into the sketches that sustained his evolution as an artist. "On the days we weren't working," said Kane later, "I used to do some drawing. I would go down to the Black Warrior River and make sketches along the banks . . . I would go to the blackberry patches and to the fields of wild strawberries. I liked to go up on the hills to draw and sketch."

Kane's embrace of drawing served a number of purposes in his life: a reflection of his interest in the world around him, a creative outlet in the life of a hardworking laborer, and an expression of his character, increasingly given to solitude.

"Gentleman Jim" Corbett strikes a manly pose for the camera. In addition to once sharing the ring for a sparring match, Jim Corbett and John Kane shared a romantic notion of manliness and fisticuffs. Vintage portrait photo of American boxer James J. Corbett (1866–1933). Fistiana/Alamy Stock Photo.

4

A RANGING AND
RESTLESS SPIRIT

URING KANE'S TIME WORKING IN THE SOUTH, he rekindled the boxing career he first started in Connellsville. He had built a reputation for toughness through a series of heavyweight fights, almost all of which ended in either a win or a draw for Kane. After he went south to find better work, he took a mining job in Glenmary, Tennessee, where he took up boxing again. According to Kane himself, a local saloon keeper who was a boxing fan focused on John as a promising fighter: "It came about in this fashion. The proprietor of the only saloon in town was a great man for fights. He had been a boxer in his young days. He never gave up his interest in the ring." When a very young Jim Corbett, several years before gaining fame as the heavyweight champion of the world, came to town with his trainer, the saloon keeper was asked to find a local opponent for him for a sparring match. And, of course, he recommended the tough young miner John Kane. "But I didn't know then that the man I met [in the ring] was someday to . . . become the world heavyweight champion," said Kane later. "It was only a friendly bout. There were no knockdowns. It lasted only a few rounds. When it was finished it was called a draw." Corbett went on several years later to knock out John L. Sullivan in the twenty-first round of their celebrated 1892 championship bout. Kane continued an amateur boxing career for several more years, even after he was seriously injured in a train accident back in Braddock.

Kane's travels through the South also acquainted him with American racism. "It was in the South that I got to know the

difference between a colored man and a white man. As a boy in Scotland I had always thought that 'a man's a man,' as our poet [Robert] Burns tells. If he was good at his work he was a good man. As a new American, one of the things that became like scripture to me was Lincoln's Gettysburg Address, which tells at the very beginning that this country was dedicated to the proposition that all men are created equal." One of Kane's later paintings, which became renowned as one of his best works, showed an American flag with a picture of Abraham Lincoln and the words of the Gettysburg Address. Kane was always proud of his own work ethic, and as much as anything he was offended by the southern racists' dismissal of the similar dedication to hard work that Kane saw in the black community: "The colored people did all the work and they weren't anything in the eyes of the southern white man."

Kane also became a union man during his time working in the South. Over the years, he joined the Knights of Labor, the Miners Union, and the Amalgamated Association of Iron and Steel Workers, and he remained loyal to the union cause for much of the rest of his working life. And that length of time—a half century—was a long period of great struggle for the American labor movement, which suffered a series of brutal strikes and antilabor actions from management in the Pittsburgh region and elsewhere in the country. One of the earliest and most devastating was the Great Railroad Strike of 1877, which came a few years before Kane arrived in Pennsylvania and was centered in Pittsburgh; there was also a series of related railroad strikes and labor actions around the country that year.

During the nineteenth century, railroads had come to dominate American transportation and industry. The Pennsylvania Railroad alone was the nation's biggest enterprise, with two hundred thousand employees, and other railroads in the United States were of a similar size. The strike started in West Virginia when the Baltimore & Ohio cut its workers' wages by 10 percent. This followed several other cuts by the B&O and other railroads, which resorted to paying devastatingly low wages to their workers in order to recoup losses during the recession that followed the market panic of 1873. Shortly after the 10 percent cut in wages, the B&O informed its board members that their business was

"entirely satisfactory" and that stockholders would receive a 10 percent boost in their dividends. That was too much for the workers, many of whose families were near starvation, and the labor action spread to Pittsburgh and burst into violence. Workers in the railyards in Pittsburgh's Strip District—at that time a warehousing and market center—blocked trains from leaving the yard. State militia and federal troops were called in to clear the railyards and bloodshed and destruction followed. The strike was eventually broken, but not before huge property losses for the Pennsylvania and Baltimore & Ohio Railroads and the loss of at least forty lives among workers and the militia members sent to control them. However, the American labor movement had made a telling mark on society, and the railroad strike created a strong and lasting impression on Kane and other workers like him.

During the years that Kane was working for enterprises associated in some way with Andrew Carnegie and Henry Clay Frick, the two industrialists were remarkably effective at combatting and diminishing the unions throughout their operations. According to historian S. J. Kleinberg,

> Carnegie plants turned to a twelve-hour day in the 1880s as further mechanization somewhat reduced the physical effort required of the workers. Hands then labored eleven hours a day on the day shift (or turn), and thirteen hours on the night turn, or seventy-two to eighty-nine hours a week. The longer working day remained standard through the first decades of the twentieth century until a coalition of church members and reformers successfully pressed for its abolition in 1923. . . . Following the Homestead Strike in 1892, employers reinstated Sunday work, so that most men labored twelve hours a day, six or seven days a week.[1]

What also happened after the Homestead Strike was a precipitous drop in unionized membership in the Amalgamated Association of Iron and Steel Workers—from a peak of twenty-four thousand to a few thousand—and one result was that workers had to rely much more on public welfare organizations after the unions were reduced.

Over the ensuing decades into the twentieth century, the labor movement slowly and inexorably gained strength in Pittsburgh

A miner works against the rock wall in the Vesta Coal Mine complex in Washington County, just south of Pittsburgh—a kind of labor very familiar to workingman John Kane. *Workers at Vesta Coal Mines* (series). *Attaching firing wire and shooting.* Identifier: MSP33.B009.F01.I13. Detre Library & Archives, Senator John Heinz History Center, Pittsburgh.

and around the nation, eventually creating dramatically better working conditions, benefits, and wages. It wasn't until twenty-five years after World War II that unions began to shrink again. Labor representation in the American workforce had dwindled to just above 10 percent in 2019 from a high of well over 30 percent in the mid-1950s.

Kane, who spent a lifetime working in crafts with close union associations, tired of his travels and labors in the American South by the mid-1880s. He found himself increasingly homesick for his family, particularly for Big Babbie and her thoughtful, mothering

The miner rides and the mule pulls the cart out of the entrance to one of
the mines in the Vesta Mine Complex in Washington County, just south of
Pittsburgh. *Workers at Vesta Coal Mines* (series). *Bill Lwaney (?) driving mule*,
1910. Identifier: MSP33.B009.F06.IO1. Detre Library & Archives, Senator John
Heinz History Center, Pittsburgh.

ways—she always stayed up for him, no matter how late he finished
work, and she always had a big supper prepared for him when he
came home. When Kane suffered an eye injury in the mines down
South, he decided to go home in 1886 to be near her:

> I came back to Braddock and stayed at home for a time. But I was
> restless to get back to work. Somehow or other I could never be content
> unless I was employed. Now I knew the most about mining. There has
> always been a pull for me around a mine. Unless a man has gone down
> into the pit and has helped to dig out the coal or coke or shale or what-
> ever, swinging his pick with his strong right arm, doing man's work in
> a manly way, he will not understand how much mining means to those
> who have done it. . . . So I soon shuffled off to Connellsville, which was

no great distance [from his family in Braddock]. . . . I could get back to Braddock to see Mother when I wanted to. It was not like being in Alabama or Tennessee.

Kane's latest job involved working for Henry Clay Frick again, this time digging shafts for Frick's H.C. Frick Coke Company, including the Standard Shaft No. 2, which dropped three hundred feet into the Pittsburgh coal seam and became famous as the state-of-art in coal mining.

The abundance of high-quality coal in the Pittsburgh region gave it a crucial competitive advantage—along with the transportation advantages of the three rivers that ran through the region. Another key advantage, according to historian Kenneth Kobus, was the intensely focused quality of Pittsburgh's entrepreneurs: "A recurring theme in Pittsburgh's rise as an industrial and financial center was the never-give-up attitude of its entrepreneurs. Failing to get federal involvement [in building dams on the three rivers to improve navigability], local people formed a capital stock company called the Monongahela Navigation Company to build, maintain, and operate a series of locks and dams on the Monongahela River. By 1841 the first two locks and dams were put into operation, and at each dam the river was raised eight feet."[2] Thereafter, Pittsburgh expanded the lock-and-dam system that sealed its advantages as a major river port with abundant coal fields to support its manufacturing. These three things—the rivers, the coal, and the dogged focus of Pittsburgh's entrepreneurs—delivered the community's great success.

Back in the coal fields of western Pennsylvania, Kane now focused less on his drawing and painting than on his avocation as an amateur boxer. His interest in defining himself as "a manly man" included a rugged toughness in the ring, and Kane relished it:

> One of the things that stands out in my memory of my days in the Connellsville Coke Region is that I became more and more handy with my fists. I could take my own part against all comers. In those days we fought more to settle an argument than for any other reason. We never meant merely to give a boxing exhibition or anything like that. Generally it was because some words were passed that we didn't like. Then

we fought. No Marquess of Queensberry rules for us. We used the old London ring rules. Every knockdown was a round and a fight could go on for I don't know how many rounds . . . we fought with our bare fists. We wouldn't wear the gloves because we wanted to punish each other. We could not have done that so well with the soft padding of gloves.

Eventually Kane had another fight with a professional boxer, a retired pro named Martin Jennings who was working as a foreman in a rock-drilling unit in Connellsville. "He was a big burly fellow, twenty-five or thirty pounds heavier than I. It was after I met him that I got the title of Jack the Giant Killer. He was somewhat of a bully. Nobody liked him." They fought five rounds and then Jennings departed from the rules, putting Kane in a chokehold. The crowd separated the two and Kane was declared the winner because he had more knockdowns than Jennings.

A year after the Jennings fight, in the mid-1880s, Kane was working in one of Frick's coal mines when a fire broke out. He and a bunch of other workers were trapped until one of the bosses told them they could run up a sloping piece of ground at one end of the mine and escape that way to the top. Kane was almost out of the mine when he suddenly remembered that there was a group of immigrant miners who didn't understand English and hadn't understood when the foreman told everyone to run up the slope. Kane turned around and went back into the mine to find the immigrant miners. "I thought of them because I had worked side-by-side with some of them. So I ran back a quarter of a mile to where they were." By then the smoke was thick and Kane and the immigrants had to run bent over to keep their heads low enough to find breathable air.

It was no easy thing to do, running in that kind of sitting position. Naturally we could not go very fast. But we did the best we could, one helping the other. What saved us was the farther we got from the burning shaft the better the air became. As we neared the slope we could feel the fresh air coming down. Finally we came to a place where the mine train was at work. (We had both a railroad and mules in that mine.) The old man who took care of the cars unhooked the loaded ones and hooked on four or five empties.

The miners climbed into the empties, six to a car, and were shot to the top. When they jumped out the engineer would take the train back for more men. I and the foreigners were about the last to ride the train that day. There were three hundred men in that mine. All escaped alive. The eighteen mine mules were burned to death, but that was the only casualty in what might have been a serious disaster.

Kane wanted to get back to Pittsburgh for work as 1890 approached, and his restless seeking of different kinds of employment took him next to street paving. One of the compelling signs of Kane's artistic temperament was that he even applied an aesthetic sensibility to the task of finding and placing just the right paving stone for each spot in the street on which he was working: "You can lay your stone straight if you can guess which stone is going to fit your row. For if you take too large or too small a stone and the next one the same, your row will get bigger and bigger or it will dwindle to a point. And if you use different sizes you will have a queer-looking hodgepodge when you are done. Now in this picking the right stone I developed a handy knack."

And, once again, John Kane found success, getting promoted repeatedly by the paving company, reflecting his rapidly increasing skill. Eventually he was making five dollars an hour, "the highest wages I had ever had up to that time." In 2020 dollars, Kane could make as much as $60,000 a year as a street laborer, depending on the hours he worked. This was significantly better than most of the workers of his day. He believed in hard toil, and he was amply repaid for his belief.

Kane's peripatetic journey—always seeking new work in new places, restlessly moving around—was very much a product of the times: workmen had few rights and protections in his day, and when economic conditions turned sour, many working people like John Kane had to move on to be able to survive. "I was always on the lookout for better jobs," he said later. "The wages interested me the most. The amount of work, the hardness of it, the hours and all like that, didn't worry me a bit. I doubt if I ever stopped to consider that part of it. I liked to work and I did not care how hard it was. I think I rather enjoyed using my strong muscles."

As he returned to the Pittsburgh locale, he began sketching

A group of street pavers, supported by a small knot of onlookers, lays the stone
blocks for a new street surface under a railroad overpass in Pittsburgh, around
the time that John Kane was doing some of the same work in the region.
Pittsburgh City Photographer. *Second Avenue* [street pavers at work], April 23,
1906. Identifier: 715.06855.CP. University of Pittsburgh.

more than ever before. "The little sketches I made in those days
were the same as I make today. I drew the mills and industrial
plants as well as the hills and valleys all around. You don't have to
go far to find beauty. It is all over, everywhere, even in the street
on which you work."

Kane's distinctive sense of restless inquiry—always seeking, al-
ways learning—enabled him to teach himself everything, from lay-
ing paving stones to steelworking to construction. And, of course,
drawing and painting. He never got professional instruction as an
artist, and yet he managed to master the work well enough to make
dozens of exceptional paintings. Although he could almost seem
to be a drifter, moving from place to place, changing residences

and forms of employment, he was dedicated to his art and stayed focused on opportunities to draw and create. For Kane, what ultimately pulled it all together, what bound his life into a coherent whole, was his searching sense of exploration and his ability to focus intensely on the work at hand. This ability to be completely absorbed in his work and fiercely committed to excellence gave him the means to master craft after craft and, ultimately, to find his place as an artist.

PART II

Railroads, strikes, a love affair with paint, marriage to "as pretty a lass as ever came out of Ireland," a peripatetic journey through the land, and earning some real money from art. Wherein John Kane, grievously injured in an accident, manages to carry on as a workman, an artist, and, now, a family man.

This Baltimore & Ohio Railroad engine is typical of the big, brawny
steam-driven machines that powered freight and passenger trains across
America throughout the nineteenth and twentieth centuries. Lloyd Geertz,
photographer, *Baltimore & Ohio Railroad Train Engine*, 1931. Postcard, gelatin
silver print. Author's collection.

▪ 5 ▪

TROUBLE COMES

JOHN KANE'S LIFE WAS INEXTRICABLY CONNECT-
ED with the railroads in America, as was the case for
most working men and women of that era. The US trans-
portation and manufacturing industries were dominated by the
network of rails across the country in the nineteenth century, and
that domination continued well into the twentieth. According to
railroad historian Mark Aldrich, "by the twentieth century rail-
roads were the largest single American industry, employing over
a million men and women in 1900 and dwarfing other dangerous
trades." Whether Kane was working in manufacturing or mining,
whether he was going to work or walking home, his path crossed
and crisscrossed the rails all his life. Again, according to Aldrich,
making an assessment of the dominance of railroads during
Kane's working life, "they transformed life as perhaps only the
automobile and the computer have done since, and they captured
the imagination."[1] Until the twentieth-century revolutions in soci-
ety wrought by the development of the gasoline-powered car and
then computer technology, nothing so defined American progress
as the pioneering growth of the rail industry. And with that growth
came a shocking harvest of injury and death for working people.

A lack of safety standards and a Gilded Age attitude of cav-
alier disregard for the lives of working people enabled the rail-
roads to provide a tsunami of accidents that maimed and killed
by the thousands. Aldrich offers this illustration: "The carnage
began early; 1853 is still remembered as the year the surge in

A postcard view of the Baltimore & Ohio Railroad station in Braddock, Pennsylvania, from 1912, years after many of John Kane's family members arrived in Braddock for American jobs. The B&O Railroad, like the Pennsylvania and so many other rail companies, had a long and tortured history of accidents. *B & O Station, Braddock, Pa.*, 1912. Color postcard. Author's collection.

train accidents began. Eleven major collisions and derailments yielded 121 fatalities. . . . American carriers were uniquely dangerous to individuals who crossed or walked the tracks or stole rides and who were killed by the thousands each year. . . . The total death list, by 1907, had come to nearly 12,000 a year and no doubt the number of serious injuries was many times larger." Kane, living and working in the industrial Monongahela Valley toward the end of the nineteenth century, became a part of that tide of suffering.

One night in 1891, when his brother Patrick was missing, John was particularly worried because their stepfather and mother were away on a trip to Scotland. Concerned that something could have

happened, John and another brother, Tom, went looking for Patrick. After visiting the homes of a number of their friends they finally found him, safe and sound, and the three of them started back to John's sister's house in Braddock, where John was living at the time.

"But instead of going by the street we took a short cut across the Baltimore and Ohio Railroad tracks. It was trespassing, of course, but we did it. It was dark by then. A shifter [a yard engine that repositions cars along the rails] was coming fast and carried no lights. It was almost upon us. Tom saw it first and yelled for us to look out. I looked up and saw it right upon us. Now Paddy wasn't feeling so well and I didn't know if he could take care of himself. There was a slope beyond the track and I put up my hand and with all my might I gave him a push that landed him at the bottom of the slope." But the train caught John, and it severed his left leg five inches below the knee. The engineer stopped the train, and, as it happened, he knew Kane, who asked him to have someone take him to the hospital. "I grabbed my leg. Strips of flesh were hanging down. It is a very strange feeling to reach for your leg and find it is not there. All I can remember is bewilderment. I don't mind that the pain was so much. But I couldn't make out why my leg wasn't where it was supposed to be. It was seven or eight weeks before I left the hospital."

Kane was thirty-one years old, in his prime, just embarking on a long life of work and art. At that time in Pittsburgh—the early 1890s—an injury like Kane's could have been a death sentence. There were few programs to help injured workers, and no significant welfare or social security programs to assist those who had a disability. The few offerings available—the Catholic Church, the Salvation Army, union-assistance programs—may have been useful to Kane during this period. The Gilded Age was characterized by the greatest economic divide between haves and have-nots until the current, appalling lack of social equity of twenty-first-century America. And the nineteenth-century evolved a culture that accepted horrific working and living conditions for those, like Kane, at the bottom rungs of society. Hundreds of thousands of working people were injured or killed at work or in their personal lives, and society often treated them as disposable. Until the reform

era led by President Teddy Roosevelt, and the New Deal era led by his cousin, President Franklin Roosevelt, the country lacked government programs to support those less fortunate. There were no disability or welfare payments, no special medical programs for people who had been injured, none of the programs that we hope today will provide a social safety net for those whose lives hit the rocks. But Kane was utterly redoubtable. Once again he proved his resilience as he made his way back into the workforce and into his art.

In one respect, he was lucky: in the aftermath of the US Civil War, significant progress was made in the technology for prostheses, and there was a much better environment, medically, for those needing artificial limbs. Kane got an artificial leg made for him, and then he improved it, using his craftsman's skills to fit and tailor it to suit his own stride. Within months, he was able to return to the workforce. Most people never even knew he was missing a leg. They thought he simply had a limp. The injury, which might have finished a lesser man, hardly slowed Kane down. "I think I became the most accomplished peg-leg wearer in the world. I could even dance a jig. Now that I am older and slower I walk unevenly. People can see that something is the matter. But not when I was a younger man. I was as good as any two-legged person agoing."

Many of the railroads, like the Baltimore & Ohio, whose engine ran over Kane, saw that they bore some responsibility for those who were injured. They knew, as Aldrich notes, that "the tracks were working-class highways." Although the railroads tried to keep the public away from tracks, they understood that, particularly in dense urban areas, the tracks were often the quickest route for pedestrians to move around from work to home. And railroad leaders often tried to help those who got injured—though few went as far as the Fitchburg Railroad in Massachusetts, which reported that "when a train employee is injured . . . it is our custom to pay his doctor's bill, to pay in part or in whole for his lost time, and to give him work suited to his condition."[2]

It's not clear whether the Baltimore & Ohio helped Kane with his medical care or his prosthesis, but they did sympathize enough with his plight to take him on as a watchman. "In my case I was not

John Kane spent time selecting and packing almost two dozen of his pictures for a solo exhibit sponsored by the Junior League of Pittsburgh in 1931. Peeking out from behind the trunk full of paintings is the bottom of an artificial leg. Copy print. Image courtesy Carnegie Library of Pittsburgh.

able to get damages from the railroad, though they took care of me after a fashion. They gave me a job as watchman at thirty-five dollars a month. Indeed, I asked no damages. I was trespassing in a place where I had no business to be. . . . I am not a man to push a claim like that." What's more, in addition to work, Kane's quick recovery enabled him to significantly increase his painting activity. Eventually, he even went back into the boxing ring to continue his athletic endeavors. "Sometimes I think it was a good thing for me to have this accident. . . . It was good for me because we younger

working men were pretty wild in those days. We drank a lot and got into fights. It had the effect of steadying me. It showed me life wasn't all for good times. It had the effect, as they say today, of slowing me down."

In fact, Kane was a heavy drinker most of his life, and, with intervals of sobriety, he kept at it for the rest of his life. But the trauma of his injury certainly focused things for him, and shifted some of his attention and energies to his art. Now he began to spend more time searching for good subjects and drawing them, particularly when he was between jobs. His technique grew steadily stronger, with more attention to detail. But, as always, the need to work and make a living had to be prioritized ahead of drawing pictures.

Working as a watchman for the B&O in McKeesport, John missed the heavy labor that exercised his muscles. But he was still right in the middle of the steelmaking industry along the Mon River, and he found himself now in the position of listener and observer, learning from others about what was happening in the mills. And what grabbed his attention soon after he took his new job was the tragedy of the Homestead Strike of 1892—or, as it was locally known, the Homestead Massacre. Kane later said that the Homestead Steel Strike "was like a bad dream. The men used to come to my watch box and tell me the terrible things that were happening down there"—about eight miles down the Mon and across the river from McKeesport—"the rioting, the shooting, the destruction. It made me almost glad I didn't get that job at the Edgar Thomson" (he had been turned down for employment there right before he got the watchman job).

The strike was one of the most violent labor disputes of the nineteenth century, and it ended as a major setback for the union movement, not just in Pennsylvania but across the country. Andrew Carnegie—who owned the Homestead Steel Works in addition to Edgar Thomson and a number of other mills in the region—hired Henry Clay Frick specifically to reduce costs and break the unions. Frick, who had built a strong antilabor reputation in the coal fields, cut the workers' wages. This led, predictably enough, to the strike, and Carnegie, who was traveling in Scotland, saw

an opportunity. He sent instructions to Frick to do whatever was needed to combat the union.

Frick shut the workers out of the mill and hired three hundred Pinkerton agents from New York to come in and break the strike. They came by train to Pittsburgh and then traveled in two large barges up the Mon to Homestead, where they tried to disembark and man the works. The resulting gun battle between striking mill workers and the Pinkertons ended in at least ten deaths, on both sides, and many more injuries. The Pinkertons surrendered, but many of them were brutally beaten and their barges were burned. Finally, the governor sent in 8,500 soldiers from the Pennsylvania National Guard to restore order, and the strike was broken. And, of course, when the works reopened, Carnegie increased the weekly hours of each worker and reduced wages at the same time.

Kane was already a union member, and what he heard from the workers at Homestead, as they came by his watchman's box along the railroad in McKeesport, strengthened his loyalty to working men and women struggling against a harsh system. Kane's sympathies were firmly planted with the workers themselves—many of whom lost their jobs at the mill. And his empathy for the working man was further charged by the sufferings of his own family. When his half brother Simon, a B&O brakeman, was killed by an express train, "it was not the first time nor the last time my mother's heart ached from railroad disasters in our family. Mine came first and then came Simon's. Patrick, the eldest, lost his arm in an accident on the Pennsylvania eight years after I was hurt. And my brother Tom, who used to help me in Scotland, was killed by a freight near St. Paul about twenty years ago." Later, Kane would give trains a prominent and respectful place in his paintings.

The plight of the Kane clan might seem extreme by today's standards, but the incidents that harmed them were fairly typical of the steady stream of accidents associated with the American railroad system. According to Aldrich, "the great majority of casualties on railroads were not the result of spectacular collisions or derailments. While such disasters might injure or kill dozens of people all at once, most of the carnage resulted from 'minor' accidents that picked them off one or two at a time. These were passengers who fell while running for the train, or employees who

DUQUESNE STEEL WORKS U.S IRON & TIN PLATE WORKS STERLING STEEL WORKS BOSTON IRON & STEEL WORKS RIVERTON STATION MONONGAHELA FURNACES McKEESPORT HOSPITAL NATIONAL ROLLING MILL NAT

HOWARD PLATE GLASS WORKS

CITY OF McKE

Lithographer Otto Krebs published this appealing view of McKeesport on the Monongahela River in 1893, a few years before John Kane and his new wife Maggie Halloran Kane set up their first house there. Otto Krebs, *City of McKeesport & Vicinity*, 1893. Color lithograph. Identifier: PGHPRINT033. University of Pittsburgh.

were crushed while coupling cars, or working men and women who took a shortcut across the tracks or tried to beat a train to the crossing."

RT & VICINITY.

Kane stuck with his railroad watchman job for eight years, and he was able to build a nice nest egg of a few thousand dollars in a savings account. A friend who knew of Kane's success at putting some money aside told Kane he was headed out west to speculate in mining, and invited him to put his savings in as an investment. Kane did trust this friend, but he still said no—he had to save his money for something far more important than profit: love.

In *Close of the Day*, painted by Kane in 1932, the artist shows his ability to compose an image that is engaging on multiple levels: from the landscape and the distant house in the background to the figure leading two strong draft horses in the foreground. John Kane, *Close of Day*, 1932. Oil on canvas. Private collection. Image courtesy Kallir Research Institute, New York.

Kane had met the young lady who would become his wife, and had immediately decided on two things: he wanted to paint Maggie Halloran, and he wanted to marry her.

TROUBLE COMES

Maggie Halloran was as pretty a lass as ever came out of Ireland or England or any other country the world around. I never knew her until I came to this country, although our families had been friends before my time. Before I was born her parents and mine lived together in a double house in West Calder. All four of them came from County Galway, Ireland.

But her people went to England to live while mine stayed on in Scotland. . . . We met at my sister's house in Braddock. I couldn't keep my eyes off that pretty lass. I wanted right away to make a picture of her . . .

We were married at St. Mary's at the Point [Saint Mary of Mercy Catholic Church] by Father McTighe. It was the night of March 2, 1897. I was still making only thirty-five dollars a month, but she didn't mind that. Not Maggie Halloran. She was willing to be poor with me. We went housekeeping in Market Street, McKeesport, opposite the Catholic Convent. The parish house stands on the site of our first home.

John and Maggie stayed married for the rest of their lives, though John's wanderlust kept taking him away from Pittsburgh and his family, sometimes for years at a time when he took jobs in other states. Margaret Halloran Kane's character was a strong amalgam of supportiveness for her family and a kind of dogged toughness that helped her strike out on her own and provide for her children. Like many working-class wives of the time, she had to be a bedrock source of strength for a family that sometimes included a husband and often did not.

For Maggie, John's weaknesses—his penchant for drink, for disappearing, for a stubborn kind of narcissism—were exasperating. She could be scornful, too, of the time he devoted to his art. It wasn't until his success near the end of both their lives that she gained an appreciation of John's talent and played an active role in trying to advance his fortunes.

An early indicator that marriage didn't change John's roving nature: no sooner had they moved into the house in McKeesport than John joined the YMCA there to resume his boxing. He was also drawn to family, to be sure, and the birth of his daughter Mary inspired him, as he later said, to concentrate on his painting. But, always, there was this competition in his life between drink and family, work and art. Usually, his family suffered.

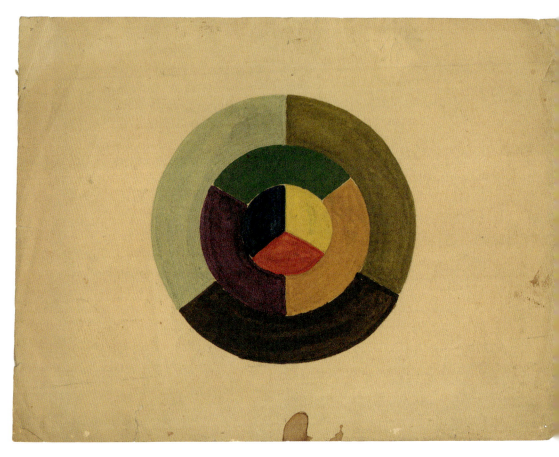

John Kane, untitled [color wheel], no date. Tempera on drawing paper. Gift of Michael Roland, Sean Roland, Timothy Roland, and Jacqueline C. Elder in loving memory of Margaret Kane Corbett. 2006.10.9. American Folk Art Museum, New York, NY. Photo: American Folk Art Museum/Art Resource, NY.

· 6 ·

PAINT

"THE NEXT JOB I HAD WAS THE ONE THAT CONTRIBUTED most of all towards my artistic work. I became a painter. I painted freight cars. I learned the use of lead paint, the mixing of colors, the necessity of keeping colors clean and a deal else of information. The best thing in the world for a young artist would be to hire himself out to a good painting contractor who knows his business." Kane spent the next few decades painting boxcars, houses, and commercial buildings—while, at the same time, he was developing skills he would need as an artist. He always felt one complemented the other, and that he never would have gained his artistic skills if he did not learn to fully understand paint and painting, even if his apprenticeship was more informal than that of an academically trained painter. It was paint itself—the texture, the stunning variety of color and tone, the very smell and feel of it—that captured the sensibility of the artist.

"Now, as everyone knows, there are but three primary colors: red, yellow and blue. Of course there are black and white, but these are not colors. A house painter buys a one-, two- or five-gallon can of each of these primary colors and the same size can of black and white. Then with turpentine and linseed oil he mixes any tone or shade he has in mind. So I say that an outdoor painter knows more about color than the artist. He knows how to get it for himself." Kane described his attraction to paint—how by its very nature it inspired him to creativity—as the key ingredient that gradually but inexorably refocused his whole life. And for much of the rest of his life he mixed his own colors as he created his pictures.

After his daughter Mary was born in McKeesport in 1898, and he was in need of more income, he took on part-time work painting boxcars for the Pressed Steel Car Company, with facilities in McKees Rocks and elsewhere around Pittsburgh. In making the move in 1899 from the hardships of the Carnegie/Frick enterprises to Pressed Steel, Kane was jumping from the frying pan into the fire. Working conditions at Pressed Steel were considered some of the worst in the region, with workers chronically underpaid and overworked. Moreover, the McKees Rocks plant was famous for its dangerous conditions and was labeled "the slaughterhouse" by members of the mostly immigrant workforce. At one point, the local coroner reported that at least one worker was being killed there every day. These conditions led to one of the most famous strikes in Pittsburgh's long, tortured labor history. In 1909 workers who felt they were being shorted in their pay went out on strike. The hard-nosed owner, Frank Norton Hoffstot, drew comparison to Henry Clay Frick when he refused to meet with the workers. The strike went on for almost two months, and one bloody battle a few weeks before it ended saw over a dozen people killed, according to the *Pittsburgh Post-Gazette.*

But for John Kane, who went to work at Pressed Steel well before the strike, his job proved to be a great opportunity: his experience taught him about paint and painting and how it could benefit his art. He later said his job at Pressed Steel was what led directly to his move from drawing to painting as an artist. "I had always loved to draw. Now I became in love with paint. For now I could color the sketches I had made with a pencil. At noon I would slip into the yards while the others were eating their lunches. I would draw a scene on the side of a box car and would color it. Oh, it was glorious. It was the first opportunity I ever had for making the pictures that were in my mind." Kane was not a graffiti artist, of course, but he did show an inclination to paint on just about any flat surface he could access. The foreman for the car company told Kane it was all right to paint pictures on the boxcars so long as, later, he painted over them with the yard's standard boxcar red.

During the time that John and Maggie lived in the rented house in McKeesport, he worked a series of different jobs, but by and large he had a very full and happy life. McKeesport gained a

View on Market Street, McKeesport, Pa.

A postcard view of Market Street in McKeesport, Pennsylvania, in 1907, ten years after John and Maggie Kane set up their first home on this street after their marriage. *View on Market Street, McKeesport, Pa.*, c. 1907. Color postcard. Pittsburg News Company, publisher. Author's collection.

reputation as one of the region's vibrant centers of immigrant life. Kane established a strong presence through his reputation as a worker and a boxer. Eventually, he earned the unofficial moniker of "mayor" of McKeesport.

On the top floor of the house John and Maggie rented was a big open room that he used as an art studio and a boxing arena: "The men from the car works would drop in from time to time for a workout with each other. By and by we had regular boxing matches. In fact a club developed out of it. Some of the young fellows we turned out became the best in Allegheny County." While they were there, the couple's second daughter, Margaret (named for her mother), was born in 1901. Kane was then full-time at the Pressed Steel Car Company, but the good times did not last. Eventually, work slowed and then the facility where Kane worked closed

Standard Steel Car Works, Butler, Pa.

John Kane and his family moved to Butler, just north of Pittsburgh, where he took his strong painting skills to the Standard Steel Car Company. This postcard from 1912 shows the sprawling industrial complex in rural Butler County. *Standard Steel Car Works, Butler, Pa.*, 1912. Color postcard. I Robbins & Son, publisher. Author's collection.

down, which was a great disappointment for Kane, who loved the work and the camaraderie he had developed with his coworkers. After that, the Kanes took up residence in Butler County, just north of Pittsburgh, when John briefly took on employment with the Standard Steel Car Company.

Soon, he was unemployed again, and—with two daughters and a wife to support—he needed to find another way to earn a living. He conceived of an idea to create work based on his ability as an artist: turning black-and-white photos into colorful portraits by painting over them. Like some portrait photographers of the time, he went door to door, knocking at each house and asking whoever answered the knock if they had a prized picture; then he marketed his skill at painting over a copy of the photo to create a

West Sunbury, Pennsylvania, ten miles north of Butler, is the sort of rural settlement, nestled into the verdant farmland of the region, where John Kane roamed from house to house offering to paint pictures for the local residents. *Bird's Eye View, West Sunbury, Pa.*, 1910. Color postcard. Breadon, Conway & Company, publisher. Author's collection.

colorful likeness of the subject. "I would go out into the country or to the little mine settlements beyond Butler. I would call at the door and ask the housewife to show me a good picture of herself or of someone she dearly loved. Sometimes it was a little dead child. Sometimes it was a bride in her white veil. Or it might be a runaway son who had not been heard from in years. Sometimes it was a young mother who died when her baby was born."

Kane took the photo and shipped it to an enlarging firm in Chicago, then took the enlargement and, based on his conversations with family members, painted the photo to give it more vibrancy and realism. "Theirs were the tragedies that follow poor people everywhere. For with every picture I took away with me I took the story of a little dead girl or a lost sweetheart or some

other happening. . . . If there was a picture to be enlarged there was a story to go with it. That you may be sure. That was the reason the colored enlargement became the family's most valuable possession."

What started as an enterprise to provide enough income to put food on the table for his family became an avenue through which Kane advanced his interest in pictures and painting. As was always the case, it was his distinctive blend of imagination and romanticism that elevated his work. His income, which ranged from three to ten dollars a painting, was constrained by the poverty of the families to whom Kane was instinctively drawn. "I worked out what I considered was fair to me and fair to them and I never deviated from this except once or twice when I did some highly detailed work for some wealthy people."

It was during this time that Kane's greatest tragedy struck. In 1904 his son was born. The very next day the boy caught a cold and died. Kane went to get a doctor, and to call the local priest. The doctor never came. By the time the priest arrived, the baby was dead. But just before the baby passed away, a neighbor woman who was visiting managed to baptize the one-day-old child, naming him John, after his father. The loss of an infant was not at all unusual in Pittsburgh at that time. According to S. J. Kleinberg's study of work and family life in the region from 1870 to 1907, "in Pittsburgh the overall infant death rate averaged 226 [per 1,000 births] between 1900 and 1904, up significantly from its level of 188–190 for the 1870s and 1880s, and a reflection of the large numbers of impoverished newcomers in the city. It was significantly higher than the national urban average, which stood at 162 per 1,000 infants in 1900." Kleinberg notes that the trend of infant health worsening in the working class at the time while it improved in the middle class at the same time "is confirmed by Children's Bureau investigations, which indicated that parental poverty was the root cause of high infant death rates."[1]

For John Kane the father, there was a terrible conflict in gaining and losing a son so quickly: he was devastated at the loss of his baby, but as a devout Catholic who attended mass frequently, there was some solace in knowing his son had been baptized into the church. Now forlorn with the loss of his son, Kane began to

drink much more heavily, and his home life deteriorated. "I drank in those days and was away from home a good deal. The picture business got away from me. I didn't care. Mrs. [Kane] got a job cooking for the Sisters [of Mercy] at Cresson and she took the little girls with her. I picked up a day's work here and another there. I was no longer ambitious. I was simply discouraged."

For her part, Maggie Kane later lamented the fact that her husband left on a protracted bender as soon as his son died, and left her alone to deal with both her recovery from childbirth and the proper burial of the little dead child. Still, despite the irresponsibility of John Kane's descents into alcoholism, both his wife and his biographer said he never resorted to violence with his family; a result, they said, of his strong Catholic values.[2]

· 7 ·

THE ARTIST AS NOMAD

F OR THE NEXT TWENTY-FIVE YEARS JOHN AND
Maggie Kane lived mostly apart. Kane would take work in
Ohio or West Virginia and nearby parts of Pennsylvania
and be away for long periods of time, and then he would be home
for some months making good money in Pittsburgh and provid-
ing some support for his family. Then, gone again. All this time,
the artist devoted his life primarily to his art and drinking. His
behavior was not unusual for his time. According to historian
S. J. Kleinberg:

> Children of the working class could grow up without really knowing
> their fathers, who lived far away, worked long hours, or died young
> in mill accidents. By commandeering the men, the industrial system
> reinforced cultural perceptions of women as primary, if not sole, nur-
> turers of the young and men as remote breadwinners. It might be said
> without exaggeration that the mills socialized both the male and female
> children, long before the boys ever entered the Vesuvian works, through
> employment patterns that separated the fathers from their children and
> placed the burden of raising the young on their mothers.[1]

The first years of separation, starting in 1905, were ones of
deep despair for Kane. "Those were the worst times I ever passed
through . . . I slept on a bare floor of the Salvation Army Building
in Seventh Street near Penn Avenue. For seven weeks I slept on that
floor. We were told to bring newspapers with us. We lay on them
and under them, in rows, soldier fashion, head to toe and feet

to feet. Every night after church services we stretched out. Every morning we were given a roll and a cup of coffee. Then we would turn out to look for work."

It was just after the economic recession of 1902–1904 and just before the banking panic of 1907—hard times for many working people in America. And Kane, uncharacteristically, had trouble finding work. As always, he turned to his art for sustenance. "But discouraged and all that I was I never lost the idea that I wanted to paint beautiful pictures. . . . Always I longed to paint it." Kane took an artistic interest in his fellow inhabitants at the Salvation Army. "The men interested me a lot. I liked to make sketches of the various ones who would come in, the old ones who had no homes nor anything at all but the clothes they wore, and the young fellows, too, who were just starting off in a life that didn't promise them much."

A janitor at the Salvation Army, a Scotsman like Kane, became friends with the artist. When the organization closed the sleeping area and turned out all the men, the janitor let Kane stay. In return, Kane painted a portrait of the Scotsman and his wife. Their gratitude showed itself when the janitor used his connections to help Kane get a job painting houses in Dormont, a near-in suburb of Pittsburgh. That led to a job painting at an amusement park, Luna Park. Pittsburgh had an array of such parks, which appealed to many working people like Kane, who turned to some of them for subjects for his art. (In fact, the Ferris wheel, a staple of most amusement parks in the country, was developed by George Ferris when he was living on Arch Street in Pittsburgh.)

And then John Kane came home. His family was reunited, for a short while, and he focused on supporting his wife and two daughters. Always artful and entrepreneurial, Kane created his own job from a combination of his experience as a house painter and his skill as an artist. That year, 1908, was the sesquicentennial of Pittsburgh's birth, when the British captured the French Fort Duquesne at the confluence of the Monongahela, the Allegheny, and the Ohio Rivers, and renamed it Fort Pitt. A popular item for sale in local stores was a miniature of the famous Fort Pitt Block House, a small defensive redoubt built in 1764 inside the larger British fort. "That year I painted this blockhouse in miniature,

Pittsburgh's Old Block House, built in 1764 near the site of Fort Pitt at the Forks of the Ohio River, is shown in this postcard from around 1908, when John Kane was making a brief but very remunerative enterprise of painting replicas of it for Pittsburgh's Sesquicentennial celebration. *Old Blockhouse 150th Anniversary*, 1908. Postcard. Author's collection.

hundreds upon hundreds of times. I would paint it to sell to merchants for window displays and for decorations of all sorts . . . [and] I put it on cards and on boards and on banners to be hung clear across the street." Kane, who would make periodic trips to the fort to reexamine the real block house for verisimilitude, tolerated the monotony of this repetition to bring in money through the use of his painting skill.

While John made these episodic contributions to his family, often through his talents as a painter, Maggie developed her own skills as a cook and a housekeeper in order to provide for her family. In addition to the work she did for Catholic institutions, she cooked for some of the most prominent Pittsburgh families. Serving dinner for the members and friends of one of these, the Nimmick family, she received a ten-dollar tip from one of the

guests, financier Andrew W. Mellon. In today's dollars, such a tip could be worth as much as $250.

And then, as quick as he had come, John Kane was gone again. This time he was off to Charleston, West Virginia, for an outside painting job, and then on to a construction job in Youngstown, Ohio. Kane was as peripatetic as ever, restless and constantly on the move in his quest for new and different jobs, for new scenes to paint, and new places in which he could try to escape the deep Catholic guilt that was fueled by his addiction to alcohol. Sometimes he would send money back home for the support of his daughters, and sometimes they had to rely on the pay Maggie got for her jobs. Like everything in the artist's life, this was episodic and almost unpredictable.

There is an expression among professionals who deal with alcoholics: "the geographic cure." It refers to the tendency on the part of people with addictions to believe that what is wrong with their lives is something else, not alcohol. It's where they live, what they do, with whom they are partnered that is the problem, and often they become convinced that their problems can only be solved by moving on. Kane died the year before Alcoholics Anonymous was formed, and he lived well before treatment for alcoholism was common. But his life, like the lives of many artists and writers, was dominated by drink.

In fact, according to the recollections of Kane's daughter Margaret, in 1909 Maggie had her husband admitted to an institution that treated alcoholics for their addiction. Margaret Kane Corbett's account includes the observation that, while institutionalized, John made many friends and even created some pictures for some of those he met. But the tragedy of John's addiction to alcohol continued. In 1918 when he visited Maggie and their daughters at a rented house in the South Oakland section of the city, Maggie called the police and took John to court for his drunken intrusions, which apparently included trying to set fire to the house. Kane was ordered by the court in Pittsburgh to stay away from his family, and he did. He was at that time back living and working in Pittsburgh, but he stayed in his own rented rooms, focusing on his work and his art—and, of course, his drink.

This drawing depicts the artist himself appearing in court after Maggie Kane called the police to arrest him. John Kane, *Oakland Police Station*, December 1918. Graphite on paper. Private collection. Image courtesy of Kallir Research Institute, New York.

What's more, his daughter recalled that, because of his addiction, Kane could even become suicidal. It is interesting that biographer Marie McSwigan did not take from her interviews of the Kanes any information about incarceration or suicide to include in *Sky Hooks*. But there was much that was omitted from McSwigan's official biography, and the narrative that John Kane provided was somewhat romanticized and idealized.

In his 1971 catalogue raisonné on Kane, Leon Arkus, director of the Carnegie Museum of Art, comments on the many ironies in John Kane's character: "He was intensely religious and regularly attended mass, yet he was often irresponsible and intemperate.

He loved to fight and dance a jig, yet he enjoyed spending hours in solitude contemplating the world around him. He lived most of his life amid the ugliness of industrial blight, yet he was deeply sensitive to all kinds of beauty, even that of the mills and factories. He adored his family, yet he spent the better part of twenty-five years away from them."[2] Writing about a later period in Kane's development as an artist, the American art dealer and critic Jane Kallir notes that despite the neglectful ways he brought to so many aspects of his life, Kane's focus on his art was relentlessly serious, deliberate, and focused:

> Once Kane had established the boundaries of the vista he wanted to de-pict, he became curious about details that could not necessarily be seen from the vantage point he had chosen. He is known to have trudged some distance into a valley to see what kind of flowers were in a window box. The painting *Aspinwall*... combines two entirely different views of its subject: the background was sketched from the summit of a hill, and the foreground was studied at close range from the banks of the Allegheny River.... Whereas academic landscape painting presents its subject from a single perspective and blurs or omits things that fall out of range, Kane studied each scene from multiple angles and rendered every part with the same precision of detail.[3]

In 1910 Maggie Kane was living in the East End of Pittsburgh with her children and her brother, Peter Halloran. John had moved on again, this time to Akron, Ohio, where he struck employment pay dirt—construction work on each of the major rubber companies in Akron: Firestone, Goodyear, Goodrich, and the General Tire Company. The advent of the automobile in America changed society in every way, and nowhere was life more affected than Akron. As the rubber industry grew in that city to meet the extraordinary demand for tires, thousands of workers like Kane poured into the region to fill jobs at the manufacturers.

The auto, of course, did much more than create a mass market for rubber tires. It helped create a consumer culture, it gave powerful impetus to the growth of the petroleum industry, and later—as the network of highways and superhighways grew steadily throughout the country—it helped create suburban America.

John Kane's trip to Akron proved a bonanza of employment opportunities as the four big rubber companies there expanded their tire-making facilities to take advantage of the growth of the American auto industry. Here, a postcard view of the Goodyear Tire and Rubber Company plant not long after Kane had finished working there. *Goodyear Tire-Rubber Company's Great Factory, Akron, Ohio, U.S.A.*, 1917. Color postcard. L. Schartenberg & Company, publishers. Author's collection.

Moreover, the advent of the car fueled tourism across the country and helped reduce rural isolation.

Few sectors benefited more than the rubber industry, centered in Akron. In the nineteenth century hard rubber tires were used on cars, bicycles, wagons, and tractors. Then pneumatic tires—pumped up with air—took over and changed the industry and the smoothness of the ride that could be achieved in a car. To capitalize on the boom in tires, the Goodyear Tire and Rubber Company was formed in 1898, followed two years later by the Firestone Tire and Rubber Company. Eventually, the other two of the big four tire makers—Goodrich and General—joined in to fashion a frenzy of industrial construction in Akron. Kane and

workers like him who moved to central Ohio were the beneficiaries of plentiful jobs with good pay. When Kane came to Akron around 1910, it was still at the very beginning of the automobile era in the United States, of course. But as the rubber companies saw the coming market they prepared for the future by building out their industrial capacities. Construction jobs were plentiful and there was an influx of migrants from parts of Appalachia and even Europe to take advantage of the employment.

Kane worked both as a painter and as a skilled carpenter in a succession of jobs for the four rubber companies. Among the skills he mastered was that of building picture frames, one he would often put to use in the future, framing his own works. And, as he continued to draw, and sketch and paint during his time in that part of Ohio, his coworkers took note of his great skill with color. Once, a foreman sent him over to the home of one of the company employees, whose wife was in charge of having the family house repainted. No one could find just the right color to please her, and the foreman decided that Kane, with his passion for paint, might help. "Well, I mixed some blue and white together along with a considerable quantity of linseed oil," recalled Kane later. "Then I added a little yellow and thinned it out with turpentine. . . . I started painting three or four laths on the front door, just where it would show up the most. 'At last, at last,' she clapped her hands. 'I've got a Scotchman.' What she wanted was the color of the virgin heather of her hills of Scotland."

During his time in Akron, Kane intensified his focus on his art:

> In Akron I took upon myself a habit that served me well the rest of my life . . . namely, of carrying my drawing and painting materials everywhere I went. Always in the past I had made little sketches of things that impressed me. But sometimes I would see something of beauty and had no means of setting down my impressions. Often as not I carried pencil and paper. But in Akron and ever afterwards I took my colors along with me wherever I went so that if I saw a good view I could set it down in the light and under the conditions that attracted me.

A shift took place in Kane's perspective that now placed his art higher than any other aspect of his life, including work or family,

The distinctive mauve-gray of the heather on the hills of Scotland inspired Kane to provide just the right color for the house of a company executive in Akron. Kane's bosses had asked him to try to help the executive's wife find the perfect paint for the house, and the artist obliged. *Loch Garve. Bonnie Scotland—Mountain, Loch, and Heather*, after 1903. Color postcard. Raphael Tuck and Sons, publishers. Author's collection.

or even drink. Whereas before he might have been expected to carry the tools of a workman with him, now he gave evidence of this new perspective by carrying the tools of an artist. "I devoted every possible second of my spare time to making pictures, to getting down the snatches of beauty I saw every day. Every waking moment, when I was not working, I would paint." Kane figured out how to save scraps of composite board from the work sites and bring them home as material on which he could paint pictures.

Kallir, who became a great fan of Kane's work during the time she ran the Galerie St. Etienne in New York, writes of this period in Kane's development: "Throughout these long, dreary years, Kane continually tried to find a place for art in his life. . . . On

several occasions, Kane considered enrolling in art school, but in each instance the tuition was too high. . . . As he had done all his life, he learned 'on the job,' through trial and error, the secrets of his chosen craft."[4] However, although Kallir may be right in describing Kane's life as hard and "dreary," his engagement with and learning from art was usually a joyous process of discovery, both of the innate beauty of things and of his own ability to capture that beauty. He would venture out into the country looking carefully for a scene—a hill or tree or valley, a railroad or even a factory—that inspired him. And, as his art and his skills evolved, he would pay more and more attention to detail, sometimes working for hours on end to get each aspect just right.

During this time in Ohio, Kane created a derivative of the business he had established in Pittsburgh of painting portraits over photos: he would pick out a house he liked and paint it, then offer the painting for sale to the occupant. This brought in more money, and gave Kane the satisfaction of knowing his art was valued by people around him.

On one such outing, Kane recalled later, "[I] set up my easel and made a sketch of it with the vines growing under it. I took it home and painted it in. It was a week before I could get back to that house." He walked all around the house in question, checking to make sure he had each detail just right—it was verisimilitude rather than style that held the focus of his artistic attention. Then Kane knocked on the front door. "'I just wanted you to see this,' I told the woman who came to the door. 'Oh my!' She clapped her hands. She called the ladies who were visiting her to come out and see the picture. 'Oh my!' They clapped their hands the way she had done." The man of the house, who had been called out to see the picture as well, offered Kane twenty-five dollars for it, considerably more than the three to ten dollars he got for the painted photo enlargements he had been selling in Pennsylvania.

This was the first original work of art that John Kane the artist sold for a significant amount. He was fifty years old: a tough, hard-muscled workingman with an exquisite sensibility, a romantic perspective on life, and a keen, searching mind. His career as a professional artist was launched. The twenty-five dollars he got

for the painting would be about $700 in today's currency, quite respectable for a first sale by a self-taught artist.

One of the results of Kane's improving financial position was that he needed to go to a bank in Akron to start a savings account. Kane's goal was to buy a good piece of land in that part of Ohio, build a small house on it, and bring his wife and two daughters there to live with him while he pursued the ample opportunities of the Akron labor market. An odd outcome of this transaction was the change in the spelling of John Kane's name. It had always been spelled *Cain*; that was how John spelled it, how his mother and his brothers all spelled it, and that's the way it would have remained were it not for a careless bank clerk in Ohio. The clerk got the spelling wrong, changing *Cain* to *Kane*, and by the time John noticed this it seemed to him to be too late to fix it. It probably wasn't, but the sometimes intense, sometimes phlegmatic Cain became Kane without protest, and it stayed that way for the rest of his life and, now, posterity.

But he did find the perfect piece of land to buy for the house he planned. "The lot that I bought and later sold was a fine piece of land . . . I had planned [it] to serve many purposes. But mainly it served for the inspiration of beauty." And, perhaps, the folly of an overblown hope: though Kane tended the land, planting potatoes and other garden crops, he never did get to the point of building the house. Nor was he successful in his appeal to Maggie to come to Akron with their two daughters.

Characteristically, though, John did make a painting of the land. When his thirteen-year-old daughter Mary came to Akron to visit in 1912, Kane took her to the lot, which was near a local farm, and painted a picture of her with a cow. The picture, titled *Our Pet*, has not survived to the current day. But Kane later made another, very like the original, and he made it from his own recollection of the land, the scene, and his young daughter. In his painting, Kane would often turn to his own memories, sometimes supplemented by photos. He imagined recently encountered places and people, or places from long ago like the hills of his native Scotland, and used those images to inform his artistry. In the case of the picture of Mary with the cow that John re-created from recollection, it was titled *Mary's Pet*, and it became a major part of Kane's legacy.

Mary's Pet, painted in 1927, is a replica from memory made of a much earlier picture Kane had painted of his daughter Mary during a visit by her to Kane's Akron home. The earlier version had been lost, and—as he often did—the artist relied on memory to re-create an image. John Kane, *Mary's Pet*, c. 1927. Oil on board. Carnegie Museum of Art, Pittsburgh: Gift of Philip H. Permar in memory of Dr. and Mrs. H.H. Permar, 77.35. Image courtesy Carnegie Museum of Art, Pittsburgh.

The nomadic artist next found himself at an industrial painting job in Johnstown, Pennsylvania. It was here that Kane started work on a portrait of Abraham Lincoln that later came to be considered one of the artist's most important works. It shows the sixteenth president of the United States superimposed on an

A postcard view of the Cambria Steel Works in Johnstown, Pennsylvania, typical of the mills in western Pennsylvania in the early twentieth century. Kane found work in Johnstown before the war, and used the occasion to roam the countryside in his endless quest for landscape subjects. *Cambria Steel Works, showing about 1–6 of entire plant, Johnstown, Pa.*, before 1923. Color postcard. Valentine & Sons, publishers. Author's collection.

American flag with the words of the Gettysburg Address. Kane had always admired Lincoln, and he likened himself to the country's Civil War president. "I believe he was a healthy robust young fellow like myself, in his young days and mine," he said later. "He started life as I did, without anything except for what he got for himself. He had no schooling but what he worked for. And so I have always thought he was pretty much like myself, strong of body, willing to work and without the advantages that have helped other men."

During his working time in Johnstown, Kane would frequently get out into the nearby countryside that had been made famous a few decades earlier by the "Scalp Level school" of landscape painters. Scalp Level was the name of a borough just south of

Construction work proceeds in 1912 on the new Aspinwall Pumping Station on the Allegheny River, part of Pittsburgh's water and sewer system—another work site in the peripatetic journey of workingman John Kane. Pittsburgh City Photographer, *New Aspinwall Pumping Station*, 1912. Identifier 715.122628.CP. University of Pittsburgh.

Johnstown, but both Kane and the Scalp Level artists worked throughout the region. This group of painters embodied the Romantic celebration of nature that so captured Kane in his time. It included such renowned painters as George Hetzel, Joseph Woodwell, Christian Walter, and the Walls—William, his brother Alfred, and Alfred's son A. Bryan Wall. These artists, most with studios in Pittsburgh, ranged around Cambria and Westmoreland Counties, inspired by the rich, green landscapes of western Pennsylvania. Now Kane explored the same terrain searching for subjects.

Just before World War I broke out, Kane was back in the Pittsburgh region working on the new public waterworks plant in Aspinwall, along the Allegheny River. Then, as quick as he had come, he was off again, moving to Cleveland to take a role on a

During his time working along the Allegheny and Monongahela Rivers, Kane formed an attachment to the distinctive look of many of western Pennsylvania's waterfront communities. He returned to Aspinwall to make this painting years after working there. John Kane, *Aspinwall*, c. 1929. Oil on canvas. Collection of the Arkell Museum at Canajoharie (NY), Gift of Bartlett Arkell, 1931. Image courtesy Collection of the Arkel Museum at Canajoharie (NY). Photo: Richard Walker.

A postcard view of the barracks at Camp Sherman in southern Ohio, built at the beginning of World War I. Kane went there to enlist, was rebuffed, and later came back to the camp as a workman helping to build the barracks for American troops. The work gave him the feeling of being a part of the war effort. *U.S. National Army Cantonment, Camp Sherman, Chillicothe, Ohio*, c. 1918. Color postcard. Robbins & Son, publisher. Author's collection.

construction project. He felt inspired to paint, but the demands of his work were eating up all of his time:

> Now some of the men knew I had this hobby and that I had made oil paintings. Some way or another a professor at the Cleveland School of Art heard of me and made arrangements for me to come to his night class. That I would dearly loved to have done. Nothing would have suited me better. But how could I when I was using my saw, hatchet, square and chisel until late at night? We were supposed to be working day turn. But it got to be night work as well. So I was in no way able to take advantage of this chance to work in a class with a professor to criticize my work.

THE ARTIST AS NOMAD

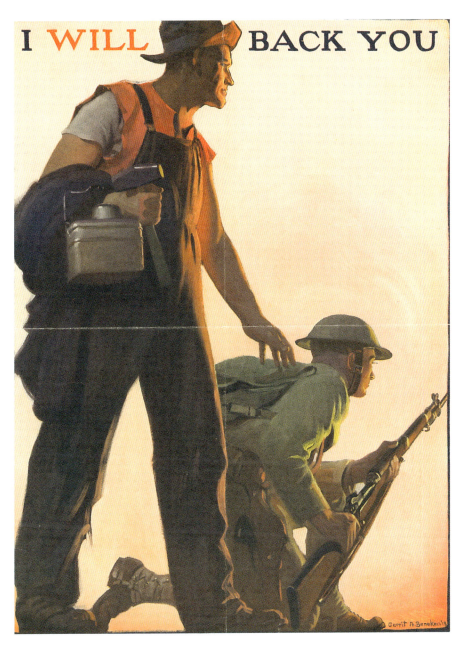

The narrative fostered by American business and political leaders during World War I was that workingmen and women, as essential to success as soldiers, backed up the military to form a core of critical support for the war effort. Here is a Gerrit Beneker poster from the time. Gerrit Beneker, *I Will Back You*, c. 1918. Poster. Courtesy the Smithsonian Libraries and Archives.

Kane always seemed to opt for hard work over instruction in his art, and it is intriguing to ponder the question of whether he might have been more successful—or even *less* successful—had he received a lot of training and become something other than the proverbial "self-taught" artist.

Then, in 1917, the United States joined the Allied war effort. And Kane, who was well over fifty, was seized by an intense desire to become a part of the fight. Always the romantic, Kane traveled the 190 miles from Cleveland to Camp Sherman, one of the nation's largest recruiting centers, a sprawling, fast-building army complex just south of Columbus. Kane was so sure that joining up was the right thing to do that he did not hesitate to make the long journey to volunteer for service to his country. "As soon as I heard the United States was going to fight I went to Camp Sherman and tried to enlist. I made the trip down to Chillicothe to try to become a recruit. 'Too old, Dad,' was all I got for my pains."

Kane, who was feeling dejected and, at the same time, frustrated by what he felt were the arbitrary rules of the establishment, went back to Akron to look for work again. In an ironic twist, the employment agency he visited sent him straight back to a construction job at Camp Sherman, which had been established that same year. A great deal of construction work was needed to turn it into the major recruit training center that it was becoming. One benefit for Kane was that he felt he was part of the war effort. "I helped build the barracks for those new recruits. Part of our job was building other barracks seven miles out from the camp. . . . I felt I was of some use to my country, even though I was beyond military age." In fact, because the nation desperately needed working men and women contributing on the home front to the war effort, there was a great public appreciation of workers during World War I. Ironically, during each of the two world wars, labor gained a stature that most often eludes it during peacetime. A great deal of public art during World War I, some of it posters commissioned by the government, glorified the contributions of working men and women.

Kane was now a part of a big crew in a military setting. And with many of his crewmates feeling as strongly about the war effort

as he did, drink remained a big part of life at Camp Sherman. Often, after work, he would go out drinking with his buddies at local taprooms. One night, coming back late to the base barracks where the workmen were housed, Kane was challenged by a sentry:

"Halt, who goes there?"

"An American workman," replied John Kane.

"Pass, American workman," called the sentry.

Locations where John Kane lived / worked and painted.

Neville Island

Ohio River

Aspinwall

Allegheny River

McKees Rocks

Ingram

Pittsburgh

N

Monongahela River

Turtle Creek

Braddock

Reynoldston

McKeesport

Lived / worked
Painted

0 1 2 3 mi
0 1 2 3 4 5 km

· 8 ·

AND HOME AGAIN

IN THE YEARS LEADING UP TO WORLD WAR I, JOHN Kane was often out of touch with his own wife and daughters; now, in the first year of America's engagement in the war, he was out of contact with the rest of the Cain family, including his brothers. When his mother died in 1917, no one knew where he was and they buried her without him. "Now she was gone and so were most of our family. Julia and Tommy and Simon were dead. Sarah and Joe had followed the steel business to Indiana. . . . Paddy and I were all that was left to console each other and Paddy was soon to be gone." Kane's brother Patrick died in 1918, and by then Kane's family circle was limited to his wife and daughters and a few other Cain relatives.

Kane's tendency toward melancholy was further encouraged by his sense of loss at the death of his mother, compounded by the guilt of not having been there: "Now my mother's death took from my life one thing that could never be replaced, namely, courage. Oh, but she put the courage into me . . . she was a deeply religious woman . . . that was the reason she could dissolve our sorrows as if they didn't exist." Barbara Cain, known throughout her life as Big Babbie, was beloved by all her family and many outside the family. In fact, in her last years, which she spent living in a shanty by the railroad tracks in Port Perry, Pennsylvania, the crews on some of the trains would slow down just enough to throw down some chunks of coal for the widow of Patrick Frazier. The train crews knew her as Granny Frazier, and they all worried that she would not have enough fuel to heat her shanty.

Nine Mile Run Seen from Calvary was painted in 1928 by Kane, who won a prize for it at the 1929 exhibition of the Associated Artists of Pittsburgh. Interestingly, Kane was later to find his final resting place in Calvary Cemetery, the place in the Greenfield neighborhood of Pittsburgh from which this image was framed. John Kane, *Nine Mile Run Seen from Calvary*, c. 1928. Oil on board. Carnegie Museum of Art, Pittsburgh: Howard Heinz Endowment Fund, 68.12. Image courtesy Carnegie Museum of Art, Pittsburgh.

Kane himself—tough, hard-drinking workingman and richly talented artist—never strayed far from his roots. He kept his Catholic faith, and as time wore on he became an increasingly faithful attendee at mass. His nostalgia for Scotland and his family included this devotion to the church, which also showed itself in myriad ways in his art.

During World War I Kane returned to Pittsburgh, this time to a job more directly related to the war effort than his construction job at Camp Sherman: he went to work at the Westinghouse Electric Corporation making artillery shells for the Allies. This job turned out to be of short duration, too, but for the best of reasons: the end of World War I. When a supervisor announced to the workmen that an armistice to end the war had just been signed in 1918, the workers poured out of the assembly areas to begin a celebration they shared with all America. "Such a celebration!" Kane later wrote. "The like of it I cannot remember. We did the thing up the way it should be done. If the war was won it was as much because of our shells as of anything else. So now that it was over we felt we could properly celebrate. . . . The Armistice left me without a job. But what matter? There was plenty of work to be had."

Kane took a succession of different jobs in Pittsburgh over the next few years, including construction, painting, and bridge building. He was often overtaken with sadness and nostalgia. What brought him through these bouts was almost always his art, which would assert its primacy in his life in ways that seemed natural and organic. "I often longed to be alone. Sometimes I would go to Calvary Cemetery, nearby, to commune with my thoughts. . . . But the scene of beauty would take hold of me and I was forced to put it down in a little sketch. My art work would never let me be. There was always something to stir me on. I tried to paint the quiet beauty I saw all about me. I have made many paintings of cemeteries." In a twist of irony that Kane would have liked, his final resting place proved to be Calvary Cemetery. Kane's great love of beauty was rewarded with a permanent place in one of the most peaceful spots in this lovely graveyard in Pittsburgh's Greenfield section, which looks down into the Mon Valley and nearby Nine Mile Run.

Kane's slightly wistful and always romantic attraction to places of solitude shows itself in many of his works. Certainly, Kane's oeuvre includes many pictures of people interacting with each other—including himself, his wife, children, kilted pipers, and visitors to a Pittsburgh amusement park—but his most moving pictures, the ones that seem most deeply felt by the artist, are of scenes around Pittsburgh that have an almost reclusive quality.

The picture *Homestead*, which was painted sometime around 1929, later went from the collection of Mrs. John D. Rockefeller to the Museum of Modern Art in New York. It shows Homestead from a distant, high perspective, almost as if seen by a soaring hawk. The viewer looks down on the town, a small borough just outside Pittsburgh, to a scene that emphasizes the industrial might along the Monongahela River: the steel mill, the smokestacks, the trains running along riverside tracks, all vying for the viewers' attention with the array of small houses in the right foreground. This is where the brutal Homestead Strike of 1892 disenfranchised so many workers.

Another picture, titled *Larimer Avenue Bridge*, also captures the might of human endeavor—the powerful, muscled steel span of the bridge itself, a tightly constructed neighborhood of commercial buildings above and below the bridge, and the long, steep stairs that descend from the avenue to the hollow below. It is a picture that signals the artist's strong interest in the details of the built environment, and it is greatly to Kane's credit that he was able to fashion such an engaging composition from these details and the greenery they frame.

Even one of Kane's more bucolic scenes from the same period, *Through Coleman Hollow up the Allegheny Valley*, beautiful and moving as it is, conveys the view of a lone and lonely artist seeing the river and the fields beyond through the cut in the hills in the foreground. The houses in the little town nearby—to the right and almost out of the frame—remind us of the human scale of things, but, compared to the power of industry and nature, it is a small scale indeed.

For Kane himself, the American dream was more a struggle than a dream. And now he chose to continue that struggle in Pittsburgh, rather than moving on to some other distant place. He

John Kane, *View from Calvary Cemetery*, c. 1928. Gelatin silver contact print. Collection of Mary McDonough.

got a small room around 1920 in a Pittsburgh neighborhood near the Point, the meeting of the rivers downtown. He was living in a shipping and warehouse neighborhood where railyards, warehouses, and wholesale produce dealers all competed for space. It could be noisy and dirty, but it also captured the intensity and energy of the city, and Kane responded to it. "There was plenty to see and draw," Kane said later. "I made good use of it in my art work. I set up in a storeroom to paint." The storeroom was most likely set up after Kane moved to slightly larger rented quarters in the Strip District, another warehouse and shipping area in the city.

Even more motivated by his Catholic faith since his mother's death, John found portrait subjects in the priests he encountered: "Here I did two portraits. One was of Bishop Boyle. The other was of Father Cox, the pastor of St. Patrick's, who led the jobless army to Washington during Hoover's administration and who ran for President of the United States on the Jobless Ticket." (Father Cox pulled out of the race in 1932 in order to throw his support to Democrat Franklin Roosevelt.) Cox was known as "Pittsburgh's

Pastor of the Poor." He and Kane had a friendship when both lived in the Strip, according to *Sky Hooks*. Although Father Cox did not like the portrait Kane had painted of him, apparently he did keep it.

Kane put great energy into creating drawings and paintings in his small, rented quarters in the Strip, which were often so cluttered with pictures and paint and brushes that they looked less like a residence than a small industrial workshop. And now Kane got a position that he later called "the best job I ever had." He was given a painting job in 1923 with the National Tube Works, where his artistic skills were truly appreciated. The tube works was head-quartered in McKeesport, which had become a major center of the manufacture of tubes and pipes, including water and gas mains, flagpoles, automobile parts—a total of forty-three different types of tubing. In addition to its huge manufacturing plant in McKeesport, the company had satellite plants elsewhere in the country.

Kane loved the job: "I was given the best wages I ever earned, with time and a half for overtime. If I worked on Sundays or holidays I got double, sixteen hours' pay for eight hours' work. I was treated fine. When I went to work in the morning everyone, even the big boss, said, 'Good morning, Mr. Kane.'" Kane was assigned to paint the office complex at the company, and what meant a great deal to him was that his skill and artistic judgment were valued and respected by those with whom he worked. In virtually every case his aesthetic judgement was trusted, and he was allowed, in effect, to make decorating decisions for the com-pany. He consulted with the managers who occupied the offices and always found the culture in the company to be congenial and cooperative, a sharp turn from the hierarchy he experienced in the industrial jobs he had done over the years. "There never was a disagreement. We worked in harmony. I was always able to make any alterations and additions I had in mind."

The combination of this supportive work environment and the steady burgeoning of his confidence as an artist now emboldened him. He found the courage to consider pursuing recognition in the established world of fine art. Kane was inspired to make a bold move, submitting his work to the Carnegie International, fully aware that it was the most prestigious art show in the country and

that in applying he was chancing painful rejection. But he was pre-
pared to march up the steps of the museum in his painter's overalls
and deliver some of his work for the judgement of the experts of
the day. This was a very gutsy thing for John Kane to do, but his
take on it was typically modest: "I painted a good deal of the time.
I had no hope to have my work accepted by the Carnegie Gallery,
but I sent them a painting that year and also the following year."
He had embarked on a journey that would utterly change his life.

PART III

At last, success, and with it comes controversy and the feeling of getting overwhelmed by all the world's attention. But John Kane, always resilient, now does some of his best work, just as wealthy collectors and museums compete for his paintings.

The joy and vivacity of the dancers from *Scene from the Scottish Highlands,* along with Kane's distinctive and engaging style, attracted juror Andrew Dasburg and others. The picture's acceptance to the Carnegie International won Kane quick fame. Dasburg himself bought the picture for fifty dollars. John Kane, *Scene from Scottish Highlands,* c. 1927. Oil on canvas. Carnegie Museum of Art, Pittsburgh: Gift of G. David Thompson, 59.11.1. Image courtesy Carnegie Museum of Art, Pittsburgh.

· 9 ·

ACCLAIM

ALTHOUGH ANDREW CARNEGIE HAD BEEN A ruthless manager who made a vast fortune in part by paying his workers as little as possible, he later became a great benefactor to his community through his philanthropy. In effect, he established American philanthropy, declaring in his *Gospel of Wealth* that the rich had an obligation to give most of their funds to charity. He is most famous for building the American library system and making access to books free to all, but one of his most influential accomplishments in Pittsburgh was the launching of the International.

Carnegie felt impelled to begin giving away his vast steel-mill fortune and to establish himself as an exemplary philanthropist when he was selling his mills to U.S. Steel Corporation in 1901. He had already moved to found the Carnegie Institute of Pittsburgh, which included an art gallery, a natural history museum, and one of the early magnificent Carnegie Library buildings. Among the first acts of the Carnegie Institute's art department was planning for an ambitious show that would be called the *Annual Exhibition*, and to which Carnegie hoped the best artists in the world would be attracted. In time, it did just that, and as its list of illustrious participants extended throughout the United States and beyond, it was renamed the Carnegie International.

Over the years, the International built its reputation as a premier venue in which American artists could demonstrate to peers and the world that they were successful and established. By the 1920s the International faced increasing competition from other

such exhibitions, and the managers of the art museum were under some pressure to demonstrate that they understood modern trends. Some of the most accomplished artists in the world were attracted to the exhibition, and it had a definite establishment cast to it. One result was that the managers of the show endeavored to widen the range of artists to reflect more current directions. Now many Pittsburgh-based painters applied as well, but it was rare for a member of the local community to gain admittance.

It was in the fall of 1925 that John Kane—aged sixty-five, just at the time of life that many consider right for retirement—carried a parcel up the stairs of the Carnegie Institute to see if he—a house painter and a carpenter, a miner and a boxer—could have one of his works admitted to the prestigious annual exhibit. He was rebuffed, of course. He came back the next year with more paintings, and was again sent away, retreating back down the steps in his drab painter's overalls.

As always, John Kane was redoubtable, and he came back yet again in 1927. That year, the jury was composed of many of the same professionals from the world of art, but it also included an artist and a critic from New York, Andrew Dasburg, who had a modern sensibility and an interest in new things. Dasburg was a sophisticate who had studied in Paris, where he joined the circle of intellectuals led by Gertrude Stein and became interested in and influenced by the new cubism movement and such painters as Pablo Picasso and Paul Cézanne. Later in life, after gaining success as a painter of cubist-style works, he moved to Taos, New Mexico, where he gravitated toward the creative community there, led by the artist Georgia O'Keefe.

When Kane again showed up, Dasburg took an interest in the painting he brought in: his *Scene from the Scottish Highlands.* In Kane style, it was a work that combined the faces of children he knew with long-ago memories of Scotland. Dasburg responded to the picture, and he pressured the other jurors to see its merit and admit it to the International. Eventually the other jurors supported it, influenced by Dasburg's enthusiasm and, perhaps, inclined to give more weight to the sense of spontaneous joy the artist had created than to some of the more primitive aspects of his draftsmanship. Besides, Dasburg had enough learning in the

American artist Andrew Dasburg lived in the Southwest when he painted
Bonnie in 1927. That same year he served as a Carnegie International juror
and fought hard to get John Kane's *Scene from the Scottish Highlands* admitted
to the show, starting Kane's roller coaster ride to fame. Andrew Dasburg,
Bonnie, 1927. Denver Art Museum: The Lucile and Donald Graham Collection,
1981.624. © Estate of Andrew Dasburg. Photo courtesy Denver Art Museum.

cubist and modernist movements to appreciate how highly those who worked in those fields valued the artistic contributions of the so-called primitive artists. It was the perceived "authenticity" or "honesty" of such self-taught artists as Henri Rousseau and, now, John Kane, that attracted artists like Dasburg, who had already embraced the experimental nature of the modernist school. *Scene from the Scottish Highlands* had been painted that very same year, 1927. With prodding from Dasburg, the full jury voted it in, where it got a positive reception from museum attendees. It later became part of the permanent collection of the Carnegie Museum of Art, along with seventeen other paintings and four drawings by Kane.

And then, suddenly, John Kane became famous. What followed as a result of his inclusion in one of the world's most exclusive art exhibits was a surge of notoriety. But it was a kind of attention that presented a real disruption of Kane's simple life. The artist had moved again, to new quarters in the Strip District, and he soon found his new abode swamped with visitors. There were newspaper and magazine reporters and photographers, mostly local but eventually national. And there were academics and others from the local arts community who wanted to talk with Kane. And, of course, there were opportunists who thought he must have come into a great deal of money through his acclaim. He hadn't, and—by and large—he didn't.

One of the first writers to seek out Kane in his modest Strip District quarters was a local newspaper reporter named Marie McSwigan. She had been tipped off by museum staff to the unusual tale of a Pittsburgh workingman admitted to the International, and she rushed to get the story. McSwigan and other reporters wrote reams of copy about Kane, but it was McSwigan who stuck with the unfolding Kane saga for years to come. Not only did she produce numerous articles, she formed a friendship with Kane that developed into admiration for his accomplishments and his character. And, later, she visited him repeatedly over a period of months to take down notes from their conversations that, when she was finished, became an autobiography published by McSwigan after Kane's death.

McSwigan went on to a successful career as a writer of books, including the celebrated children's book *Snow Treasure*, later made into a movie. But her renown as a writer came from her authorship

Across the Strip was painted by Kane in 1929, a time when he was living in that Pittsburgh neighborhood and gaining a national reputation for his art. John Kane, *Across the Strip*, 1929. Oil on canvas. The Phillips Collection, Washington, DC. Acquired 1930.

with Kane of *Sky Hooks*, the story of his life presented by her as a Kane autobiography. In the book, Kane gives an account of his experience with "sky hooks" when he was painting large structures

at a Pittsburgh amusement park of the time, Luna Park. It was McSwigan who became attracted to the idea of using the term "sky hooks" for the title of the book. She either convinced Kane to do so or simply applied the title to the autobiography after the artist's death. But the term didn't just provide the title of his autobiography. It also—perhaps—represented a bit of a practical joke by Kane on his readers and possibly his coauthor as well.

Sky hooks, Kane reported, referred to the rigging that suspends the painter's scaffold from the top of a structure. But it also seems to have been a term used by workmen in the Pittsburgh region to gull unsuspecting novices, who were told to look for nonexistent rigging hooked to the sky. At any rate, *Sky Hooks* became the title of the autobiographical work that Kane collaborated on with McSwigan, who evidently thought of the hooks as metaphors for his life. Kane certainly conceived of himself as one who was always reaching, always aspiring, always searching for beauty. Perhaps McSwigan was tricked by Kane, or perhaps the two really believed in the hooks. Whatever the case, Kane was deeply indebted to McSwigan for her tireless efforts to record his story, as are all who care about American art.

One of the strongest reactions Kane had to his newfound fame was that he didn't want his life to change. In *Sky Hooks* he says he felt very strongly that his own appreciation of his art was unaffected: "I am a very humble man. But I would be dishonest if I claimed that I did not value my work before it was recognized by the art juries. I valued it then as I do today." And he worried about an identity that might threaten to shift from "workingman" to "artist," and that it might somehow imply that he wasn't the strong, capable worker he had been all his life: "I wouldn't want anyone to think that I gave up outdoor painting when I was recognized as an artist. I gave it up when I could no longer get it. I was almost seventy years old when I painted my last house. But that had nothing to do with it at all. I can still handle a bucket of lead paint as well as the next. I can still climb the highest scaffolding as I have done many times."

Perhaps the saddest reaction Kane had to the startling news from the Carnegie was that there were so few people with whom he could share the joy. "I wanted to tell someone about it," said Kane later. But, he said, "I had no one to tell. I was out of touch

with everyone. Mrs. Kane was in Washington and all my people were dead except Joe and I had not heard from him in a long time. Now ever since I came from Scotland I had a little tin whistle [his flute]. So I pulled it out and played a Highland fling for the little girls to dance to in imagination. 'The Forty-Second Highlanders Crossing the Broom Loch' was what I played. . . . It was my way of communicating the good news."

When the coverage started coming in, and Kane got a look at what was being written, he was caught off guard: "It may have seemed unusual to some that a house painter from the Strip would show his work alongside of the art school men, the portrait painters to the King of England and all like that. Of course I didn't see anything unusual about it until I read in the papers how the others were surprised."

And, by Kane's own description, the disruption escalated: "At any rate, I had a good many visitors, more than I liked or were good for the solitude of my work. The newspaper photographers came in and took my picture at the little board easel I had cobbled up from a few unpainted boards. . . . I had write-ups and editorials in many papers. Mary [Mullett], a writer for the *American Magazine*, came from New York to see me. I had a great many other visitors as well—art dealers, commercial art companies and various concerns, some wanting one thing, some another." The most frequent visitor, of course, was the reporter who became his biographer, McSwigan; she reported later that Kane was often annoyed by having to stay inside for interviews when he wanted more than anything to get out into the fresh air to paint his pictures.[1]

Kane learned that his suddenly intense relationship with the world of art could be both disenchanting and surprisingly unremunerative. He sold *Scene from the Scottish Highlands* for fifty dollars to Dasburg himself, and also sold his painting *Squirrel Hill Farm* for a like amount to the Carnegie's curator of prints and drawings, Edward Duff Balken. None of the prices Kane got during his lifetime were substantial or amounted to enough to make the artist wealthy (though he and his wife had over $4,000 in a savings account when he died).

"In all, it made very little difference to me," said Kane. "I still had to work for my bread. They said I got fame overnight. But fame was practically all there was to it." Later, an art investor offered

So many of John Kane's landscapes combine rural and industrial elements in a mix familiar to the Pittsburgh populace from the early twentieth century. But in *Squirrel Hill Farm*, painted in 1925, Kane presents a more completely rural look at his environs. John Kane, *Squirrel Hill Farm*, c. 1925. Oil on canvas. Private collection. Image courtesy Kallir Research Institute, New York.

Kane a generous salary to free him from physical labor and to give him ample time to paint. The catch: the product of his work would belong to the investor. Kane, always independent, said no. He kept painting houses for income, even after his picture *Old Clinton Furnace* was accepted by the Carnegie in 1928.

Combines Art and Trade!

(By Pacific & Atlantic)

WORKER BY DAY, ARTIST BY NIGHT!—For fifty years old John Kane has been painting houses to make a living during the day; but at night he has been wielding the brush more delicately in bedroom studio. And at last he has won recognition by exhibit in Pittsburgh, Pa., show.

As Kane's fame spread, more and more of the popular press invaded his life and his work. Here the *New York Daily News* has the artist posed at his easel. For a private person like Kane, with his artist's sensibility, the intrusions could feel distracting. John Kane by easel, photo accompanying news article, *New York Daily News*, October 21, 1927. Newspapers.com.

But there was an entirely unexpected benefit that made an exceptionally positive impact on John's life: "A month after the opening of the 1927 show, the first time my work was ever

exhibited, Mrs. Kane returned to me. . . . She was reading a New York newspaper one Sunday when she opened the page to my picture." Maggie was living in Washington, DC, where she had moved with her two daughters when they had each found work in that region. "It was raining hard the thirteenth of November, the night she came back to me," recalled John. "There was a tap on the door. I opened the door just a little. The light fell in a long streak. I thought I saw ghost. It was Mrs. Kane."

Her companionship saw Kane through ups and downs over the next seven years. More importantly, she now provided a stability, an anchor, to his life that enabled him to focus on his art and to establish the most productive routine as an artist that he ever had. Maggie sat with John during many interviews and many meetings with visitors, and she was with him through every writing session with McSwigan. Likely she recognized her own interest in Kane's accomplishments, and this may have put some more pressure on him to find commercial success.

In all that time, he only referred to her as "Mrs. Kane." It is clear that Maggie Kane not only created a stable environment within which John could paint but provided some of the information in *Sky Hooks* and helped shape it.

· 10 ·

AND CONTROVERSY

B
Y 1930 JOHN KANE WAS BUSY PAINTING AND having significant success beyond his multiyear acceptances at the Carnegie International. In fact, he participated in two shows at the Harvard Society for Contemporary Arts in Cambridge, Massachusetts, and three of his paintings were exhibited at the Museum of Modern Art in New York. After he joined the Associated Artists of Pittsburgh, he had five paintings accepted to their annual exhibit, one of which won a prize.

So, he was encouraged—and he was discouraged, too. He had suffered some broken ribs in a trolley accident, and—for the first time in his life—he was feeling a bit older and frailer than he had ever felt before. That, along with his struggle to make a living as an artist, with a far less reliable income than as a house painter, was wearing for him. "I felt lame and weak for the first time in my life," said Kane. "Perhaps it was the winter coming on. The black smoke rolled up from the railroad and blew up from the factories along the river. Outdoor work was over for me and I was not certain I could support myself from my pictures as I had as a day laborer."

Some time after the shows at Harvard and MoMA, interest heightened in his work and Kane sold *Through Coleman Hollow up the Allegheny Valley* and *Homestead* to wealthy collectors. One of them, renowned educator and philosopher John Dewey of Columbia University in New York, wrote, "You have given me, and I am sure a lot of others, a great deal of pleasure and you have the feeling and power to make painting real." Kane was so proud he kept the letter.

When the Junior League of Pittsburgh asked Kane for pictures to be hung in a one-man show in their gallery in 1931, he was pleased, and he sent them a number of pieces. But they came back to say they had a lot of wall space to fill and they needed more works. Kane sent them a few of the pictures he had made back in his Butler County days, when he was painting over photographs. But this was controversial: there was an expectation that submission to fine arts exhibitions would include only original paintings, not photographs that had been painted over.

A competitor of Kane's, Milan Petrovits—perhaps jealous of the acclaim the self-taught artist was achieving—went to the local newspapers with a sensational story: John Kane, the brilliant new discovery of the art world, was a fraud! And the very newspapers that had boosted Kane's fame now rushed—predictably, one supposes—to tear him down. Two of the papers took photo/paintings to their own art departments to remove some of the paint, revealing the photographs beneath. The coverage suggested that all of Kane's work was thus copied, and the popular press pilloried him as a fraud.

Kane was deeply wounded: "I was bewildered when this thing took place for I had always thought all my dealings were honorable. . . . Now this art work was a special pride to me. . . . Even though I took this enormous pride in my art, I would sooner have let it go than have anyone doubt my honesty or to think that I took something through a fraud." Kane wasn't paying careful attention to the rules of the game, and he was a ready victim for a competitor who was jealous of his success. The irony of this is that time and again, as a person and an artist, Kane had demonstrated his integrity. The oils that were to make Kane famous are original works—not copied and not painted-over photos. Kane was a fierce believer in the importance of his integrity, which was based on his deeply held Catholic values. It was a sharp jolt to him to have people questioning that integrity.

The art world, to its credit, rose up to defend John Kane. Artists, critics, and museum directors worked hard to correct the wrong impression that the papers seemed intent on creating. They wrote Kane, they wrote each other, and they wrote the newspapers. One of them, Duncan Phillips of the Phillips Memorial Gallery

(now called the Phillips Collection) in Washington, DC, had a deep background as a critic and writer, as well as the founder of an art museum. Phillips, who came from Pittsburgh himself, wrote to the editors of the Hearst newspapers: "Kane's unsophisticated pictures are as devoid of tricks as the work of a little child. Their innocence shames the attitude of those responsible for this absurd publicity." He went on to say that Kane "won the admiration of the good judges of quality because, in spite of lack of knowledge and training, he alone comes closer to the essentials of expression than the most competent professionals who resent his success."[1]

Eventually the air cleared and Kane felt vindicated. "I don't believe this rumpus did me any harm, though, naturally, it is not the kind of thing that anyone wants to happen. . . . It would only be common sense to look at my scenes and to see that no camera was ever constructed to get the view of objects that I, as an artist, see and paint. I don't believe anyone in his right mind would credit a camera with such faculties."

Kane's reputation and legacy may have survived this challenge undamaged, but the controversy reflected poorly on the performance of the popular press of the time. The press had made an almost hysterical rush to acclaim Kane when his story fit one of the stereotypes editors seemed to love: workingman hero triumphs over art-world establishment. When another cherished stereotype presented itself—the artist as fraud, guilty of trying to gull the public—the press rushed to embrace this new narrative. Only with time, and pressure from the experts, did the press accept Kane for what he was: an authentic artistic talent. Ironically, the press had missed a genuine big story two years earlier, when Kane had sent a provocative and powerful picture to one of two exhibitions he entered at the Harvard Society for Contemporary Art. Kane had created a large, full-length portrait of himself, mostly nude, flexing his muscles, and adorned with his artificial leg. This self-portrait had been rejected by the Carnegie International, and after consultation with one of his advisors, Kane had sent it on to the Harvard show, with the hope that it would be recognized as one of his great works. But it didn't connect in prudish Boston, and Kane's expectations of an artistic stir were not realized.

The picture later disappeared, almost surely painted over by a disappointed Kane himself. And the world of art—then and today—was deprived of seeing what probably was Kane's most dramatic creation. But the popular press missed the story. Very little was ever written about the power of this controversial self-portrait, its potential importance to the Kane legacy, or its loss, probably at the hands of a dismayed artist. The press's penchant for the sensational, and its failure to recognize the essential, stand as embarrassments to many of the journalists who covered Kane's story.

· 11 ·

LEGACY

JOHN KANE WAS, FOREMOST AND ALWAYS, A tough guy. That was his persona, his aura, the self-image that he carefully crafted through all his life: boxer and brawler, hard-drinking workingman who could master virtually any trade, a man so tough he could overcome the loss of a limb to keep on working to his seventies, a nomadic, almost mythical figure who could go anywhere and do anything. To all that, he added the persona of a sensitive, romantic artist who loved beauty—who, in fact, pursued what he saw as beautiful his whole life. Among his accomplishments was the ability to extract beauty from his everyday surroundings. His strong sense of solitude brought with it the artistic weight to create utterly distinctive and moving pieces of art.

This Kane paradox—brawny and tough, sensitive and creative—was at the heart of much of the public's interest in Kane as a person. As much a cliché as a reality, this perceived conundrum of the workingman/artist fueled the public's fascination with Kane, and that allure was heightened all the more by the fact that he did not achieve renown until he was well into his sixties. A lot of this image was carefully advanced by the artist himself, and by his amanuensis, Marie McSwigan. No doubt, McSwigan was taken with the heroic aspects of Kane's life story. And she was a good writer who knew a great story when she encountered it. Whether one accepts McSwigan's description of *Sky Hooks* as Kane's autobiography or views it more as a biographical interpretation of the artist by an accomplished journalist, it is clearly a skillful piece of marketing as well as a fascinating life narrative.

A lot of Kane's signature characteristics come out clearly in his paintings: the solitary point of view, the passion for detail, the relentless artistic commitment to beauty, and the inclination to tell a story. As he grew older, he became more solitary and more committed to his art. In one sense, he was a flash in the pan: an overnight sensation who, later, was at risk of being forgotten. But, as numerous scholars and critics have noted, he had a significant impact on the evolution of twentieth-century American art. And he was a seminal figure in the developing appreciation—even acclaim—for the self-taught artist.

But what elevates the Kane story is not the paradox, not the sensational and surprising success, but the work itself. What brings people—art lovers, critics, museum curators, scholars—back to Kane is the sharply distinctive character of his work. That he was self-taught was a key to his success as a creator: a Kane is unmistakably a Kane. In a way, John Kane was lucky to have been taught by John Kane.

He always said he didn't care much at all about recognition, but clearly he did care about getting appreciation for his skills. And, once he was discovered as an artist, he got his share of approbation. According to Frank Crowninshield, American art critic, editor of *Vanity Fair* magazine and a founding member of the Algonquin Round Table literary group, "few careers in the long history of art have been more singular than that of John Kane." Crowninshield wrote, "Everything in it seems to have come from the other side of probability. Search Vasari's *Lives of the Artists* from beginning to end, and you will find in them no more magnificent paradox than this: that an immigrant day laborer, who had no time to paint, no money to paint, no earthly provocation or encouragement to paint, should yet emerge, at the age of sixty-seven, as the most significant painter America has produced during the past quarter century."[1] And this from Henry Adams, Curator of Fine Arts at the Carnegie Museum of Art in the 1980s: "Among the great artists of this century, John Kane holds a unique position. Discovered at a time when folk art was still intimately linked with the development of modern art, he was the first American folk artist to win fame in his own lifetime, and the last to have his works placed alongside those of the most progressive American painters."[2]

One of the reasons for Kane's acceptance into the main-stream of American art was the widely held belief that there was something about the self-taught artist that "represented the most authentic example of American art," according to historian and curator Katherine Jentleson. "For in addition to embodying the democratic spirit of the nation in terms of their everyman . . . status, by virtue of being untrained, they were also cut off from awareness of historic or contemporary trends in European paint-ing and sculpture that has made so many American artists appear derivative." [3]

One critic to assess the meaning of Kane's work was the co-director of the Galerie St. Etienne in New York, Jane Kallir. She wrote of Kane's place as an influential American folk artist and as one of the influencers, like France's Henri Rousseau, of the evolu-tion of twentieth-century art: "He was 'the American Rousseau,' whose work, even today, is not segregated in our few specialized folk art museums, but rather may be found in the great public collections of twentieth-century art." [4] Jentleson adds this corollary thought: "Folk art was not merely a source of formal inspiration for contemporary artists; it was also material proof that art had long flourished outside the academy in the United States." [5]

Former Carnegie Museum of Art director Leon Arkus argues that for Kane, "beauty was a part of everyday life. He sought beauty in the written word, in the poetry of Robert Burns, the Bible, the Gettysburg Address. He found it in people's faces, in the natural world of forests, hills and rivers, and in the accomplishments of man. The industrial scene, as he saw it, was imbued with a rare and marvelous poetry." [6] And Jentleson offers this observation about where Kane found his inspiration: "Although Kane was hardly the first painter to capture Pittsburgh, by the mid-1930s he had arguably become to the Steel City what Grant Wood was to Iowa and John Steuart Curry was to Kansas. An unsigned 1936 review of Kane's memorial show at the Carnegie in Pittsburgh's *Bulletin Index* attested to Kane's mastery of Pittsburgh: 'He had caught her tortuous, troubled spirit and the cut-up hills and the sweep of her green valleys as no other man before him.'" [7]

Kane did enjoy some significant posthumous success in the 1930s, before he faded from the public's attention. In assessing

This is vintage John Kane, presented at his very best. *Turtle Creek Valley, No 1*, dating from 1932–1934, shows all the muscularity of the built environment—the railroads, the bridges, the human activity—cutting directly into nature's green hills around Pittsburgh. Kane's depiction of the bridge was widely praised. John Kane, *Turtle Creek Valley, No. 1*, c. 1932–34. Oil on canvas attached to pressed-paper board mounted to a wooden panel with a cradle. Gift of the Estate of Richard M. Scaife, 2015.5. The Westmoreland Museum of American Art.

the qualities in Kane's work that aroused this interest, Crown-inshield uses such words as *pathos, isolation,* and *mystical* in his 1930s essay. "Kane's mounting fame is also an indication of the increased emphasis that the world now places on *personality* in art, on spirit and feeling as against the trained hand and the

This aerial photo of the Turtle Creek Valley area was taken around the same time that John Kane was making a celebrated painting of the valley, which proved to be another instance of Kane successfully capturing the feel of the built environment around Pittsburgh. Unknown photographer, *Aerial View of Turtle Creek Valley and George Westinghouse Bridge*, c. 1932. Identifier: 20170320-hpichswp-0081. Detre Library & Archives, Senator John Heinz History Center, Pittsburgh.

calculating mind. It is certainly a wonder that, in a day so obscured by the murk of the material and commonplace, an artist should have emerged whose aesthetic doctrine was of so simple an order: 'Truth,' he said—in summing up the matter—'is love in thought. Beauty is love in expression. Art and painting are both of these.'"[8]

The picture *Homestead*, which was painted around 1929, eventually went to the Museum of Modern Art in New York. It shows Homestead from a high perspective, almost as if seen by a soaring hawk. This is where the controversial Homestead Strike of 1892 took place. John Kane, *Homestead*, c. 1929. Oil on canvas. Museum of Modern Art: Gift of Abby Aldrich Rockefeller. Digital Image © The Museum of Modern Art/SCALA/Art Resource, NY.

But there is something else that comes through in all this: John Kane's powerfully romantic spirit. Though much of his art may be tinged with sadness, there is also a touching romanticism suffusing all his work. Kallir writes of this:

Another example of John Kane's great care for detail, this picture—*Larimer Avenue Bridge*, also known as *Frankstown Bridge*, painted in 1932—shows Kane's capacity for skillful composition. The bridge, the hill, the buildings, the sky, all come together in an engaging and pleasing whole. John Kane, *Larimer Avenue Bridge (Frankstown Bridge)*, 1932. Oil on canvas. Carnegie Museum of Art, Pittsburgh: Patrons Art Fund, 54.50. Image courtesy Museum of Art, Pittsburgh.

John Kane's particular vision is unique in our time. . . . The artist painted slums without squalor, industry without horror—omissions that, to more socially minded critics, seem politically naive and, to others, are merely inexplicable.

How could an artist celebrate something whose ugliness is universally acknowledged? Why didn't Kane see what we see? Or, more to the point, what did he see that we do not? For when John Kane looked at the

billowing smokestacks of a bustling factory, he saw the majestic surge of prosperity. . . . Walking along the many bridges that link Pittsburgh's hills and cross its railroad tracks and roadways, Kane gazed into the lush valleys and found, in the little houses and trees and trains and cars, the living embodiment of the American dream that the rest of us have long ago given up for lost.[9]

It is this distinctive Kane quality—perhaps some of Crowninshield's mysticism mixed with some of Kallir's optimism—that fixes so many of his paintings in the mind. The reason collectors have been drawn to his work is the same reason that other great painters have sustained an enduring appeal: their work is not just beautiful, it is distinctively so. Kane's personal history shows in each of his pieces in idiosyncratic ways that make his work easily recognizable. His gift for detail in his landscapes, and storytelling in his people, are important elements of the Kane appeal.

A week before his seventy-fourth birthday, John Kane died of tuberculosis in Pittsburgh. He worked as a laboring man to the age of seventy, and worked as an artist to the end of his life. He was buried in an unmarked grave in Calvary Cemetery in the Greenfield section of the city. In 1948, when Maggie Halloran Kane died, John's body apparently was moved to a new Calvary gravesite to be buried with her under a marker with a cross chiseled into the stone at the top, along with this inscription:

<div align="center">

JOHN KANE
AUG. 19, 1860
AUG. 10, 1934

</div>

And, below that:

<div align="center">

MARGARET
1863–1948

</div>

Like so many other acclaimed artists, Kane never sold enough works for enough money during his lifetime to be well off. But his art sold, and continues to sell today. Some of Kane's works went

John Kane died in 1934, about a week short of his seventy-fourth birthday. Here art world dignitaries from Pittsburgh and New York carry his coffin in procession. Image courtesy Carnegie Library of Pittsburgh.

for good prices right after his death in 1934. Today they typically go for around $10,000 to $20,000, and the highest recent prices have been well over $100,000. Still, these relatively modest prices reflect the degree to which Kane has been somewhat forgotten in today's supercharged art world, in which original works by the most renowned artists can fetch scores or even hundreds of millions of dollars.

There may be more than 150 Kane paintings still in existence, as well as a significant number of sketches that Kane typically made to frame out scenes in which he was interested. In addition to the dozen and a half paintings in the permanent collection of the Carnegie Museum of Art, there are others in the collections

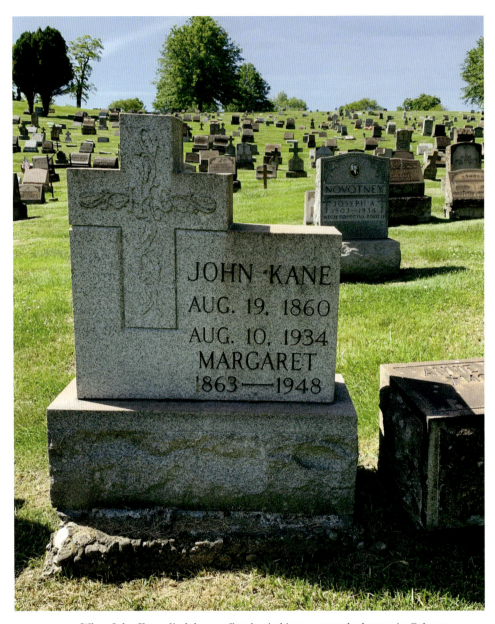

When John Kane died, he was first buried in an unmarked grave in Calvary Cemetery in the Greenfield section of Pittsburgh. Later, when Maggie died, Kane's body was moved to join her at this marked gravesite on a sunny hillside in Calvary. Photo by Max King.

of the Museum of Modern Art in New York, the Whitney Museum in New York, the Art Institute of Chicago, the Westmoreland Museum of American Art in Greensburg, Pennsylvania, and other museums.

And some number of other paintings exist in private collections, mostly in the eastern part of the country. Almost all of the Kane works in museums come from the later period of his working life, and almost all of his earlier works are either gone, still with dealers, or scattered in various private holdings.

There have been many exhibitions of Kane's artistry over the years, including at the Carnegie in Pittsburgh; the MoMA in New York; the Harvard Society for Contemporary Arts in Cambridge, Massachusetts; the Phillips Collection in Washington, DC; the Arts Club of Chicago; the Barnes Foundation in Philadelphia; the Knoedler Galleries in New York and London; the Galerie St. Etienne in New York; the Valentine Gallery in New York; Gallery One Hundred Forty Four in New York; and the Contemporary Arts Society of New York.

John Kane the person was flawed, as he himself well knew: he was given to excessive drinking most of his life, he abandoned his family for long periods of time during which he did not provide support for them, he had the wandering nature of a man averse to commitment, and he could be selfish and self-absorbed. All these contributed to his leading a solitary life. But he had great virtues, too. He had the kind of real integrity as a person that imbued him with a powerful and distinctive character. He also believed fervently in the Christian values he was taught by his mother: kindness, love, compassion, justice, fairness, respect, thankfulness, and service. And he had the talent, the courage, and the creativity to support his ambitions.

All of these virtues were focused and given power by the truly stirring level of perseverance he brought to his work. Yes, he resisted commitment all his life, but when he did engage—in fact, *every single time* he engaged—he did so with a relentless drive and focus. Then he would move on, to the next job or the next painting project. And then again, intense focus on his work, both as a laborer and an artist. Increasingly, as he grew older, the focus was on art, and that fierce, relentless Kane drive would kick in,

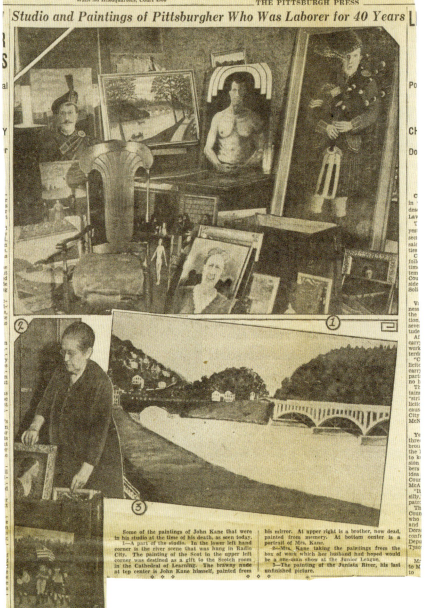

Studio and Paintings of Pittsburgher Who Was Laborer for 40 Years

Some of the paintings of John Kane that were in his studio at the time of his death, as seen today. 1—A part of the studio. In the lower left hand corner is the river scene that was hung in Radio City. The painting of the Scot in the upper left corner, was destined as a gift to the Scotch room in the Cathedral of Learning. The brawny nude at top center is John Kane himself, painted from his mirror. At upper right is a brother, now dead, painted from memory. At bottom center is a portrait of Mrs. Kane. 2—Mrs. Kane taking the paintings from the box of work which her husband had hoped would be a one-man show at the Junior League. 3—The painting of the Juniata River, his last unfinished picture.

News clipping showing Kane's studio shortly after his death. *Pittsburg Press*, c. August 11–15, 1934. Image courtesy Carnegie Library of Pittsburgh.

yielding a dedication to every detail of every job. Flawed—yes, indeed. But when he chose to focus, he was indefatigable in his drive for excellence.

It was almost surely this perseverance that enabled Kane to rise above his shortcomings and achieve a laudable level of success. He always protested that he didn't care a whit for the acclaim that came his way. But, in fact, he did pursue it: in the subjects he chose to paint and in the approach he brought to his subject matter. And it is clear in the stories he tells in *Sky Hooks*—and how he tells them—that he did want recognition. After all, his métier was hard work, and all his life he showed a vast pride in what his dedication to labor could accomplish.

THE
ART

by Louise Lippincott

BIRD'S-EYE VIEW OF INGERSOLL'S LUNA PARK, PITTSBURG, PA.

Pittsburgh's Luna Park, where Kane worked for a while as a painter, was one of the first such sites in a nationwide development of amusement parks for working-class families. Always fearless, Kane had painted the roller coaster. Sadly, the park closed in 1909, four years after it opened, when the developer became overextended and declared bankruptcy. *Bird's-Eye View of Ingersoll's Luna Park, Pittsburg, Pa.*, 1907. Color postcard. Kresge & Wilson, publishers. Author's collection.

PROLOGUE

A Fable

THE STOCK MARKET HITS ALL-TIME HIGHS. ECONOMIC inequality and political unrest threaten democracy. New technologies transform communications and entertainment, news consumption, and visual culture. A booming art market makes headlines with astounding prices for strange works by obscure artists. Troubled observers ask, "But is it art?" and assert, "My child could make that." Critics denounce decadent artists and nouveaux riches buyers. Museums exploit the sensation and pacify the traditionalists.

Is this 2021, when the technology is digital, the price is tens of millions, and the artist's internet name is Beeple? Could it be the mid-1960s, when Pittsburgh-born Andy Warhol transformed the New York scene, and pop art took off? Or are we talking about the 1920s, when radio, movies, and television changed America's consumption of art and culture, Old Master art prices soared, and John Kane became a media and art world darling?

It could be any, or all. Economic, political, and cultural forces come together, a daring individual makes a play, and history changes. Recently an earnest television reporter asked Beeple, "Do you feel like an artist now?" as if price tag alone makes his work into art, and Beeple reacted with a mixture of terror and delight. Kane would have understood that top-of-the-rollercoaster feeling. Kane knew that when the emotional thing fades, what's left one hundred years later, if the buyer is lucky or perceptive, and the artist is good, is the art.

PART IV

Art world insiders have struggled to define unconventional artists like John Kane. The difficulties begin with Sky Hooks, *a unique, problematic story of his life.*

John Kane's best work, regardless of subject, combines slow observation of the natural world, meaningful arrangements of detail, and moral storytelling. John Kane, *Hills and Rivers, Steamboat at Sleepy Hollow*, c. 1929. Oil on canvas. Gift of the Estate of Richard M. Scaife, 2015.4. Westmoreland Museum of American Art.

· 12 ·

KISSING THE
BLARNEY STONE

S KY HOOKS: THE AUTOBIOGRAPHY OF JOHN KANE
was published four years after Kane's death with an intro-
duction by New York aesthete Frank Crowninshield and a
postscript by Pittsburgh journalist Marie McSwigan. Long accept-
ed as the definitive life of the artist, told in his own words, the
story of its evolution reveals that it is neither. Yet it remains the
indispensable resource for all fans and students of John Kane,
this book's authors included.

Sky Hooks began as an invitation to Marie McSwigan from Mag-
gie Kane in October 1932. The Kanes were suffering through the
Depression and they faced a new challenge. John Kane was show-
ing signs of tuberculosis, and at seventy-two was approaching the
end of his life. Maggie was looking anxiously toward an insecure
future and hoping for a magazine-length article from a sympathet-
ic writer. McSwigan, author of genteel puff pieces about the Kanes,
a devout Catholic from a wealthy Pittsburgh family, and a specialist
in society news and cultural gossip, was Mrs. Kane's choice.

Maggie Kane might have been seeking to update an earlier,
influential national story titled "Maybe It's All I'll Ever Get, But It's
Worthwhile," published in the *American Magazine* in April 1928.[1]
Its author, New York journalist Mary Mullett, interviewed John
shortly after his first International triumph, and before Maggie's
permanent return to Pittsburgh turned moneymaking into a cen-
tral concern for the artist. Mullett describes a frightening taxi
ride through a decaying slum, the artist's small, dark, messy room

On rainy days, John Kane painted on canvas because bad weather kept him from plying his trade as house painter. Sundays and holidays he would go into the country around Pittsburgh, make sketches, bring them home to be worked over in paint. He would return to the scene of his painting again and again to make sure that his rendering was accurate.

On good days, John Kane slapped paint with heavy brushes on the sides of houses, barns, silos. Kane loved hard work. He was a strong man, 6 ft. tall, weighing 180 lb. When he was young he liked to box. He once went 75 rounds with a professional, another time stayed five informal rounds with a stranger he always believed was James J. Corbett.

The tendency to view Kane as a split personality is exemplified in this *Life* magazine spread from May 17, 1937. While images of Kane at his easel are common, the photo at right is a rare record of his good-weather day job. Author's collection.

reverberating to the roar and screech of passing trains, his shy, wary demeanor and monosyllabic responses to questions. A sophisticated, empathetic reporter, Mullett interpreted his silences as a workman's practiced defense against elite interrogators and his unfamiliarity with the esoteric vocabulary of the contemporary art world.[2] In the end, she answered her questions herself, and waited for the artist to signal some kind of acceptance or agreement to each statement. Her conclusion, that he worked for his own satisfaction rather than fame or money, rings true. Many of the classic stories about John Kane—his travels, his boxcar paintings,

his unconventional character—originated in this 1928 article and were repeated constantly in the press.

Maggie Kane sought to change the narrative. To her, fame should mean money, and John had fame aplenty but very little money. The national news wires and popular press covered him gleefully as an art world scandal—a lowly house painter fooling snobbish connoisseurs. "Housepainter turned artist" and "Is it art?" are the common themes. John tolerated this approach, going so far as to pose for a news photographer as if painting a picture of a famous riverboat, and then touching up its water tank with a bucket of white paint.[3] He may have viewed these performances as free advertising for both of his painting occupations.

Maggie scheduled, attended, and facilitated the interviews that would become the basis for *Sky Hooks*, and she provided many stories about the Kanes' family life, some of which McSwigan would include in *Sky Hooks*. Its rare facts and dates often correspond to times Maggie was present in John's life. Her presence at the *Sky Hooks* sessions surely influenced John's discussions of his family, his religious views, his bachelor lifestyle during their lengthy separations, his reputation for violence, and his drinking. Mostly he wanted to get back to painting. He was reprimanded. A Saint Patrick's Day card depicting Blarney Castle, addressed to his oldest daughter Mary following their reconciliation in the early 1930s, bears the following inscription: "Mam says I should go and kiss the Blarney stone aint Mam sweet / Dad."[4] Kissing the Blarney Stone embedded in the walls of an ancient Irish castle was said to endow a person with "the gift of gab," skill at humorous storytelling and the ability to deceive without offending. Apparently, Maggie thought her husband lacked the gift. His most thoughtful and personal narratives went into his paintings, and he brought a different set out for each interview in an effort to show what he couldn't always tell. Thus, he told McSwigan, "I was in McKees Rocks painting cars in poor health in Woodville awhile." He didn't say that Woodville was the popular name for the Collier Township workhouse, Allegheny County Home for the Poor and Hospital for the Insane and Tubercular, or that he was incarcerated there, around 1899. But he showed McSwigan his painting *Escape from the Workhouse*, painted two versions of it, featured it in a central position in his

first *Touching Up* self-portrait, and depicted another workhouse in the moral landscape of the *Coleman Hollow* paintings, among his most beautiful.[5]

Like Mullett, McSwigan found Kane difficult to interview.[6] She seems to have initiated the process with typed questionnaires that provided generous spaces for written responses; in surviving examples, a modestly penned "yes" or "no" in the margins was often all she got back. In this respect, Kane's approach seemed unchanged from his 1928 interview style. McSwigan's next tack was more productive. Over a two-year period she filled four composition books with hasty scrawls as she struggled to keep up with his story of the day. Once he embarked on a topic, she was able to follow through with questions of her own. The surviving notebooks contain many of the texts to be found in *Sky Hooks*, but not all of them and not exactly.

In some cases this was due diligence. Kane organized events in his life by the places where (as opposed to the times when) they occurred, perhaps not surprising for a landscape painter. The last page of McSwigan's 1933 notebook is an attempt to find dates for key places and events as she sought to locate his free-floating memories in historical time and space. She tracked down Joe Evans and Sam Harry, buddies from Kane's coal mining, traveling days. She also acknowledged that Kane's Scotch-Irish grammar and accent could be difficult to understand and even harder to transcribe. But once she got Kane talking, she sometimes missed the point of his ramblings. She noted ruefully that an attempt to focus on Kane's boyhood in Scotland was thwarted when he obsessed on the etymology of Irish names, which went unrecorded.[7] She missed the fact that Kane's litany of names and kinship captured his understanding of his family's history and identity.

A third strategy emerged in late 1933. On October 10, Kane spoke about his art over WCAE radio. A photograph of the event shows him seated at a table before a microphone, wife and daughter standing by. The interview ran from a prepared script, the papers visible under Kane's folded hands in the photograph. A copy of that script is preserved among McSwigan's papers, with cross-outs penciled over paragraphs she transcribed straight into the final chapters of *Sky Hooks*.[8] It provides some of his most

moving statements about art. Kane did not type, so who wrote it? The literary style of the late chapters in *Sky Hooks* differs from the informal language and tall stories characteristic of the rest of the book. Did John or Maggie Kane ask McSwigan to get his words and ideas into suitable form for radio broadcast? Or was the interview, staged in the editorial rooms of the *Pittsburgh Sun-Telegraph*, ghostwritten by that paper's art reporter and Kane friend, Penelope Redd? Clearly not a direct transcript in the vein of the interview notebooks, it emulates Mullett's final resort: finding the right words for him.

As Kane's death approached in late summer 1934 McSwigan realized the project had outgrown the article envisioned in 1932. In anticipation, she drew up a contract for Kane's signature dividing equally between them any proceeds, royalties, and revenues from the story of his life "as told by him and written by Marie McSwigan." John O'Connor Jr., of the Carnegie Institute, was to serve as referee in the event of disputes. The final sentence states, "This work has been read to me and is approved by me as the true story of my life," despite the fact that nothing, as yet, had been written.[9]

And the plan changed almost immediately. The final interview in McSwigan's fourth notebook occurred in November 1934, three months after Kane's death. The notes are headed "For novelized version on Kane," and begins "Mrs. Kane visited me today and told me more facts on K that could be embodied in a novel." Maggie described two horrifying medical interventions when the stump of her husband's amputated leg became infected and gangrenous. Then she moved on to his drinking, stating in his defense that he was never violent or abusive with his family when drunk. However, she recalled with pleasure an incident when her husband pawned her statue of "the Blessed Mother & St. Joseph" in order to buy drink, only to have the bottle smashed to bits in his pocket as he descended from the streetcar. This incident became a family legend, remembered by his daughter Margaret and memorialized in the mantelpiece figures appearing in *Daughter and Grandchild*. And then, "Once he came into the house in L[awn] Street & fell asleep drunk. She pulled him outside of house on porch. Cold and snowing hard. Began to have remorse for her act so she dragged him back inside, fearing he might freeze to death & she might be blamed."[10]

The 1935 John Kane retrospective at the Department of Labor and plans for important exhibitions in New York and Pittsburgh in 1936 changed the plan yet again. A trashy novel would undermine the market for the work of America's newly enshrined artist-worker-hero, a high priority for Maggie. That year McSwigan declared herself to be Kane's "official biographer," drawing the wrath of New York critic John Boling. Boling, familiar with the details of Kane's life and work, denounced her project in April 1935. "Already a biography has been prepared, which not only omits the dramatic facts of his life but attempts to cover up the tragic background of his idyllic pictures of escape with a patina of rose-colored saccharine." He had some choice words for Maggie Kane as well, although he sympathized with her financial woes.[11] Boling also attacked the New York art dealers preparing to capitalize on the rising market that any prominent artist's death will ignite.

Some sense of McSwigan's initial approach can be obtained from an unpublished three-thousand-word article covering Kane's life in the art world and its aftermath through 1936. Heavily edited and revised, it would morph into the *Sky Hooks* postscript. The cover page reads: "'—and Exalteth the Lowly.' How America's Number One Primitive Was Branded a Faker, a Painter over Photographs." By Marie McSwigan, Amanuensis to John Kane. Note: The true story of the house painter artist, who exhibited in the country's leading painting shows, will shortly be published by the J. B. Lippincott company. The story was dictated by John Kane to the writer."[12] The opening phrase derives from the New Testament, Luke 1:52: "He hath put down the mighty from their seats, and exalted them of low degree."

By 1937 McSwigan had the manuscript that would become *Sky Hooks* and was dreaming of movie rights.[13] After several rejections, she revised it again before J. B. Lippincott Company in Philadelphia accepted her proposal. Lippincott appointed one of its scions, this author's (Louise Lippincott's) grandfather Bertram Lippincott, as managing editor for the John Kane book. Lippincott made two demands: add a piece by New York writer and art collector Frank Crowninshield to address some of the weaknesses of the main narrative and find $2,000 (a considerable sum in those times) to cover the cost of publication.[14] Embarrassed and

desperate, McSwigan coughed up money she had been saving for a lavish Mediterranean holiday and sent a copy of her manuscript to Crowninshield. He wrote back in lofty fashion:

> You will note that I have purposely included some of the most interesting and curious phases of Kane's life and character, partly with the idea of book reviewers in mind, partly to add a little to the bulk of the book, and partly because the facts in the autobiography itself are scattered and at times a little difficult to fit into a chronology or continuing history of the events in John Kane's life. . . . You will notice that I have put the critical stuff,—things having to do with his spirit as a painter—at the end. I was afraid that if I put this material in the front the readers might shy from it, as anything like the appearance of culture has, in America, a somewhat alarming effect.[15]

The fraught issue of class and cultural differences in America inevitably colored Crowninshield's, McSwigan's and others' views of Kane the man and the artist. A friendly reporter remarked on the social divide at an opening night at Carnegie Institute in 1933, as the *Sky Hooks* interviews were under way. "Standing apart from the crowd swarming the galleries were John Kane, winner of the first honor and prize of $150, and Mrs. Kane. Bundled up in their heavy winter clothes, they listened a little diffidently to the comments that buzzed around him." In contrast, "Dark crepe gowns, frocks, and small hats outnumbered the velvets and rather formal afternoon gowns. Simple afternoon gowns and even sports costumes seemed to be the choice of most of the Pittsburgh artists."[16] Most of the information coming down to the present has been collected and interpreted by members of the velvets-and-sports-costume class intent on explaining or justifying the unusual success of a self-taught, poverty-stricken worker, as well as their own agendas, jealousies, and profiteering.

The disconnects between elite and worker languages and cultures further complicates our understanding of Kane's art, meaning, and intention as expressed in *Sky Hooks*. According to her postscript, McSwigan proposed the *Sky Hooks* title to Kane "because the tools of his lowly trade had been instruments with which to reach the stars." When Kane resisted, asking, "Why not the big beautiful

Massive stone blocks suspended from air on gossamer ropes exemplify the sky hooks concept as misunderstood by art world elites. Notice that the aesthetically pleasing angle of the crane shaft receding into the left distance does not connect with the stone blocks floating smoothly across the foreground in opposing directions. John White Alexander, *Apotheosis of Labor*, detail, ground floor frieze, 1907. Oil on canvas. Image courtesy Carnegie Museum of Art, Pittsburgh. Photo: Bryan Conley.

sky the way God made it?" she "showed him why he might be misunderstood if he used any of a half dozen titles he had written on a neatly trimmed piece of brown wrapping paper."[17] She suggests he was wise to accept her suggestion. Yet a prepublication review of the book mentions a different title: "The Way of My Life."[18] Did Kane ever accept *Sky Hooks*, as stated in the postscript, or hold out for "The Way of My Life," or are both titles of McSwigan's invention?

The *Sky Hooks* title misinterprets one of the oldest jokes in industrial worker culture. McSwigan pretended to learn about sky hooks from a Kane anecdote about a clueless greenhorn on a painting job. However, her original notes from the interview, preserved in notebook 3, indicate that Kane never mentioned

sky hooks in the conversation, and never defined them.[19] In McSwigan's published version of the story, the greenhorn tied the wrong knot on the sky hooks, risking a dangerous slip or fall. "Sky hooks are, of course, the curves of steel from which a painter hangs his scaffold," she has the artist explain.[20]

McSwigan did not know that in Kane's world, a sky hook is an imaginary rope that dangles from a cloud, with an imaginary hook at its lower end for attaching and lifting heavy objects. A traditional prank among industrial laborers is to send a novice on a wild goose chase to "fetch the sky hooks"—similarly, an apprentice painter might look for a can of tartan paint, a novice window washer would need a bucket of steam, glass hammers for construction workers, and so on. It was a common enough worker prank, custom, or initiation rite—or clueless elite gaffe—that one appears, wittingly or not, in a panel of the Carnegie Institute mural *The Apotheosis of Labor* of 1907.

To McSwigan, or her editor at Lippincott, substituting "Sky Hooks" for "Exalteth the Lowly" would replace the old-fashioned religious overtones of the earlier title with a modern industrial version of the "uplift" metaphor, more appropriate for a twentieth-century worker-artist. *Sky Hooks* suggests the aspirational parable of a humble workman laboring toward the heights of aesthetic achievement and struggling in the thin air at the top, while leaving open its cynical, emperor's-new-clothes alternative: an unsophisticated naïve hoisted by invisible forces (whether divine or commercial) into an alien universe of delusional sophisticates.[21] One goes back to Samuel Johnson's comment about another norm-busting individual: "Sir, a woman preaching is like a dog's walking on his hinder legs. It is not done well, but you are surprised it is done at all."[22]

At the same time, members of the avant-garde, some with left-wing sympathies, defended a worker-hero heartlessly exploited by sensation-seeking reporters and rapacious dealer-collectors. They were not wrong about this and McSwigan was not the only offender. The *Sun-Telegraph* would publish gruesome photographs of Kane on his deathbed, and constant rumors of an unnamed Pittsburgh industrialist lurking in wait for cheap deals, or plying him with alcohol, may be true. By far the most perceptive contemporary response to the Kane controversy acknowledges the

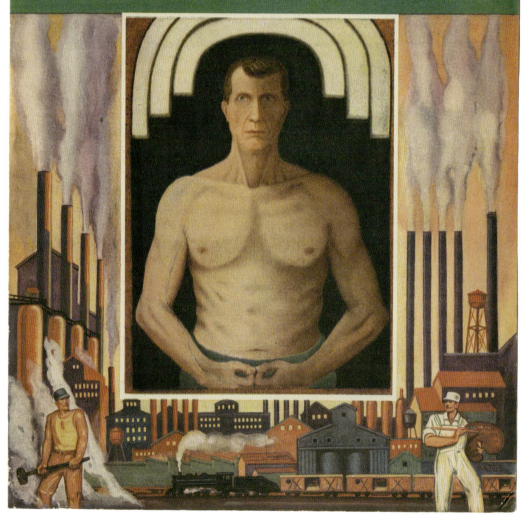

Sky Hooks dust jacket, 1938. Courtesy Carnegie Museum of Art Archives, Pittsburgh.

Samuel Rosenberg, like Kane, depicted Pittsburgh's industrial landscape from a worker's perspective. This painting's original title was *Man Made Desert*. Samuel Rosenberg, *Street by the Mill*, c. 1932. Oil on canvas. Carnegie Museum of Art, Pittsburgh. Gift of Mr. and Mrs. Charles Dreifus, Jr., in memory of his father, 62.28. Image courtesy Carnegie Museum of Art, Pittsburgh. © Estate of Samuel Rosenberg.

importance of class differences among artists in the modernist movement. It came from American painter Edward Hopper, printed in a Pittsburgh newspaper in 1933.

The question of naïve and primitive works in painting . . . has been causing hatreds and enthusiasms among artists for some time, since the advent of the so-called "modern movement." That bakers, blacksmiths and white wings [wealthy amateurs] should be "glorified" and achieve honors and recognition is, of course, a bitter thing to painters who have spent years of toil learning the painter's craft. But long years of work at the craft, while they may bring some skill, do not always bring something to say and though many competent painters have something to say a great many more have little or nothing to say. . . . The case of John Kane, the Pittsburgh house painter, is to the point. With a limited technical equipment he has created things of considerable beauty. If a painter can make known his vision with limited skill, perhaps more is excess baggage. I do not know.[23]

Sky Hooks was reviewed and publicized nationwide and McSwigan's version of John Kane's story prevailed. Over time, other titles would change as *Sky Hooks* did. Kane landscapes and city views, which he named for the slum neighborhoods he lived in or knew, were retitled to feature geographically and socially distant landmarks. Thus, *View across the Strip* became nostalgic *Old Pittsburgh*, and *Skunk Hollow*, named for a toxic industrial slum, gave way to suburban-commuter-friendly *Bloomfield Bridge*. Kane was not the only artist sanitized by and for elites. His colleague Sam Rosenberg's *Man-Made Desert* is known today by the generic *Street by the Mill*.[24]

· 13 ·

MODERNIST MYTHOLOGIES

BEGINNING IN THE 1940S ART CRITICS AND scholars celebrated artists whose style developed outside European contexts and supported the ideology of triumphant American democracy and capitalism. Sidney Janis, Holger Cahill, and others argued that twentieth-century self-taught artists connected America's tradition of rugged individualism to avant-garde trendsetters. Abandoning politics or narrative content in favor of formalism as an analytic tool, American art historians mashed up primitives, folk artists, self-taught artists, and New York moderns into a uniquely individualistic, nationalist school of art. The heroes of this story—Edward Hicks, John Kane, Jackson Pollock—were seen to transcend history.

Against this background, Carnegie Museum of Art director Leon Arkus compiled his magisterial study, *John Kane, Painter*, published in 1971. The book's catalogue raisonné format is the conventional treatment for timeless masters; Arkus elevated Kane and the home-grown American school he represented to the highest art historical status. Summarizing his view in 1972, Arkus, like Frank Crowninshield, compared Kane to Giotto, another so-called primitive who would open the way for Italian Renaissance art.[1] The book incorporates the *Sky Hooks* narrative in lieu of a critical or scholarly biography, a decision that Arkus would attempt to reverse later. Preparing for a second edition in 1987, he began a lengthy correspondence with the artist's daughter Margaret Corbett, swapping stories with a new Kane biography in mind. It never materialized, but the correspondence forms the nucleus of

147

Frank Crowninshield and Leon Arkus identified Kane and Giotto as innovative "primitives"—artists who based their work on direct observation of nature and broke with outmoded stylistic conventions. Giotto di Bondone, *Baptism of Christ* (no. 23 from Scenes from the Life of Christ). ART Collection/Alamy Stock Photo.

the Leon A. Arkus Collection of John Kane at Carnegie Library of Pittsburgh; other materials remain with Arkus's widow, Jane.

Arkus, a fan of formalism and color field painting, loved Kane's individualism, color sense, and textured surfaces. But by the late 1960s, as he was compiling the catalogue, the oeuvre was

already problematic. The artist kept no written record and few surviving works were securely dated. Comparing Arkus catalogue entries to currently available information, it's clear that he didn't see some in person, or knew them only as titles in exhibition records. In addition, Arkus had to consider the stakeholders in Kane's paintings, including his employer, Carnegie Institute, and its supporters, notably the collector G. David Thompson. Kane's practice of repeating compositions and changing titles complicated key decisions. Which version of a favorite subject appeared in certain public exhibitions? Which in a sequence came first, or might have originated before Kane self-consciously produced his important "freehand" works?

Arkus organized Kane's paintings in traditional formal categories: portraits (single and group), genre scenes, historical and religious subjects, landscapes (by location). The absence of chronology has led to misunderstandings, such as the common belief that his artistic career began in the late 1920s, and that his style never changed. Focused on Kane's fifteen minutes of fame, Arkus, like others, ignored his formative decades in obscurity and learning from his experience as a workman. Rather, he presents Kane as a precursor of New York's 1950s Bohemians—shaped by poverty, exemplifying All-American, self-made-manhood, living on the margins, and ultimately rewarded by elite New Yorkers' generous attention.

Close study of the provenances in each catalogue entry reveals a more complex story. Arkus created two categories of ownership. Under "Owners," near the top of each entry, he lists the famous collectors who bought from major exhibitions and galleries and donated to prestigious museums; the Kane estate also features prominently, along with scattered friends of the artist and some galleries. That's the myth. Drilling down toward the end of each entry, "Collections" contains the names of previous owners and a different story emerges. The first owners of at least forty Kane paintings, approximately one-quarter of his known output and more than a third of all sales, were Pittsburgh industrialist G. David Thompson (seventeen paintings) and Valentine Gallery, New York (twenty-three paintings, having bought up the inventory of Kanes when Manfred Schwartz closed Gallery 144). Arkus acknowledged

in his memoirs that Thompson was Valentine Dudensing's silent partner; thus, while Kane publicly denied reliance on dealers and commerce, privately he became heavily dependent on Thompson and his New York connections. It was not a happy relationship: Kane's daughter Margaret met Thompson in 1934 and accused him of stealing paintings, "I told him of Father telling me never to let him into his apartment, as he was a sneak, a liar, and a thief."[2]

Thompson asserted that he met Kane in 1925 while the artist was peddling house portraits in a wealthy Pittsburgh neighborhood. Thompson may have been the mysterious collector-critic who showed up whenever a journalist ventured into Kane's slum neighborhood in 1927 and 1928. He may have urged Valentine Gallery to give Kane a one-man show in 1931—a commitment the gallery hastily dropped after a brief scandal in the press. Thompson attended Kane's funeral, and may have been the expert connoisseur who appraised Kane's entire estate, approximately forty paintings, for almost no value. Then Valentine Gallery helped organize the memorial exhibitions of 1935 and 1936, when Kane prices suddenly reached and surpassed $1,000 per painting. Although the contemporary press had noted these speculations in Kane's art from the beginning, none dared mention the mysterious connoisseur by name.

· 14 ·

TESTS OF VIRTUE

EVERY CRITIC, SCHOLAR, AND COLLECTOR AFTER
Andrew Dasburg has struggled with three aspects of
John Kane's oeuvre that did not bother the artist him-
self at all: originality, regional focus, and modernity. Originality
became a problem in 1931, when a jealous competitor exposed
two works on view in a Pittsburgh exhibition as overpainted pho-
tographs. The resulting scandal forced Kane belatedly to distin-
guish photo-based art works from "freehand" paintings made
for exhibitions, galleries, and collectors. This is likely the reason
that the Kane estate's first dealer, Valentine Dudensing, recom-
mended that all of his small works and drawings be burned.[1]
Nervous scholars, collectors, and curators have felt compelled to
distinguish between "a good Kane" and "bad ones" ever since. Yet
consistent criteria for distinguishing good from bad—through
technical studies of Kane's drawings, materials, and techniques,
or systematic searches for his artistic models or prototypes—have
yet to develop.

Kane's reputation as an artist of national significance rose
and fell with the fortunes of his adopted city, Pittsburgh. Unlike
Mary Cassatt and Andy Warhol, Pittsburgh-born artists who
found success in Paris and New York, Kane stayed in town after
his breakthrough. He stuck to local subjects. These seemed na-
tionally significant when Pittsburgh was celebrated as a global
manufacturing power and the industrial landscape was a novel
phenomenon. Steel mills produced spectacles of light and scale;
railroads projected speed and power; workers starred as heroes

during labor shortages or menacing anarchists during times of labor unrest. At the height of the city's glory in the first decades of the twentieth century, a group of post-impressionists clustered around Aaron Gorson and James Bonar popularized an artistic genre that might be characterized as "industrial sublime."

But when its steel mills rusted away in the late twentieth century, Pittsburgh's national image decayed from hell-with-the-lid-off grandeur to provincial, nostalgic irrelevance at best, toxic environmental ruin at worst. Locally, the buildings and places that give meaning to Kane's compositions vanished from sight and memory. Pittsburghers continued to cherish Kane, but the market value of his work eroded gradually. Some of his reputation's decline is on this author's conscience as a long-time curator of the largest Kane collection in a US institution, Carnegie Museum of Art. Where to hang the Kanes? And how many? After 2000, his work usually went to spaces reserved for local artists; it rarely appeared in the galleries dedicated to contemporaneous "mainstream" movements such as late post-impressionism or American realism. Most scholars accepted *Sky Hooks* and the catalogue raisonné at face value and mistakenly believed there was nothing new to learn or say about a quirky local artist.[2] Then the new Andy Warhol Museum, dedicated to Pittsburgh's latest, greatest artist and hipsters in general, overshadowed Kane in the Pittsburgh region as well.

The fundamental problem for Kane's fans and critics has been that he is not—never was—a self-conscious modernist in the Alfred Barr–Museum of Modern Art sense of the term. Barr compared him, justifiably, to an Old Master.[3] Kane himself rejected attempts to label him by style or school, claiming that terms like *realist, impressionist,* or *classicist* had no meaning for him. He considered modern art the province of a younger generation. Kane became a modernist by accident, when modern artists championed him. Then modern art exhibitions featured his paintings. Modern art museums and collectors with advanced taste bought them. A great advocate of modernism compiled the catalogue raisonné. Because Kane's work doesn't fit the modernist canon in technique, appearance, or purpose, subsequent critics have cited intangibles such as its honesty and innocence, equating Kane's lack of schooling and pretension with avant-garde rejections of the academy. Or they

called out its "expression," a vague term linking his personalized subjects and unpolished techniques to surrealism and painterly abstraction. Others looked selectively to subject matter—surely portrayals of a modernizing city must be modern? They dismiss those aspects that undermine modernist interpretations, such as Kane's devotional imagery, sentimental genre scenes, obsession with detail, narrative complexity, and moralizing symbolism—ingrained from his Victorian-era youth.

Late twentieth-century scholars and dealers lumped Kane with art makers from different centuries and cultures into a field of protomodernists because their works share certain appealing formal qualities. The approach is largely abandoned now due to concern about the discriminatory overtones of descriptive terms like *other* and *primitive*. Today, they file Kane in a multicultural "outsider" box with folk, self-taught, Sunday, naïve, and vernacular artists, as MoMA considers dropping them from the modernist canon altogether.[4] But even in this fashionable context, designed to showcase rather than marginalize the undervalued achievements of women, Black, rural, and indigenous artists, Kane the surly aging white male laborer remains thoroughly out of style.

PART V

Work-life experiences informed John Kane's artistic identity and aesthetic vision long before he attempted a fine arts career. His evolution from daydreaming schoolboy to professional artist emerges in his self-portraits.

Franco-Prussian War 1870–1871: Prussian Infantry at the Charge, 1870. From the *Graphic* (London), September 3, 1870. Wood engraving. World History Archive/Alamy Stock Photo.

· 15 ·

HERO'S QUEST

THE ARTIST'S QUEST BEGAN LONG BEFORE 1927. Like Giotto before him, John Kane neglected childhood duties in favor of drawing. The drive was there from the beginning. His lifelong difficulties with standard English spelling, grammar, and pronunciation masked his interest in literature, art history, and art criticism. He studied art books, among them *Artists Past and Present* by Elisabeth Luther Cary; *The Renaissance and Modern Art*, by W. H. Goodyear; and *Angels in Art*, by Clara Erskine Clement.[1] From Sir Joshua Reynolds's *Discourses on Art* he extracted a defining message to art students: "Nothing is denied to Well directed labor. Nothing is to be obtained without it. To thine own self be true."[2] He collected verses and aphorisms that would become painting titles and inscriptions, and he took classes in speech and literature when they were free of cost.

A visual culture was there, too. His schoolboy sketches in chalk on slate depicted battles from the Franco-Prussian War inspired by popular prints or newspaper illustrations. Catholic, he was steeped in the imagery of church decoration, devotional prints, and illustrated books. He knew the Old Masters through reproductions of their greatest altarpieces. Catholic iconography and belief pervade his art, a dimension that is frequently overlooked or ignored in modernist appraisals. Kane would consistently describe his artistic vision in religious terms: "I see it both the way God made it and as man changed it."[3] He visited museums; he remembered what

When Kane saw a version of Thomas Hovenden's painting of abolitionist John Brown in West Virginia, he focused on Brown's interaction with mother and child. Thomas Hovenden, *Last Moments of John Brown*, 1882–1884. Oil on canvas. Metropolitan Museum of Art: Gift of Mr. and Mrs. Carl Stoeckel, 1897. 97.5. The Metropolitan Museum of Art, New York.

he saw. Years after stopping for an afternoon at a gallery in West Virginia, he could recall seeing a version of a Thomas Hovenden masterpiece.[4] His love of landscape originated in long childhood walks through the Pentland Hills, the Trossachs, and the city of Edinburgh; his memories of these places persisted until the end of his life. From the beginning he associated art with images of sainted and secular heroes, while beauty was to be found outdoors, in nature.

To trace John Kane's artistic development and achievements according to criteria or tests of virtue unusual in modern art history and criticism, and specific to him, one must first abandon the conventional assumption that this painter's professional career began with art school, educational travel, and immersion in a commercial or elite art world. Second, one must look in strange places for the experiences and models that did shape his artistic practice. Finally, one must evaluate Kane's work by Kane's standards: the extent to which each painting served his lifelong, personal ambition to acquire and display skill or please a friend; how these same paintings, when considered as works made for hire or sale, could provide an adequate living; and how effectively each painting tells a story or preserves a memory. These motivations, internal or external, sometimes in conflict and sometimes complementary, outweigh the academic modernist expectations by which Kane's work has been understood and evaluated in the past.

As a painter, John Kane was a great boxer. His most ambitious self-portraits display his body stripped and flexed as if for a boxing match. He began boxing in the 1880s. First boxing, then art served as his favored after-hours occupation, because to him they had much in common. Shortly after his marriage, his attic art studio doubled as the local boxers' training gym, the ultimate man-cave. He would use one term, "handy," to describe his skills with fists and brush.[5] Painting and boxing are performative displays of skill with a prize as a possible goal. Fine art, like boxing, is competitive and individualistic, with referees, judges, juries, and audiences deciding winners and losers. Rules ensure a fair fight; fame is the reward. Kane feared nothing in both endeavors. As

John Kane, *Along the Lincoln Highway*, 1933. Oil on canvas. Gift of the Estate of Richard M. Scaife, 2015.2. The Westmoreland Museum of American Art.

a boxer he was known as "Jack the Giant Killer." When he finally entered juried art competitions in 1925–1926, Kane's boxer mentality got him through setbacks and knockdowns and drove him to victories.

His art education started with a job in 1890–1891 paving Pittsburgh streets, such as Fifth Avenue going toward Oakland. Paving taught him about design, composition, pattern, and movement. At the turn of the century the big blank canvas of

an empty roadway was dynamically structured by the tracery of streetcar rails. The road's central highpoint descending gradually to its edges to facilitate water runoff defined the street's basic triangular cross-section. The flow of water and traffic would become central to Kane's landscape compositions. Intersections and crossings establish a grid. Block paving consisted of filling the grids and traceries with stone blocks that had been selected to create the correct pattern of overlapping joints. Kane prided himself on his ability to find just the right size stones to fill a space. Many observers have connected the numerous examples of block paving and masonry walls in Kane's canvases to this moment in his life, but none has noted that Kane laid out entire landscape paintings as if they were city streets. He animates a canvas's flat surface with dynamic transportation lines (railroad and trolley tracks, roads, rivers); he fills the voids between with trees, fields, gardens, walls, windows, stones. Summing up his life's work and story, Kane himself would state, "I have made my picture and tried to fill it in."[6]

Along the Lincoln Highway is a typical product of Kane's street-paving/art composing process. The view can be recognized as a stretch of Route 30 along the Juniata River near Everett, Pennsylvania, from a color 1920s postcard that served as a model or aide-mémoire for the artist. Kane adopted the basic outlines of road, river, hills, and bridge as portrayed in the postcard. In his painting, the road and river function like the streetcar lines in a Pittsburgh street by carrying the viewer through the landscape. For the details, Kane's imagination takes over. Distinctly patterned flower gardens, tilled fields, apple orchards, stone walls, and green meadows make up the "blocks" he has selected to fill in between the lines. The elaborate mansion in the center of the composition acts like a visual streetcar stop, where the eye, like a weary traveler, comes to rest, lingers, and notices that each window has a different set of curtains, each suggesting a different human story.

Forty years later, Kane still associated drawing with paving. "When my back wasn't hunched over blockstone, at lunch, or some other time, I would get out my pencil and make drawings."

An example of complex block patterns and streetcar lines in downtown Pittsburgh. Flat streets flanked by rising buildings echo the shapes of hills cut by rivers, the landscapes Kane found most beautiful. Pittsburgh City Photographer, Street Closed to Through Traffic, 1908. Identifier: 715.08880. CP. University of Pittsburgh, City Photographer Collection.

Street paving and pencil drawing are both monochromatic, two-dimensional, linear visual activities. "[Beauty] is all over, everywhere, even in the street on which you work," Kane remarked.[7] A shift in focus from schoolboy fantasies to a consciously observed and structured real world seems to have begun during his time paving. Kane's surviving drawings, loose renderings of isolated motifs from late in his career, suggest that, pencil in hand, he was finding just the right "block" to fill a compositional void. As a house and decorative painter decades later, he would continue to divide flat surfaces—floors, walls, and ceilings—into zones of different patterns, textures, and colors. A

Lincoln Highway and Juniata River at Everett, Pennsylvania, 1920s. Color
postcard. Author's collection.

relevant postcard depicts the elaborate lobby of the Nixon Hotel
in Butler, Pennsylvania—a room Kane most likely decorated in
1909 and which may have inspired the room decor of his late
self-portraits.[8]

 After working as a paver, "the next job I had," Kane stated,
"was the one that contributed most of all towards my artistic work.
I became a painter."[9] Painting railcars for the Pressed Steel Car
Company circa 1899–1903 taught him color mixing, brush work,
lettering, and fine detail skills. He was extraordinarily proud of
his ability to create any color from mixtures of red, blue, yellow,
white, and black, and his homemade color wheel survives at the
American Folk Art Museum. Continuing his lunchtime art prac-
tice, he painted landscapes and portraits on the flat surfaces of
boxcars as breaktime entertainment. "I recall how I used to sketch

the boys at work while sitting atop a boxcar. I would yell to one of them, 'Hold still, move over,' and soon I would have them down on paper. And I still like to wear overalls when painting."[10] As he rode his burgeoning skills to the top, he was given the trickiest job of all: retouching others' work to secure final approval and payment for the crew. His coworkers teased him about becoming an artist painting for the galleries. Kane recalled that after his supervisor caught him, "I thought he treated me a little differently after that."[11] Art might rescue him from the anonymity of an industrial laborer's life.

Railcar painting imposed a new order on Kane's artistic practice: layering. The technique is visible in all versions of an early work, *Lincoln's Gettysburg Address*. The initial, lowest layer is a raw steel boxcar, or a blank board or canvas. The next layer is primer on the boxcar, ground color on the blank canvas. In the *Gettysburg Address*, an earth color serves as primer for the golden topcoat. Boxcars were usually red, the cheapest color. These layers precede the portrait image: a steelworker on the boxcar, Abraham Lincoln on the canvas. (Supervisors demanded the steelworker images be covered up.) The final design layer positioned the car's lettering and logos; Kane lettered in Lincoln's famous speech in the voids around the portrait. He would have learned design transfer techniques such as stenciling and scaling up at this step. Touching up—revisiting a work to perfect its finish and details—in Kane's experience constituted the highest order of technical skill and the final layer. He never minded touching up another's boxcar work, despite offers of better pay for less interesting but more responsible jobs. He spent inordinate amounts of time on tiny details (such as microscopic window curtains) in his own compositions, and he titled his retrospective self-portraits, constructed around the *Gettysburg Address* painting, *Touching Up*. He learned to draw like a street paver and paint like a steelworker.

From 1899 to 1927 Kane painted on the side, on spec, and on commission for fellow workers, bosses, and contractors. This was his "contemporary art world." Portraits were the easiest sell, despite his lack of skill and experience in figure painting. He started

The luxurious Nixon Hotel burned in 1909. John Kane encountered his estranged wife there while painting the ceiling of the renovated interior. *Lobby, Nixon Hotel, Butler, Pa.*, c. 1909. Color postcard 403,251. Nixon Brothers, publishers. Author's collection.

with informal sketches of his boxcar comrades. After 1904, often when strikes or financial crashes limited job opportunities, he made images of people, their loved ones, and their homes in oil or pastel for money. He could earn as much as twenty-five dollars for a portrait, the equivalent of two or more weeks of conventional labor. He recalled that many commissions memorialized lost loved ones such as children, spouses, or soldiers who died young. Few if any of these early portraits are known today, although numerically they must form an important percentage of his lifetime output. First, Kane asked a prospective client to think about loved ones and their memories. From there, it was a short step to requesting a photograph as the basis for a commissioned portrait. He would send the photograph to Chicago to be copied

John Kane, *Boxcar for Budweiser Beer*, n.d. Graphite on paper. Image courtesy Carnegie Library of Pittsburgh.

and enlarged. Soon thereafter, Kane would deliver a hand-colored bromoil print, return the original photograph and, hopefully, receive payment.

The practice of hand coloring photographic enlargements, usually with pastels, had been common since the 1880s as a quick, cheap alternative to "real paintings." Although the best can still deceive experienced eyes, the anonymous colorists never achieved status as independent artists. As one would expect from photographs, the sitters pose stiffly and conventionally. Critics usually pass such works over in silence, but Kane viewed them as

The adoption of PRESSED STEEL CARS Assures larger net earnings per train-mile and longer life for the cars. The Pressed Steel system of construction distributes the metal along theoretical lines, making all sections of uniform strength, thus securing a maximum load with a minimum dead weight.

The use of PRESSED STEEL UNDERFRAMES For wooden cars, not only reduce the present cost of maintaining, the draft rigging, underframe and car-body at least 80 per cent. but practically eliminate sagging center sills; leaky roofs, bulging sides and improperly fitting doors are thus reduced to a minimum.

PRESSED STEEL CARS OF ALL TYPES. WOODEN CARS WITH PRESSED STEEL UNDERFRAMING

PRESSED STEEL SPECIALTIES.

PRESSED STEEL CAR COMPANY.

NEW YORK. PITTSBURG. CHICAGO.

Foreign Agents: Transportation Development Co., No. 6 Clements Lane, Lombard Street, London, E. C., England.

Boxcars and gondola cars. Illustration from *Official Proceedings of the Pressed Steel Car Company* (November 1901).

important vehicles for memory and stories. "Now I have stories innumerable to tell of these people and their rejoicings and their sorrows. Theirs were the tragedies that follow poor people everywhere."[12] For him, as for many in predominantly oral cultures, recognizable images anchored memories, names, and stories and transmitted shared values and family histories.

A comical transaction with a mill girl in Butler illustrates Kane's pragmatic adaptations to the demands of these patrons and his own limitations. With living subjects, the challenge was to capture the sitter's self-image or aspirations as well as likeness. In this case, he followed usual procedures, but the sitter instantly rejected his work because her hair appeared insufficiently golden and curly. Kane hid in a nearby shed where he created a coiffure "like metal" and curly beyond all possibility in nature to satisfy his client and get paid for his work.[13] Making art for money taught

John Kane, *The Gettysburg Address*, c. 1930. Oil on Masonite. Carnegie Museum of Art, Pittsburgh: Gift of the McGivern Family, 2005.66.1.B. Image courtesy Carnegie Museum of Art, Pittsburgh.

him how to mimic the work of professionally trained artists, or deviate from the visual truth, when circumstances demanded. It also hooked him on the use of photographic images when he needed to create a recognizable likeness.

Kane learned how to make bromide photographic prints while working in Butler circa 1904–1905. As he explained to Marie McSwigan in 1933, "I was working in the coal mines when I learned to do this on the side at night. I learned to photograph in this way when I was in the car shop at Butler. You put the picture in the sun [and] the rays of the sun reflect a shadow on the board or whatever you want it on. *It is art all the way through.*"[14] The bromoil process, developed around the same time, enabled enlargement of the image and its modification by inking and coloring, and was a preferred medium for pictorialist photographers. The treated gelatin surface would rapidly absorb colored inks and paints, as the half-cleaned *Dad's Pay Day* reveals. Even as the oil paints dissolved under mineral spirits, the underlying pigmentation, crosslinked with the substrate, endured. Kane would paint over bromoil prints for the rest of his career. However, their purpose changed, becoming part of his creative process rather than an end in themselves. The best surviving example of Kane's evolving practice is a series of views of Mount Mercy Academy; the first is a conventional oil painting dated 1927, the second is a painted photographic reproduction considerably altered in background and foreground. The third version is a photographic reproduction of the second painting, partially overpainted with a radically different arrangement of buildings in the distance.[15]

Kane acquired a Kodak box camera by the winter of 1928, and McSwigan preserved eighty small gelatin silver contact prints on Velox paper in their original envelope from Eastman Kodak Stores, Inc., 606 Wood Street, Pittsburgh. Her note on the envelope reads: "John Kane's own photos taken by him in his box camera for reference in ptg."[16] Many prints carry inky fingerprints or smears of red or black paint, as do Kane's working drawings. Each is stamped on its verso with a batch number (altogether, twenty-two batches); three styles of numerals and notations suggest that Kane used different stores to print various batches. Two batches reproduce ten Kane paintings in varying states of completion, four of them otherwise unrecorded.[17] The remaining prints show landscapes. The earliest that can be securely dated

are two batches representing an elm tree taken in the winter of 1928–1929, following an October 1928 news article about the tree, and preceding exhibition of Kane's painting of it in spring of 1929. The painting is a literal representation of the tree, in keeping with Kane's established practice of basing portraits on photographic images.[18] While the purpose might have been the same, Kane's practice was changing. Box cameras are portable, which meant that Kane didn't have to copy the leafy image in the news article; he could take his camera out to Crafton and make his own view of the tree's skeletal, by then leafless structure. The portable camera would transform his approach to landscape by freeing him from reliance on published views or his own drawings for compositions and significant details. The remaining batches reveal the artist walking around selected motifs—a tree, a steel mill, a bridge—or shifting his perspective across distant horizons, looking for just the right element for a composition. In this respect, the photographs function like his drawings. Many can be associated with his most original and personal landscape compositions, suggesting that he may have brought out his camera for subjects not available in readymade images such as postcards. Thus, in preparation for his Coleman Hollow landscapes, Kane photographed a view comprising an obscure amusement park and a distant workhouse—but he centered the image on the space between them, which would become crucial to the symbolism of the finished painting.[19] The newfound freedom, the sense of movement through the landscape conveyed in these ambitious paintings, may be attributed to the camera's ability to capture the sense of Kane's wanderings.

Whether painting boxcars, patriotic decorations, office walls, or photographs during his first two decades as a professional painter, Kane's practice derived from industrial labor methods and processes. News photographs suggest that even as his artistic career progressed and he flashed paint tubes and fancy palettes in some self-portraits, he continued to work with house paints and palettes made from scraps of building materials. He achieved success—recognition and earnings from his peers and bosses—by working quickly, neatly, and consistently to make images that were

One of several photographs of an elm tree serving as the model for *The Old Elm* (Metropolitan Museum of Art, NY). John Kane, *Elm Tree in Crafton, Pa.*, 1928–1929. Gelatin silver contact print. Collection of Mary McDonough.

The blurred foliage on the right indicates Kane may have climbed a tree to make this view. John Kane, *Steel Mill*, c. 1928. Gelatin silver contact print. Collection of Mary McDonough.

John Kane, *River View with Barges*, c. 1928. Gelatin silver contact print. Collection of Mary McDonough.

The configuration of buildings, street, and tracks corresponds to the perspective in Kane's Old Saint Patrick's Pittsburgh (p. 253). John Kane, *Rail Tracks and Bluff*, c. 1928. Gelatin silver contact print. Collection of Mary McDonough.

This view, published shortly after completion of John White Alexander's *Apotheosis of Labor*, features scantily draped winged women offering the gifts of civilization to a steel-plated knight floating upward on clouds of industrial smoke, generated by toiling industrial workers in the (unseen) ground floor frieze below. *Carnegie Library. Lobby of Art Gallery, Pittsburgh, Pa.* Color postcard, albertype process. Albertype Company. Author's collection.

pleasing, cheap to produce, recognizable, and easily replicated. Yet he was not satisfied; the gap between his skills and his aspirations—to match the art he saw in galleries and capture the beauties he found in people and landscape—was enormous. The conventional solution was art school, new skills, and different values. Art school entailed financial hardship, social dislocation, and many unknowns. Despite encouragement and opportunities in Cleveland and Pittsburgh, Kane never went. Instead, he looked for work with better crews.

Kane's application for a job assisting renowned muralist John White Alexander in the execution of *The Apotheosis of Labor*, a

Fletcher, a Scots-born house painter, AAP member, and friend of John Kane, was another Pittsburgh-area workman with dreams of a fine arts career. Alex Fletcher, *Rejected*, c. 1934–1936. Oil on Masonite. Carnegie Museum of Art, Pittsburgh: Gift of David T. Owsley, 78.26.7. Image courtesy of Carnegie Museum of Art, Pittsburgh.

three-story decoration at Carnegie Institute, circa 1907–1908, must have seemed a logical next step in his quest for artistic mastery. He had learned drawing and painting by joining outdoor labor crews and working as a house painter. He was familiar with Carnegie Institute, having painted interiors for W. J. Holland, the director of its museum section (natural history collections), in 1905.[20] Why

Kane collaborated with Heathcock, a sign painter by trade, on the production of Block House views for the Pittsburgh sesquicentennial of 1908. Heathcock may have hired Kane for his contracting business; they reconnected as members of the AAP. Unknown photographer, *John Kane Visiting in Walter Heathcock's Studio*, c. 1932. News photo. Courtesy Carnegie Museum of Art Archives, Pittsburgh.

not take the next step with a fine art crew in the Institute's new building? The mural's novel, relatively realistic representation of workers must have appealed.

Alexander considered the application and declined politely a week later. This moment has gone down in history as an elite artist's rejection of an obviously unqualified worker. However,

posterity has overlooked the skills that worker had acquired independently and missed the importance of Alexander's project for Kane's developing artistic vision. For example, it may have widened his ambitions, as family members would later recall him painting life-size murals of cows and Highland dancers (not together) on fences and walls at the Lawn Street house where they lived at the time. The mural was the single most important representation of industrial labor in Kane's world. His application to join the crew making it was his first, fearless test of elite art world norms. No doubt he would have pointed out the problem with the sky hook panel.

Eventually Kane found a new set of sparring partners, or another crew, or possibly the art world's equivalent of the Knights of Labor, when, late in life, he joined the Associated Artists of Pittsburgh. Its leadership in the 1910s and early 1920s, artists Aaron Gorson and James Bonar, had pioneered the local industrial sublime; Gorson and Bonar even went so far as to portray themselves in the guise of steelworkers (which Scots émigré Bonar had been). The AAP sponsored an annual exhibition that rivaled the Carnegie International in regional popularity and probably outdid it in sales. Kane exhibited multiple works every year and sold many. More importantly, he interacted with experienced professional artists, including Martin Leisser (who may have encouraged Kane to take classes at the Carnegie Institute of Technology, now Carnegie Mellon University), Sam Rosenberg (who taught "freehand drawing"), Milan Petrovits and Christian Walter (not fans), among others.

For many AAP members, fine art was an avocation rather than a trade or profession and in this respect Kane fit right in. A 1932 news article documents his reunion with his former boss and painting partner Walter Heathcock, also an AAP artist.[21] Alex Fletcher, a Scots-born professional house painter like Kane, became a friend. Members and jurors of the society bought his work. Edward Hopper awarded him prize money. He mastered perspective, he learned to paint shadows and reflections, to scumble and glaze. He learned "freehand" drawing from accomplished teachers. Surviving drawings include studies of nudes. His canvases grew bigger, the compositions more elaborate. AAP members

would have been a rich source of casual technical advice, useful role models, and relevant paintings to study. They brought him up to speed on current trends in art. Like the sparring partners of his youth, Pittsburgh's AAP artists prepared him for the juried exhibition ring.

Milan Petrovits cleaned away John Kane's paint from the left half to reveal the underlying photograph. John Kane, *Dad's Pay Day*, 1931. Oil on paper on board in original frame. Collections of Mary McDonough. Photo: Tom Little.

· 16 ·

COMEDY AND TRAGEDY

WINNING ADMISSION TO THE CARNEGIE International exhibition in 1927 was the biggest victory of John Kane's life and career. At first, fame excited him. He sent paintings to an exhibition at Horne's Department Store in 1928 and allowed them to advertise his daily presence in the galleries. He posed for photographs at home, at work, and at galleries for the local and national press. He advertised for a "first rate painter" to partner on house-painting jobs, expecting more contracting work or hoping for time off to paint more pictures. He approached an assistant professor at the Carnegie Institute of Technology (now Carnegie Mellon University) for advice on advanced training.[1] His most ambitious self-portraits date from these years, and may be considered as expressions of his newly unleashed ambition and pride.

Then the roof fell in. Maggie Kane's permanent return, probably in 1928, brought new pressure to earn. Returning home from a visit to Carnegie Institute in February 1930, John broke several ribs in a streetcar accident, and reinjured them in a fall at home in October. The second injury landed him in Saint Francis Hospital.[2] His daughter Margaret recalled him drinking heavily during this time as he attempted to work and paint while in severe pain. His poor health, plus a rent increase and loss of house-painting jobs due to the Depression, caused financial distress, which the papers covered as avidly as his previous triumphs. The conventional rags-to-riches fairytale didn't seem to be working.

Well-intentioned outsiders tried to help. John O'Connor, Jr., of Carnegie Institute, probably egged on by G. David Thompson, persuaded New York dealers and museums to show his work and helped with promotion.[3] O'Connor landed him spots in prestigious group shows in Boston, and the swanky Pittsburgh Junior League offered a one-man exhibition at the women's club headquarters in 1931. No other Pittsburgh artist received such extraordinary attention; most would have to be satisfied with representation at a brief summer art fair and/or a local benefit group exhibition where paintings could be traded for bread or soup rather than money.

Desperate for money, Kane accepted the exhibition opportunities without considering how to fulfill competing demands from high-visibility patrons. Marie McSwigan reported that on average he might execute about eight paintings in a twelve-month period.[4] Before 1931 he participated in two or three exhibitions annually, never showing more than eleven paintings in a year. Output and potential sales roughly matched. In 1931 he sent forty-three paintings to four exhibitions; not surprisingly he reverted to his industrial-era practice of painting over photographs, repurposing casual keepsake images, and churning out duplicates of favorite subjects to meet the unprecedented demand. The pain from broken ribs would have hampered his mobility and stamina, one possible reason so many paintings from this moment are small. Fellow artists at the Associated Artists of Pittsburgh had noticed a dropoff in the quality of his work.[5]

McSwigan, wearing her society-publicist hat, puffed the Junior League show with a feature news story offering fulsome praise and the temptation of nude pictures.[6] An article in the weekly *Bulletin Index* asserted that acceptance by local high society represented the pinnacle of artistic success. Milan Petrovits, fed up with all the attention showered on his upstart colleague, demonstrated that one of the Junior League paintings, *Dad's Pay Day*, was a hand-colored photograph by removing the paint from its left side. He denounced the artist and his practice as "unethical." As art world scandals go, it was a tempest in a Pittsburgh teapot. Museum officials, art critics, and collectors rallied to Kane's

A typed label on the verso reads: "Here is Kane with all his belongings moving. Note hat from my wardrobe—a bit large coat and tie from same source." Paintings too large for the trunk are wrapped in newspaper and lean against the side panels. Unknown photographer (David Craig?), John Kane seated on trunk in back of truck, c. 1931. Courtesy Carnegie Museum of Art Archives, Pittsburgh.

defense; his admissions to prestigious exhibitions continued, as did his sales. The Junior League extended the run of the show to satisfy rampant public curiosity, and Kane's embarrassment was short-lived, although financial instability continued to haunt him. In April 1932 he wrote to Homer Saint-Gaudens, "I am all mussed up throug moving untill we go to our happy homes above So I will keep on struggling along the wayside to keep the Pot Boiling for Mrs Kane."[7] In 1933 another artist's prizewinning AAP submission was also revealed to be painted over a photograph, and his prize money was awarded to the second-place finisher, John Kane. The ensuing uproar forced Edward Hopper, one of the judges, to consider the difference between Kane and the rest.

The two AAP scandals bookended the *Sky Hooks* project, the one occurring just before, the other toward the end, of the interview process. The consequences of these events, thanks to the lengthy self-justifications in "Exalteth the Lowly" and *Sky Hooks,* have dogged Kane's reputation and discouraged efforts to understand his creative method ever since. Jane Kallir began to set the story straight in her well-researched 1984 exhibition catalogue, noting that many early twentieth-century artists integrated photography into their working processes; avant-garde artists of the era were even incorporating photographs directly into prints and collages.[8] Kane's practice was not materially different from many of his contemporaries'; however, his reputation as an unschooled "primitive" may have encouraged critics to treat his use of photography as a crutch rather than a tool.

Modernist prejudices have also discouraged serious engagement with Kane's subject matter. How Kane chose to portray himself over time, and the paintings he selected for his ultimate competitive arena, illuminate his story, achievements, and failures. A close study of Kane's self-portraits and his submissions to Carnegie International juries, then, may help crack open that studio door a bit further and allow us to not only glimpse how he worked but also comprehend what he had to say. We can see how he developed ideas as well as compositions through iteration and expressed them in symbolic terms based on contemporary industrial labor culture. The themes that emerge are unique

to Kane: the champion worker, the alliance between music and memory, the urge to escape, dreams of family and home, and the value of a good story. Like his judge and juror Edward Hopper in personality, self-isolation, poverty, and dedication to the uncelebrated, overlooked moments in American life, Kane had much to say.

John Kane, *The Girl I Left Behind Me*, c. 1927. Collection of Janice and Mickey Cartin.

· 17 ·

MIRROR, MIRROR

"'I would like to see the Devil,' he said.

"'Look in that glass.' I pointed to the mirror."

John Kane remembered this interchange as a barroom conversation.[1] The drinkers seem to have reached a low point in their progress through the evening, although Kane told Marie McSwigan they were still sober. In the Irish folktale "Stingy Jack," a down-and-out fellow matching Kane in name and behavior meets the devil in a bar and gambles his soul for a few free drinks. Despite its folkloric quality, McSwigan positioned this moment in the final chapter of *Sky Hooks*, on art and religion, as evidence of Kane's awareness of human sinfulness. It is one of the rare moments of vulnerability Kane, or McSwigan, reveals to the reader. It's the key to understanding Kane's many self-portraits.

Kane's self-portrait in an undated drawing, possibly the earliest to survive, describes the aftermath of a night of heavy drinking. He drew himself as one of three figures facing a magistrate in Pittsburgh's Oakland Police Station on December 12, 1918. Standing at left, he holds his hat in his left hand and confesses his crime: "This is the stewed prune that tried to drown the fire with whiskey." The central figure, the arresting officer, swears: "This man lives at 56 Lawn st he has been drinking Gets drunk She send for me to arrest him." On the right, Mrs. Kane testifies, "He wont stop drinking and we can't do nothing. I want him to stay away and do for himself." The magistrate rules, "I will give him 10 days to sober up but you keep away from her." At far right, two officers or bailiffs announce, "Jail."

At first glance, the drawing with its inscriptions seems cartoonish. Yet the figures are smartly observed: Kane abject and a bit wobbly, the officer straight and upright, Mrs. Kane a large and formidable object (relative to her true physical size) firmly delineated. The magistrate functions as Stingy Jack's devil in the mirror consigning him to ten days in hell and separation from his family after losing the drinking bet. The room itself is drawn in simple perspective. Two paintings, a clock, and an American flag decorate the walls; the flag, straight from the background of *Lincoln's Gettysburg Address,* is waving indoors.

For all its crudeness as a drawing, *Oakland Police Station* is a brilliant work of storytelling. Kane embeds a story in each body, physically and literally. The figures freeze in character when the verdict comes down. As a document of Kane's figure painting practice, *Oakland Police Station* alerts us to the possibility of underlying stories in other figural subjects, including self-portraits. Moreover, it raises a question about Kane's purpose in recording and preserving the most difficult facts of his life in art. Art making as a therapy for mental and behavioral problems was in common use by the late nineteenth century; patients were encouraged to draw their memories, dreams, and visions to assist with diagnosis and treatment—or exorcism. Furthermore, Kane's art making would conform to Catholic belief in the value of a well-examined life and the sacrament of confession. It would also keep him away from bars.

At least eight self-portraits by Kane survive today. The famous half-length nude in the Museum of Modern Art, in New York, is a masterpiece of American art. The rest have languished outside the modernist spotlight or disappeared or been misidentified. They share a dominant compositional device—the artist depicts himself staring at an image reflected in a mirror or painted on a canvas. Deeply absorbed in his vision, he seems oblivious to the audience. All, including the MoMA work, have been misdated and/or misidentified in the Arkus catalogue and subsequent scholarship. This essay attempts to reconstruct the group by analyzing in detail the visual content of each known and possible self-portrait. Matching the paintings to original Kane titles as recorded in his inscriptions, McSwigan's interview notebooks, contemporaneous

news articles, and exhibition records comprises the second step. The corrected titles—of great personal importance to the artist—drive the interpretation of each work, while the correlated news events and exhibition dates provide secure endpoints for their evolutions.

Kane included two self-portraits among the four paintings he submitted to the Carnegie International in the fall of 1927. Institute records list *The Girl I Left Behind Me* and *Before and After* among the works rejected.[2] Leon Arkus believed that both works were lost and suggested that *The Girl I Left Behind Me* might be a nostalgic farm scene, and *Before and After* might be a double portrait of Kane's nephew Patrick Cain, known only from a photograph.[3] In point of fact, the titles correspond to the Kane self-portraits in the Cartin Collection: the little-known seated image inscribed "The Girl I Left Behind Me," and the enigmatic double profile Arkus miscatalogued as *Seen in the Mirror.*[4] Because both works predate Kane's sudden elevation to the International, which occurred shortly after the jury submission, they shed some light on his artistic practice and self-image up to that moment. They also predate the return of Maggie Kane and reconciliation with his family.

Art historian Judith Stein assigned the portrait inscribed *The Girl I Left Behind Me* a possible execution date of 1920 given Kane's youthful appearance and the awkward perspective.[5] However, when the painting appeared in the ill-fated Junior League exhibition of 1931, it was titled *Seated Self Portrait as a Lad in Scotland*, which Arkus had logically but mistakenly associated with the painting called *My Grandson*. McSwigan's preview of the Junior League show sorts out this puzzle by describing *The Girl I Left Behind Me* as a seated self-portrait depicting Kane's concept of himself as "a young lad just come out of Scotland." It's a good example of Kane's association of life events with place rather than time, and his use of art to re-create memories. Kane, sitting right next to his wife during the 1931 interview, told McSwigan that *The Girl I Left Behind Me* "is the one who had all the luck."[6]

"The Girl I Left Behind Me" is the title of a classic folk song popular in Ireland, Britain, and America from the eighteenth century or before. Kane learned it in Scotland as a member of a boys'

marching band; the painting's title identifies the song he plays on his tin whistle. Soldiers and sailors sang or played it when marching off to war; an Irish adaptation called "The Rambling Laborer" is even more appropriate to Kane's life experience. In the first verse of a common version, the departing hero/singer swears fidelity to the girl he will soon leave behind; the second verse describes where he thinks he might be going: "Then to the east we bore away / to win a name in story / and there where dawns the sun of day / there dawned our sun of glory." Substitute "west" for "east" and it describes Kane's migration from Scotland to the US. The dark clouds parting behind him reveal his "sun of glory," a future in America. Winning "a name in story" describes ambitions he would pursue as a worker, boxer, and artist. A likely inspiration for the "glory" and the cherubic onlookers, a Renaissance painting of a miraculous event he would have known from books, suggests the scope of his dream. Two girls floating above the clouds like Renaissance cherubs in modern dress might represent his sisters Julia and Sarah, whom he left behind in Scotland in 1880–1881, or his daughters Mary and Maggie, who endured repeated separations from their father after 1904. The composition's deviation from the song's singular "girl" may reflect Kane's ongoing feelings about the realities of his marriage.

The traditional early date of the double self-portrait *Before and After* (catalogued by Arkus as *Seen in the Mirror*) is confirmed by the submission of a painting with that title to the 1927 International jury. Careful study of the two profiles reveals differences that should not be dismissed as failures of the artist's skill. They also justify the title. On the left side one sees a glaring, lined, battered visage, and on the right a cleaner, calmer, more youthful face. The profile of the nose, bulbous or straight, is the giveaway. Kane does not tell us which event in his life separates *Before* from *After*. It's also not clear if the grim profile on the left is a reflection in a small mirror (such as a shaving mirror) or a framed portrait or photograph. *Before and After* suggests that Kane recognized that his internalized self-image or memory of himself as a powerful, handsome youth (as depicted in *The Girl I Left Behind Me*) might not match others' perceptions based on his external appearance—that of an itinerant, one-legged laborer in his mid-sixties, a fighter after too many blows to the face. Mary Mullett, meeting him in early 1928,

noticed "a face worn and lined, almost haggard," and graying hair.[7] Others have described Kane's dual nature. Pittsburgh art critic Douglas Naylor memorialized him as "a lovable old character, as gentle as he was pugnacious."[8]

Kane's inscription in the lower right corner provides moral depth: WAD THE POWERS TE GIVEFT TO GAE US TA SEE OURSELS AS ITHERS SEE US. "To see ourselves as others see us" underlines the paradox of a self-portrait in profile—how does one see one's profile so as to paint it? Try this in mirror; it's impossible. Most self-portraits are, of necessity, full-face or three-quarter views. Kane may have solved the problem using his bromide technique to capture his profile in silhouette. On the other hand, his predilection for profile and frontal poses and dependence on photographs for recognizable likenesses hint that police mug shots might have provided his model. By 1905 US police departments, including Pittsburgh's, had adopted the French Bertillon method of identifying arrested persons' appearances with profile and full-face photographs and meticulous measurements of key physical characteristics (not so different from today's digital surveillance methods). Fingerprinting would not be adopted until the 1930s. Kane's multiple incarcerations, suicide attempt, and jobs in army camps and munition factories during World War I would call for several Bertillon cards.

The event separating Before from After is still a mystery. John Kane, *Before and After*, c. 1927. Collection of Janice and Mickey Cartin.

In *Before and After* Kane looks for sides of himself he cannot see. Inside the paradox and the joke is a moral lesson. The handsome

right-hand profile confronts his devilish alter ego, rather like the angels and demons described in chapter 5 of Clara Erskine Clement's *Angels in Art* (1899), or Stingy Jack and the devil in the mirror. "To see ourselves as others see us," inscribed in the lower right, is a quotation from Scotland's national poet, Robert Burns. It begins the final verse of his marvelous poem "To a Louse. On Seeing One on a Lady's Bonnet, At Church," dated 1786. The poem's subject is the moral value of close observation and self-knowledge. In "To a Louse" the poet observes the back of the head of an elaborately bonneted lady—a side of herself she cannot see. Admiring her adornments, the poet notices a crawling insect of which the lady is blissfully unaware, and his initial attraction turns to disillusionment and moral philosophizing. We are not as fine and beautiful as we might think or wish to appear. Kane would apply this moral concept to landscape painting as well as self-portraiture. His scenes capture the beauties of sky and terrain adorned with superficial human additions like roads, bridges, and buildings, and the tiny accidents and details, too easily overlooked, that betray our fallibilities and tell a story.

In October 1927 Kane suddenly entered the world of elite artists exhibiting in the Carnegie International, and in 1928 or 1929 his wife returned after a ten-year absence. The remaining self-portraits reveal his response to these life-altering events: miraculous rescue, hard-earned success, or wages of sin? The moment launched a long process of retrospection, re-evaluation, obsessive self-observation, and the emergence of a new persona.

That process may have begun with another misidentified self-portrait that stylistically and thematically seems to initiate Kane's transition from reprobate industrial laborer to nationally recognized fine artist. Marie McSwigan noticed it on her first visit to the Kanes' rooms in October 1932. "He has a trench helmet and army rifle hanging over a picture in the hall. I wonder where he got them and what they signify. Remember his self portrait in a soldiers uniform 'If We Could See Ourselves as Others See Us,' he calls it."[9] Kane had attempted to enlist in the army at the start of World War I but served the war effort building barracks and torpedoes at home; his fictitious self-portrait in uniform combined with a soldier's trophies evoke his lifelong desire for hero status, "a name in story"—whether as a worker, boxer, soldier, or eventually, artist.

The painting that McSwigan probably saw in the hallway may be the work known only from a photograph that Arkus identified as a double portrait of Kane's nephew and mistakenly associated with the exhibition history of *Before and After* above.[10] It shares its reference to the verse from "To a Louse." For this image, a Bertillon card may have served again as the foundation for the profile view, dressed up in army uniform, and the frontal view with neatly coiffed hair, immaculate shirt and tie, and tailored jacket. Based on what is known about Kane's personal appearance, it is unlikely he ever donned either outfit in real life. Rather, he is adding a new persona—successful artist-entrepreneur—to his private vision of wartime heroism. The title, *To See Ourselves as Others See Us*, addresses Kane's Catholic guilt if, indeed, these fantasies of heroic virtue disguise, literally, a photographic record of his worst moments.

Arkus dated the small version of *Touching Up* circa 1927, noting its presence under that title in an Associated Artists of Pittsburgh exhibition in February 1928. The painting's date corresponds to the exhilarating rush of fame and attention Kane experienced during the run of his first Carnegie International. Kane's facial features come straight from the left (aged, devilish) profile of *Before and After*. The perspective of the picture frames, receding on a diagonal to left, conflicts with the two-point perspective of the room space, reminiscent of the uncertain spatial relationships and framing in *Before and After*. The meticulously grained floorboards advertise Kane's primary, soon to be former, occupation as a house and decorative painter. The cleaned-up painting room and the artist's genteel dress and demeanor, similar to the tidy civilian in *Too See Ourselves*, indicate that some "touching up" has already occurred, possibly in anticipation of Mrs. Kane's impending return; note the laundry escaping the dresser drawers. The artist holds a brush and conventional artist's palette, although contemporaneous photographs show him mixing his paints on scrap wood. He gazes fixedly at an incomplete rendition of *Lincoln's Gettysburg Address*. Lincoln stares back.

This time, there's no song title or quotation to reveal the story. *Lincoln's Gettysburg Address* is mostly blank canvas awaiting its final layer of lettering. Instead, Kane narrates through the paintings on the walls and easel, a tactic he would repeat to guide McSwigan's

John Kane, *Touching Up 1* (small version), c. 1927–28. Kane Estate. Image courtesy Kallir Research Institute, New York.

Sky Hooks interviews a few years later. From left to right we see the outer edge of an unidentifiable genre scene (possibly a Highland dancer or playing child), a view of *Mount Mercy Academy* (a Pittsburgh school for girls run by the Sisters of Mercy); a farm scene called *Escape from the Workhouse*; a landscape view of a private Pittsburgh estate; and a copy of *Christ in Gethsemane*, a popular Catholic devotional work.[11] Kane had submitted the *Mount Mercy* view and a version of *Christ in Gethsemane* to Carnegie Internationals in previous years, so he must have considered them good measures of

his artistic skill; the estate view may have been a house portrait executed on spec. The three support his credentials as a professional fine artist and proper Catholic. It is very much about how Kane wished others to see him following his first International triumph.

We know the title of the centrally positioned painting, *Escape from the Workhouse*, because Kane lettered it carefully on another version.[12] The scene focuses on a large dapple-gray horse galloping away from a pursuing human and a barnlike building. The animal's massive proportions and distinctive markings identify it as a Percheron, a powerful European breed of draft horse. It's a worker, like John Kane. Its spirited flight across the field expresses the liberating joy Kane experienced whenever he took off to make drawings in the hills after workdays in underground coal mines or hellish, toxic factories. Pittsburgh art critic Harvey Gaul would remark that *escape* is "a happy word for John."[13] In his 1935 condemnation of *Sky Hooks* and art world speculators, John Boling mentioned escape as an important theme for Kane's art.

The phrase "from the workhouse" adds another layer of personal meaning. Horses live in barns; sick, poverty-stricken, addicted, and mentally ill humans lived in workhouses and poor farms, remote prisons for the desperately poor. Kane had been committed to one in 1899 and his stepfather, Patrick Frazier, died, abandoned by his family, in the same place around 1901.[14] Kane experienced another hospitalization in 1909 and jail in 1918. *Escape*'s central position in *Touching Up* highlights incarceration as an indelible memory in Kane's life, possibly the moment that separates *before* from *after* in his double self-portrait of about the same date. It may also have served as a pointed rejoinder to his returning wife. This painting, more than any other surviving record, expresses Kane's joy at the prospect of escaping the constant threat of imprisonment, disability, and poverty while pursuing the activity he loved. It is another self-portrait.

Why is *Lincoln's Gettysburg Address* on the easel? Why did Kane feature one of his oldest, least typical works? According to *Sky Hooks*, *Lincoln's Gettysburg Address* was one of the few early paintings still in Kane's possession at this stage of his life.[15] His first *Gettysburg Address* painting—several are recorded and three or four

John Kane, *Escape*, c. 1930. Oil on canvas. Private collection. Image courtesy Kallir Research Institute, New York.

survive—may have originated as a prototype for a mass-marketable patriotic souvenir. Its boxcar execution process would generate an industrial-style product—consistent, quick, cheap, and easy to manufacture in replica. Kane learned the business model while painting block houses for Walter Heathcock during Pittsburgh's 1908 celebrations of the 150th anniversary of the surrender of Fort Duquesne. Five years later, 1912–1913, his first *Gettysburg Address* coincided with national celebration of the 50th anniversary of the Battle of Gettysburg.

Attributed to David R. Craig. John Kane leaning on unfinished canvas of
Escape, 1930. Courtesy Carnegie Museum of Art Archives, Pittsburgh.

This work is far more than a practical solution to the chal-
lenge of earning from art, however. Understanding the layers of
meaning Kane built into *Lincoln's Gettysburg Address* begins with
his admonition, "Look in the mirror." The artist in *Touching Up*
looks at *Lincoln's Gettysburg Address* as if at the mirror, and Abra-
ham Lincoln looks back. Kane replaces Stingy Jack's devil or a
police record with a more positive role and heroic self-image. The

glances don't quite meet in the goofy perspective of *Touching Up 1*; he would get it right in the later version. The visual connection matches Kane's personal identification with the famous American president recounted in *Sky Hooks*. "I believe he was a healthy young robust fellow like myself, in his young days and mine. He started life as I did, without anything except what he got for himself. He had no schooling but what he worked for. . . . And so I have always thought he was pretty much like myself. . . . Now Abraham Lincoln put his heart and soul into everything he did. That, of course, is foremost too in the artist's life."[16]

Kane's words and images suggest that he revered Abraham Lincoln and identified with him as a Catholic reveres and identifies with a patron saint, his antidote to the devil's temptations. In *Sky Hooks* he asserted that the Gettysburg Address "became like scripture to me."[17] Kane was not unusual in venerating Lincoln at this time (Lincoln was the focus of patriotic cult in the early twentieth century), but his mode of expression is unique. The *Address*'s gold ground, stylized portrait, and black letter inscription derive from traditional devotional paintings depicting saints and martyrs. A practicing Catholic, Kane would have seen examples— mostly copies of gothic and Renaissance gold-ground images—in local churches even before he found the originals in art galleries and library books. Portraying Lincoln as a saint and martyr to the American cause would make sense to someone with Kane's grounding in Catholic practice and visual culture. It also explains why Kane used this special format for Lincoln only. Painting such an image would be an act of devotion, replicating it for fellow believers was a religious duty, contemplating its subject is good Catholic/patriotic American practice. *Touching Up* tells the story of how John Kane created an American icon, very much in the way Saint Luke, brush and palette in hand, inspired by a vision, painted the first icon of the Virgin and became the patron saint of all painters.

An example of the commemorative imagery likely to have inspired *Lincoln's Gettysburg Address*. Lincoln Centennial Souvenir, 1909. Embossed color postcard. E. Nash, publisher. Author's collection.

· 18 ·

SOUL OF A CHAMPION

JOHN KANE'S ART WORLD REPUTATION PEAKED in 1929. A veteran of two Carnegie Internationals, he could no longer be dismissed as a fluke. The Museum of Modern Art exhibited Kane paintings in four separate exhibitions that year. He had been accepted into the ranks of the Associated Artists of Pittsburgh, and as its only member admitted to the International, could claim to be Pittsburgh's leading artist. He was certainly its most famous. In response, he exhibited two life-size self-portraits, both nudes. He was about to turn seventy, the biblical "three score and ten."

The famous self-portrait acquired by MoMA in 1939 is a mirror view. Kane exhibited it in the AAP exhibition opening at Carnegie Institute in February 1929. An extraordinary news photo showing the artist in his Sunday best conferring with his painted self documents the event, the painting's correct title, and date of completion. *Seen in the Mirror* continues the painter-painting relationship of *Before and After* and *Touching Up*. However, the title alerts us to a difference as well—this image is taken from life rather than a photograph. It announces the artist's growing skill, ambition, and sophistication. Kane would show it again at the Junior League exhibition of 1931 as *John Kane in the Looking Glass*; it was received

◄ John Kane titled this painting *Seen in the Mirror* for a 1928 exhibition, and *John Kane in the Looking Glass* in 1931. John Kane, *Self-Portrait*, c. 1929. Oil on canvas over board. Abby Aldrich Rockefeller Fund, 6.1939. Digital Image © The Museum of Modern Art/Licensed by SCALA/Art Resource, NY.

John Kane and his self-portrait at Carnegie Institute. P & A Photo. *Des Moines Register*, March 10, 1929. Newspapers.com.

with embarrassed silence in the local press. Just before his death in 1934, Maggie Kane seems to have objected to its confrontational facial expression and he added a grimacing smile in water-soluble paint, which dealer Valentine Dudensing cleaned off when the work passed through his gallery in around 1935.[1]

Leon Arkus suggests that *Seen in the Mirror* was under way as early as 1927. Quite possibly it originated as a life study where, like many figure painters with limited funds, the artist used himself as the model. Marie McSwigan might have seen a work in progress during a visit to Kane's room at 1711 Liberty Avenue shortly before the October 1928 Carnegie International opening. She remarked, "The man's eyes are at times mirrors of reflected sadness.

Doubtless he feels that with training he could have given the world a rare gift. Perhaps another Mona Lisa or Last Supper. But circumstances were against him. And now, even in his heyday of recognition, stingy Fortune holds tight her purse strings. But a man who dreams dreams when he is almost penniless is something more than a great genius. He is primarily a hero, a man staunch in faith, dignified in faith, dignified in his crucifixion."[2] In spite of her off-base musings on what-might-have-been and money, McSwigan got three things right about the John Kane represented in *Seen in the Mirror*: his knowledge of grief and sorrow, his ambition to emulate the greatest artists of the Renaissance, and his Catholic acceptance of human suffering.

Black-and-white photographs and illustrated books found in public libraries were a source of information and ideas for artists unable to travel. Albrecht Dürer, *Self-Portrait as Man of Sorrows*, 1522.

Crucifixion can mean Christian suffering in general or the iconic moment from Christ's Passion, his death on the cross. Certainly, a quotation from the book of Job, a case study of faith and suffering prefiguring the Passion, applies to Kane and his self-portrait. "Naked came I out of my mother's womb, and naked shall I return thither: The Lord gave, and the Lord has taken away; Blessed be the name of the Lord" (Job 1:21). The Catholic concept of believers standing "naked before God" implies Christian acceptance, repentance, and humility in the face of divine judgment. In Catholic art, a naked human figure represents the soul.

The most likely Catholic prototype for Kane's self-portrait is a drawing by German Renaissance artist Albrecht Dürer from 1522 (formerly in the collection of the Kunsthalle Bremen; destroyed in WWII). In contrast to the Ecce Homo images that show Christ half nude, undergoing public humiliation, Dürer's work represents

endurance and dignity through suffering. "He is despised and rejected of men, a Man of Sorrows, and acquainted with grief" (Isaiah 53:3). Christ as the Man of Sorrows presents the physical evidence of torture and crucifixion, agonies endured on behalf of others. Dürer's *Self-Portrait as the Man of Sorrows*, which Kane would have known from book illustrations or the Carnegie Library's extensive public photo archive, is a half-length nude figure of unflinching honesty.[3] The slumping flesh of an aging man, the scattered hairs on arms and chest, gnarled fingers loosely curled, are common to the Dürer and the Kane and result in each case from painstaking observation of physical realities. Yet both men look up and out into another world. The ambiguous triple arc above Kane's head might allude to the form of architectural niche or apse that typically encloses images of saints in Gothic and Renaissance-style churches and paintings. A possible modern prototype Kane might have seen in person, Thomas Eakins's *Crucifixion*, matches his brutally honest approach to the male nude, although the artist is not the model. It would be typical of Kane to challenge the greatest realists of the Renaissance and modern times at just this moment in his artistic career.

Modernist critics have proposed secular interpretations of *Seen in the Mirror* despite its Old Master and Catholic overtones. Recent scholars have plausibly referenced Kane's boxing career, and the popular imagery of champion fighters stripped for battle, such as Jim Corbett (whom Kane once sparred against) or John Sullivan, as the inspiration for the composition and the basis of Kane's self-image.[4] One can easily imagine the artist flexing in front of his mirror, studying his veins, musculature, and skin, as if preparing for a fight or recalling the bouts of his youth. In this case too, Eakins got there first.

Frank Crowninshield believed that Kane showed himself as a laborer washing up after a day's work; Leon Arkus would repeat

▶ Famous for portraits and male nudes, Thomas Eakins was recognized as America's greatest artist during Kane's lifetime. John Kane might have seen this painting on view in the 1900 Carnegie International. Thomas Eakins, *Crucifixion*, 1880. Oil on canvas. Philadelphia Museum of Art: Gift of Mrs. Thomas Eakins and Miss Mary Adeline Williams, 1929-184-24.

John Kane might have seen this painting on view in the 1899 Carnegie International. Thomas Eakins, *Salutat*, 1898. Oil on canvas. Addison Gallery of American Art, Philips Academy, Andover, Massachusetts, gift of anonymous donor, 1930.18. Photo: Addison Gallery of American Art, Philips Academy, Andover, MA/Art Resource, NY.

the suggestion in the catalogue raisonné. In that case, the triple arc above John's head painted from strips of linen cut by Maggie may represent the deco ornamentation of the mirror's surface. Kane would have noticed and appreciated the coincidence of modern and medieval framing devices. Washing hands—cleansing away the marks and dirt of manual labor before stepping up to a fine arts studio—fits the upwardly mobile mindset of *Touching Up 1*. Mine and mill workers washed in boshes (troughs used for cooling or cleaning work tools) in factory settings, or outdoor tubs before entering their homes. According to labor historian Peter Shergold, access to indoor washing facilities (possibly with larger mirrors) differentiated skilled and unskilled American laborers in the early twentieth century.[5]

Hand washing was the opening ritual at meetings of the Knights of Labor, the dominant American labor organization that Kane joined shortly after his arrival in the United States. Feudal knights' initiations began with ceremonial baths. The Knights of Labor washing ceremony honored workers' hands as sources of skill, power, and livelihood. The left hand was known as "the shield," while the right hand held a working tool, a metaphorical lance or sword. Kane's grasp of palette/shield and brush/lance in *Touching Up* evokes the metaphor. Every Knights meeting began with a hand ritual called the Sign of Obliteration. With hands held low, elbows close to the sides, members would "place the palm of the right hand on the palm of the left hand . . . then separate the hands, right and left as if wiping something off the left hand with the right." The meaning of the sign is "to erase, obliterate wipe out, everything on entering here, as the draughtsman erases useless lines."[6] Kane's hand position in *Seen in the Mirror* mirrors Dürer's in the same way that a Knights of Labor initiate would mirror the ritual gestures of the Master Workman.

Kane also knew a secular precedent for presenting himself as a worthy laborer seeking to rise. He saw shirtless industrial laborers toiling in the ground floor frieze of John White Alexander's *Apotheosis of Labor* mural every time he entered Carnegie Institute. Unlike the stark realism of Dürer's and Eakins's suffering Christs, these laborers display model-perfect bodies posed to simulate physical exertion. Viewers of all walks of life would recognize

Diego de Velázquez, *Apollo at the Forge of Vulcan*, 1629. © Madrid, Museo
Nacional del Prado.

them as ironworkers both mythic and real. Pittsburgh's ironwork-
ers' union was named Sons of Vulcan, and industrial artist Gerrit
Beneker, in a *Time* magazine article, traced the origins of its visual
imagery to a baroque masterpiece, Diego de Velázquez's *Apollo
at the Forge of Vulcan* in the Prado Museum.[7] It is conceivable that
Kane, as a maimed workman, identified with the master artisan
of classical mythology, also lame in one leg. On the second floor
of the Alexander mural, skilled construction workers in shirts and
overalls build the modern city while up above a floating knight
receives symbols of wealth and victory from scantily clad flying
ladies. On the top floor, well-scrubbed Pittsburghers march to a
better future. How many workers, Kane included, must have seen

John White Alexander, *Apotheosis of Labor*, detail (workers), ground floor frieze, c. 1907. Oil on canvas. Image Courtesy Carnegie Museum of Art, Pittsburgh. Photo: Bryan Conley.

that floating knight and those godlike workers as the embodiment of labor union ideals, heroic visions connecting industrial workers' hellish lives to a better future?

Christian suffering, abysmal working conditions, heroic labors, and physical violence were every industrial worker's lot in the late nineteenth and early twentieth centuries. Kane's peers would have recognized his layered allusions to the "tragedies in the lives of poor people" in *Seen in the Mirror*. In sum, Kane merges the suffering Christ, the master workman, the glorified knight of labor, the intimidating boxer, and his own self into the archetype of a modern champion of the working poor: fighter, winner, leader, representative, and advocate.

Kane may have sent the half-length *Seen in the Mirror* to a secondary regional venue, the February 1929 AAP annual exhibition, because he was preparing an even more ambitious work, a full-length figure of himself, for the prestigious Carnegie International exhibition opening in October. He submitted the full-length nude to the International jury under the title *Three Score and Ten*, corresponding to his age in 1929.[8] The jurors accepted an industrial scene, *Homestead*, and rejected *Three Score and Ten*, *Through Coleman Hollow*, and a view of the University of

Pittsburgh's Cathedral of Learning, although rules would allow up to three works per artist. Some of the subsequent silence surrounding the fate of *Three Score and Ten* reflects local embarrassment about the official decision not to show the painting in Pittsburgh in 1929, but to inject it into the national cultural debate over modernism—elsewhere.

Following the jury's decision, the Carnegie Institute art department's business manager, John O'Connor Jr., finagled an invitation to show two of the rejected works at an exhibition in Boston opening just before the International. A group of Harvard students, including John Walker III, a sophomore from Pittsburgh, had created the Harvard Society for Contemporary Art as a venue for exhibiting and promoting avant-garde modernism, and had already shown Kane works in their spring exhibition. The autumn project, featuring artists based in New York City, had no obvious place for Kane (who probably never set foot in New York), but the curators, including Walker, found space for *Through Coleman Hollow* and *Three Score and Ten.*

O'Connor had the work professionally packed and shipped to Boston. He told *Pittsburgh Press* reporter McSwigan what he had done. "The Harvard show opens tomorrow. . . . Unless I am greatly mistaken John Kane's Self Portrait will cause about as much excitement in Boston as 'Strange Interlude' and 'Farewell to Arms,'" he said to her. As he had demonstrated in 1927 when he dropped hints about the controversial new artist in that year's International, O'Connor had a nose for the sensational news event. McSwigan looked forward to an outraged reaction from "the lorgnettes and lace mitts in a land of conservatism and correctness."[9]

Boston in 1929 was notorious for the activities of its Watch and Ward Society, a highly effective civic organization dedicated to eradicating modernity in all its most exciting and troubling aspects. Nudes and sexuality were taboo, also profanity. Ernest Hemingway's *Farewell to Arms* and D. H. Lawrence's *Lady Chatterley's Lover* both got "banned in Boston" in 1929. O'Connor anticipated a similar reaction to John Kane's *Three Score and Ten.* That may have been the aim of the exhibition organizers—college students, after all—or of O'Connor seeking to keep his protégé in the spotlight.

The painting was installed, and the exhibition opened on October 17 for a two-week run.

Whatever the motivations of the exhibition organizers and contributors, it fell flat as a news event. Anthony J. Philpott, the *Boston Globe* art critic, published the only review known to this author three days before the show closed. He gave Kane the most of his brief attention. "There are two paintings here by John Kane, the house painter who won the first prize at the International Exhibition in Pittsburg [*sic*], last year. One is a life size nude portrait of a man 70 years old who looks as if he had been in an auto or a railway accident. It is not a pleasant picture. The landscape—'Through Coleman Hollow'—by this artist is an interesting bit of scenic painting—simple in color and topographically well done." This brief, dry description confirms the painting's subject, the wooden leg, the title, and its presence in Boston in October 1929.

Three Score and Ten made a deep enough impression to color Philpott's characterization of the exhibition in general. "As far as the paintings are concerned it will be found that the ordinary ideas of harmony and beauty in color and line have not been a consideration with the artists. They evidently strive for something else—for a kind of self-expression which, as a rule, seems to reflect a melancholy emotion or a mental state in which a scene or an object calls up something void of luminosity—*a thing rather stark in its naked crudeness*."[10] The *Art Digest* gave it a mention (as *Self Portrait*) in their November issue, and the *Pittsburgh Press* published a silly cartoon and an Art Note: "House-painter John Kane's portrait of himself in the altogether will be, or is, in the Boston exhibition," more than two weeks after the exhibition had closed.[11]

The silence from Boston mystified everyone in the know. Crowninshield believed that the painting never went on display on the grounds that it was too extreme even for Harvard students. A year later, gearing up for another International, McSwigan attributed its failure to snobbism, while revealing her own: "Boston was unprepared for a person of Kane's type." Pittsburgh art critic Penelope Redd, a thoughtful supporter of modern art, pointed out that "John Kane's 'Self Portrait' is a whimsical reassurance when compared with the disturbing humans painted

(*Left*) John Kane, *Brother Patrick*, c. 1928–1929. Oil on canvas. Chrysler
Museum of Art, Norfolk, VA. Gift of Walter P Chrysler, Jr., 71.664. (*Right*)
Raking light image to show textural changes. Photo: Mark Lewis.

by the German [Otto] Dix." She considered it a vanguard work in the new trend toward simplicity in modern art, and relatively uncontroversial.[12]

Although Crowninshield and McSwigan describe the full-length self-portrait in *Sky Hooks* as if each had seen it, each got it wrong. Crowninshield called it a profile and possibly Kane's greatest painting; McSwigan described a three-quarter view. He imagined leather straps attaching the leg to the body, she described superficial anatomical details probably extrapolated from *Seen in the Mirror*.[13] They agree that Kane covered it with another figure of Kane's older brother Patrick. Arkus omitted it from the catalogue raisonné, only remarking that a full-length nude self-portrait was thought to exist under the figure of Patrick. He assigned its title, *Three Score and Ten*, and its exhibition history to a small genre scene.

Mark Lewis, paintings conservator at the Chrysler Museum, Norfolk, has recently studied the physical makeup of the original canvas, retitled *Brother Patrick in the Uniform of the 42nd Highlanders*. His findings, summarized below, confirm the presence of an underlying figure.[14]

> The original painting support consists of two canvases spliced together near the overall horizontal center with an approximately eight-inch-wide canvas insert in the join;
>
> spliced edges are deliberately cut in a zigzag or sawtooth pattern, possibly with a sharp knife.
>
> Cuts are 1 ½ to 2 inches in length, short and controlled (this technique is used in wallpapering to make a join or repair less conspicuous).
>
> An underlying figure exists and seems to match the form of brother Patrick in size, frontal view, basic pose.
>
> Extensive overpainting is visible in raking light in areas of Patrick's legs, forearms, proper right hand, and head.
>
> Present-day lining and stretcher are later additions to the original canvas.

Kane transformed his self-portrait by disguising the wooden leg, raising the forearms and hands to support the bagpipes, and

(*Left*) John Kane, *Brother Patrick*, composition changes visible on painting surface. Photo: Mark Lewis. (*Right*) John Kane, *Three Score and Ten*, 1929. From Monroe Wheeler, *20th Century Portraits* (The Museum of Modern Art, 1942).

overpainting the face to resemble Patrick playing a tune (perhaps "Wha Saw the 42nd," another Kane favorite). Uniform and bagpipes cover the nude figure and the original's plain background is decorated with trees, green leaves, and two rabbits. Rabbits may evoke Kane's memories of chasing them with his brother in Scotland, as well as the song's verse describing the 42nd's practice of foraging as they marched.

As this essay approached completion, Pittsburgh collector Patrick McArdle pulled out his copy of *20th Century Portraits*, by Monroe Wheeler (1942), and flipped to page 98, revealing a photograph of *Three Score and Ten*, solving the mystery of the painting's original appearance. The two seams on *Brother Patrick* are visible on the left edge of the photograph. Kane's body fills the entire canvas, matching his height to its dimensions. His stance is frontal, and the pose of the upper half of the body conforms to the earlier half-length. A pair of briefs such as what a boxer would wear preserves modesty. The proper left leg is well muscled, and what remains of the right is narrower, in part due to the constricting, corset-like structure attaching the wooden leg to his body. Yet the effect is very different from the heroic persona of the half-length. The face appears emaciated, the eyes sunk and shadowed, the arms relaxed rather than flexed, the hands schematized. The lighting has shifted too; now the artist's proper right, weaker side is in shadow. The image, full frontal and fully symmetrical, recalls anatomical diagrams, funerary sculpture, and the grimmer renditions of Ecce Homo or Christ in the Tomb. Again, the Book of Job seems relevant: "Naked came I out of my mother's womb, and naked shall I return thither."

Kane's titles matter, and it matters that he never called any of his representations of himself a "self-portrait." In this he was bucking (or oblivious to) three hundred years of art criticism and Western art history dating back to Rembrandt, as well as common practice in his own time. Kane's titles suggest stories, with the result that many of his self-portraits have been confused with genre scenes. When *Three Score and Ten* is inserted into the chronological sequence of Kane's self-portrait titles, it becomes the next significant landmark along a well-considered "way of my life." *The Girl I Left Behind Me* remembers his hopeful departure from Scotland

for America. *Before and After* commemorates a life-changing event predating 1927. *Touching Up* celebrates his elevation to fine artist status and return to married respectability. *Seen in the Mirror* is an assertion of mastery and ambition, the vision of a twentieth-century Saint Luke. *Three Score and Ten* is about facing the limit of his allotted time.

A workman born in 1860 had an average life expectancy of 39.4 years in America.[15] In August 1929, shortly before unveiling *Three Score and Ten*, Kane entered his seventieth year; twelve months later he turned seventy. Three score and ten, or seventy, is the traditional biblical human lifespan, and until recently a good approximation of its biological upper limit as well. "The days of our years are three-score years and ten; and if by reason of strength they be fourscore years; yet is their strength labor and sorrow; for it is soon cut off, and we fly away" (Psalms 90:10). "Labor and sorrow" are also the themes of *Seen in the Mirror*. In the conversation with McSwigan about *Three Score and Ten* just preceding its debut in Boston, Kane quoted William Shakespeare on old age: "Nor with unbashful fore-head woo / the ways of weakness of debility; / therefore my age is as a lusty winter, / Frosty but kindly."[16] He was the last surviving member of his generation in the Kane family. Enjoying success and respect in his new profession, in interviews and conversations he expressed his desire for many more years of productive life.

Philpott said only that *Three Score and Ten* represented the seventy-year-old survivor of a train or automobile accident. In the foreword to *Sky Hooks*, Crowninshield called the wooden leg "maca-bre," and McSwigan emphasized it as well. Both described anatomi-cal details, also present in *Seen in the Mirror*, that suggest that for both paintings Kane studied his body as he would a street or a landscape. His figure's veins, sinews, and muscles correspond compositionally to the streetcar rails and stone blocks from his paving days, or the rivers, roadways, and hills in his rural views. Minutely observed body hairs make up the final touchups on the top layer. The artificial leg is a truthful representation of the man-made element in this human landscape. "I see it both the way God made it and as man changed it," applies to Kane's body as well as his environment. His wooden leg exemplifies the violence done to human bodies and the natural world in the course of an Industrial Revolution.

Another unconventional self-portrait linked to Patrick appears in *Bubbly Jock*, an undated work, more like a keepsake than an exhibition picture, not shown in Kane's lifetime.[17] Whatever its date of execution, *Bubbly Jock* marks the first of Shakespeare's seven ages of man or John Kane's stages in the "way of my life." The artist depicts himself as little more than a baby ("Jock" was a common nickname for Jack), a full-face parody of his mature whistle-playing self, blowing on a tin whistle beside future bagpiper Patrick, who howls in protest. The title comes from the Scottish name for a male turkey, the calls and squawks of which no doubt resembled the noises emanating from baby John's tin whistle.[18] Kane uses music to make a fond joke about a lullaby gone wrong, in contrast to the brave marches that would pace their separate adult lives.

Kane's musical connection to his Scottish heritage and his family, expressed in *The Girl I Left Behind Me* and numerous manifestations of brother Patrick and his bagpipe, are key to understanding his Highland dancers.[19] The series begins with scenes of children dancing in rural settings, possibly Scotland, an experience Kane and his siblings must have remembered with joy. The loss of his leg and mobility seems to have heightened his memories. Kane described playing his tin whistle for imaginary dancing girls (the children in the accepted painting) in 1927 in celebration of his first admission to the Carnegie International. It's a fling, not a march; it's a party, not a departure. Over time, Kane added more context and detail. The setting changes from vaguely Scottish to Pittsburgh's Kennywood Park and its annual Scotch Day, timed to coincide with Scotland's Saint Andrew's Day holiday. The Patrick figure and kilted elders guide the children's steps. The title of one of them, *Scots Wha Hae*, is a Burns poem set to music and the Scottish national anthem.[20] Music and art transmit more than personal memory, they transmit an entire culture.

The large version of *Touching Up* (*Touching Up 2*) is the least controversial of Kane's self-portraits. It first appeared in the 1931 Junior League Exhibition. The room in the painting is paneled, and walls are decorated with a stencil pattern. Since the Ophelia Street rooms Kane inhabited at that point were decorated with floral wallpaper, the walls and floor in *Touching Up* must illustrate his decorative painting skills, recalling the Nixon Hotel. The artist

John Kane, *Touching Up 2*, c. 1931–1932. Oil on canvas. Carnegie Museum of Art, Pittsburgh: Gift of Thomas Mellon Evans, 72.58. Image courtesy Carnegie Museum of Art, Pittsburgh.

wears tailored workman's overalls, far more flattering than the stained baggy covering visible in a 1929 photo. His pose echoes a prominent worker figure in Alexander's *Apotheosis of Labor* from the second floor of the mural, which is dedicated to skilled construction workers. But his worker's garb may also have been intended to advertise that, due to money problems, he was considering a return to house painting. Kane has modeled his profile on the younger, straight-nosed self from *Before and After*. Paintings hang in proper perspective on the side and back walls. They include the fancier

version of *Agony in the Garden* and the view of *Mount Mercy Academy,* as well as portraits of a man and woman, and a Scottish view from Kane's childhood memories. *Escape from the Workhouse* has disappeared. *Lincoln's Gettysburg Address* is almost finished, corresponding better to the title, *Touching Up,* the final phase of his creative process. Full of allusions to his artistic origins and development, it captures him midlife as a house painter and itinerant artist. The big picture of his life is formed. He's perfecting the details. As he would say in *Sky Hooks,* "I want to paint my story and let it speak for itself."[21]

Although Arkus dated *John Kane and His Wife* to circa 1928, it may well be later; Kane based the scene on a staged news photo first published in October 1929.[22] A more likely execution date would be closer to 1931–1932. Maggie Kane's dresses suspended on hooks between the doors match McSwigan's inventory of the Kanes' final dwelling rooms at 1700 Fifth Avenue, where they

Kane's self-image in *Touching Up 2* closely resembles the overalled worker on the right of this panel. John White Alexander, *Apotheosis of Labor,* detail, second floor, c. 1907. Oil on canvas. Image courtesy Carnegie Museum of Art, Pittsburgh. Photo: Bryan Conley.

Photo by Pittsburgh Sun-Telegraph

JOHN KANE AT WORK AS HIS WIFE WATCHES IN HIS SMALL HOME ON A RAINY DAY

John Kane, three successive times admitted to the International Exhibit and this year the only resident Pittsburgh painter whose work was hung, at work on a canvas in his tiny home as Mrs. Kane sits and watches. He is a house-painter and you'll notice he's wearing his over-alls. On this day, it was raining and he was driven to his canvas while losing his wages.

News photos sometimes reveal Kane's sources for paintings or capture a stage in his work process. John Kane painting with Mrs. Kane looking on, c. 1928–1929. Image accompanying "When It Rains, He's An Artist," *Pittsburgh Sun-Telegraph*, October 21, 1929. Newspapers.com.

moved in summer 1931. Maggie hovers nearby in her role as . . . inspirational muse? recording angel? watchful supervisor? silent witness? Perhaps John is reenacting his first memories of drawing battle scenes at school, when "a lot of little girls had left their seats behind me and had come crowding around to look over my shoulder at the picture I was making."[23] The 1928 photograph shows a Kennywood subject on the easel but in this self-portrait he replaces it with a scene evoking a family farm. He may have viewed the motif of harnessed draft horses as a symbol of married or

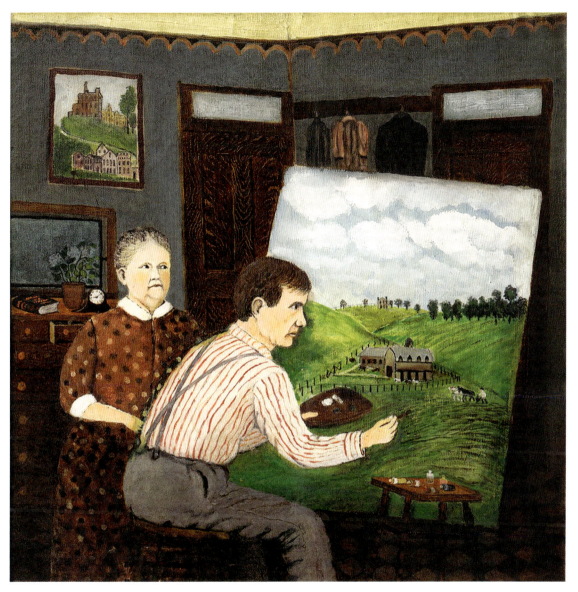

John Kane, *John Kane and His Wife*, c. 1932. Private collection. Image courtesy Kallir Research Institute, New York.

family life, the hardworking, domesticated version of the charging Percheron in *Escape*. It also suggests that his unsuccessful attempts to own and operate a small farm, first in Butler and later in Akron,

John Kane, *Pietà*. Oil on canvas. Carnegie Museum of Art, Pittsburgh: Bequest of Paul J. Winschel in memory of Jean Mertz Winschel, 71.13. Image Courtesy Carnegie Museum of Art, Pittsburgh.

arose from his and/or her dreams of escape from the transient lifestyles of wage laboring to land ownership, self-employment, and settled family life.

The *Pietà*, signed and dated 1933, is Kane's last known self-portrait. Urged by Carnegie Institute's curator of prints and

A framed black-and-white photograph of this painting, Enguerrand Quarton's *Pietà*, hung in the Carnegie Library during John Kane's lifetime. Enguerrand Quarton, *Pieta of Villeneuve-lès-Avignon*. Louvre, RF 1569.

drawings Edward Duff Balken, Kane based it reluctantly on the magnificent *Pietà of Villeneuve-lès-Avignon*, circa 1455, attributed to Enguerrand Quarton, well photographed after its discovery in 1904. A standard subject in Catholic art, a pietà represents the Madonna grieving over the body of the crucified Christ—a mother and her dead son—shortly after deposition from the cross and preceding the entombment. Quarton adds a mourning saint on each side. The praying male figure in the left foreground is a portrait of the donor whose gift paid for the painting. Such gifts or endowments might be motivated by a donor's gratitude for a service provided by the church, or as atonement for past sins and

hopes of salvation after death. As was customary treatment for a mere mortal, the donor occupies a distinctly different space than the biblical characters and appears not to see them; his prayers are directed to heaven. An elaborate church appears beyond the Madonna's proper right shoulder.

The Kane version is not a pure copy. Kane updates the setting to Pittsburgh's Oakland neighborhood, with the University of Pittsburgh's Cathedral of Learning under construction on the left, Saint Paul's Cathedral (the mother church of Pittsburgh's Catholic diocese) framing the head of the Madonna, and the globe-crested roof of Carnegie Institute to the right. Their presence invites interpretation of the scene as a personal allegory. The donor's facial features and dark hair resemble Kane's, the Madonna's stricken face is more twentieth-century Maggie Kane than fifteenth-century Madonna. The two young mourners on either side might represent the Kanes' daughters Mary and Margaret, completing a portrait of Pittsburgh's Kane family centered on grief for the only son, whose death in 1904 shattered Kane's life. The artist's desertion of wife and daughters on the night of that death would be a sin hard to forgive. As he said of portraits of lost loved ones he had painted for others, "theirs were the tragedies that follow poor people everywhere."[24] Kane, in the role of penitent donor, with the central group but not fully of it, prays for redemption and salvation and offers the painting as a legacy. Unbeknown to his family, Kane was also building a legacy for them in a bank account he kept secret from his improvident wife.[25] After his death, in keeping with medieval Catholic tradition, Maggie Kane offered the painting to Mercy Hospital, a charitable Catholic organization, in recompense for the medical care provided during her husband's last illness.[26]

PART VI

John Kane's submissions to Carnegie International juries confronted a workman-artist's skills and values with the expectations and standards of the modern art world. Viewing Kane's Carnegie International landscapes in light of his lived experience reveals layered meanings.

Name: Kane, John

YEAR	A.C.	TITLE OF PAINTING	LISTED	A	R	POSITION	CON. FOR HONORS
1926	25	The Campbells are Coming	PP		R		
1926	25	Expectation	PP		R		
1926	25	Mother's Boy 'round	PP		R		
1926	25	Squirrel Hill Farm	PP		R		
1927	26	* Scene from the Scottish Highlands	PP	A			•
1927	26	Before and After	PP		R		
1927	26	Girl I Left Behind Me	PP		R		
1927	26	Mount Mercy Academy	PP		R		
1928	27	* Old Clinton Furnace		A			
1928	27	Close of Day			R		
1928	27	Days of Auld Lang Syne			R		

*included in 1958 Retrospective exhibition

Name: Kane, John American Died August 10, 1934

YEAR	A.C.	TITLE OF PAINTING	LISTED	A	R	POSITION	CON. FOR HONORS
1928	27	Expectation			R		
1929	28	Homestead	PP	A			
1929	28	Three Score and Ten	PP		R		
1929	28	Cathedral of Learning in Sight	PP		R		
1929	28	Through Coleman Hollow, along the Allegheny Valley	PP		R		
1930	29	Across the Strip	PP	A			
1930	29	Coleman Hollow	PP		R		
1930	29	Gran'ma	PP		R		
1930	29	Scotch Highlanders	PP		R		
1931	30	Monongahela Valley	XX	A			
	31	Industry's Increase	XX				

KANE, John American (Pittsburgh) DIED: August 10, 1934

YEAR	A.C.	TITLE OF PAINTING	LISTED	A	R	POSITION	CON. FOR HONORS
1934		Crossing the Junction	Loan XX				

· 19 ·

CINDERELLA STORY?

I N ITS MOST COMPRESSED FORM JOHN KANE'S LIFE is a Cinderella story: a seemingly magical transformation from a laborer's life on the edge of poverty to "overnight" art world celebrity and success, with the 1927 Carnegie International Exhibition as the glass slipper moment. Juror Andrew Dasburg, in the role of fairytale prince, saw in Kane's art the beauties Pablo Picasso had discovered in the "primitive" genius Henri Rousseau decades before, and pulled him out of obscurity. In true Cinderella fashion, Kane and Dasburg have been linked art historically ever since. The story as it comes down to us today has at least three narrators: Kane as recorded in *Sky Hooks*, Carnegie Institute as it documented each jury selection process, and the visual evidence of the paintings themselves. The sources agree on certain facts:

> Kane suffered at least one rejection before winning admission.
> The glass slipper would fit in 1927.
> Carnegie Institute exhibited one Kane in the International
> each year from 1927 to 1934.
> The exhibited works are known.

On many other details they disagree fundamentally. What really happened? It seems likely that Carnegie Institute business manager John O'Connor Jr. viewed some of Kane's early submissions to the

◄ Carnegie International admissions records for John Kane. Courtesy Carnegie Museum of Art Archives, Pittsburgh.

International, going back to before 1927. "My first recollection of John Kane goes back five or six years. I recall a poorly dressed, forsaken-looking man who seemed to be dragging his legs after him, carrying canvases wrapped in newspapers. He came just the day the Carnegie Institute Jury was meeting and wanted to submit some paintings. Because of his unkempt appearance and recalling many like him who came with paintings for the International, I thought him a harmless but slightly demented individual. He kept on coming year after year until the 26th International, when a painting was accepted."[1]

In another account, O'Connor recalled just one fruitless visit and never expecting Kane to return.[2] How many times did Kane apply for admission before 1927? Many, according to O'Connor; two, according to Kane; one, according to Carnegie records. How many works were rejected? Two according to Kane, at least fifteen according to Carnegie records. Which ones? In *Sky Hooks* Kane recalled submitting *Lost Boy Found* for the 1925 International and Homer Saint-Gaudens rejecting it as a copy of an Old Master painting. A year later, according to Kane, Saint-Gaudens rejected *Agony in the Garden*, reasons unspecified.[3] However, Carnegie Institute records show zero entries for Kane in 1925, and four in 1926, including *Lost Boy Found* but not *Agony in the Garden*.

Why would Kane select a copy of another work for one of the country's most competitive venues? In 1925 he still thought more like a boxer than a fine artist, and he approached an art competition as if it were a barroom brawl, by showing proof that he was ready, willing, and able to take on all comers. A copy is a display of skill. A copy of a famous masterpiece would prove in an instant that Kane was ready to compete with the best, and it worked, because he was invited to try again. In Kane's boxer mentality a knockdown is not a loss; it is merely the end of round 1. One can trace, through the history of the rejected submissions, Kane's slow development of a new artistic identity—from isolated visionary in the folk art tradition to popular realist in modern America. Like any good boxer, Kane learned from defeat as well as victory and he was always ready to go another round.

Which work did he show in 1925? Although Kane asserted it was *Lost Boy Found* that year, Carnegie Institute records put that

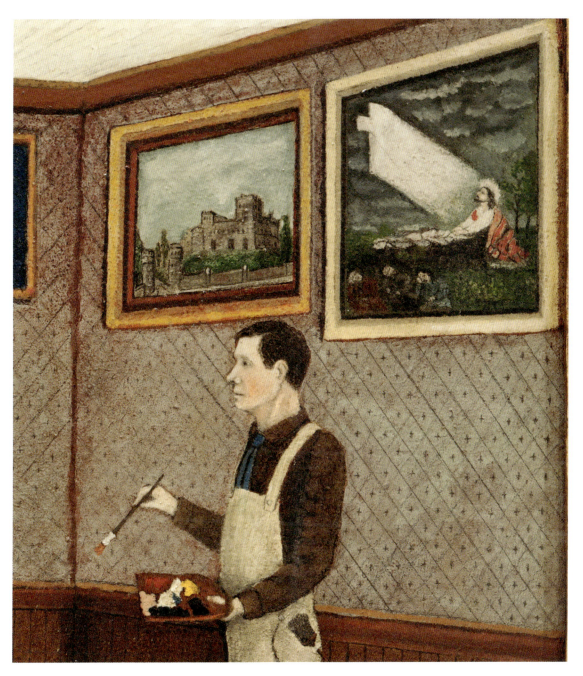

The evolution of this subject can be traced through early versions seen in
Touching Up 1 and *Touching Up 2* and two surviving paintings. John Kane,
Touching Up 2, detail showing painting *Agony in the Garden* at far right.

107 "JESUS IN GETHSEMANE"

Jesus in Gethsemane. Color postcard, Art Series, Religious Subjects, no. 10. CBJ, publisher. Author's collection.

Pietro Perugino, *Agony in the Garden*. Uffizi, Florence.

submission into 1926. It seems likely that in 1925 Kane submitted
an early version of *Agony in the Garden* (which he misremembered
as his 1926 submission). It's a nocturnal landscape centered
on the figure of Christ, kneeling and illuminated by a shaft of
heavenly light. It would have been rejected, rightly, because it
is an outright copy of *Christ in Gethsemane*, a popular devotional
image derived from the Oberammergau Passion Play. Numerous

artists, including Heinrich Hoffmann and Josef Mathauser, had painted widely disseminated versions. Kane apparently owned the postcards, like a Nativity scene sent to his daughter Mary in the early 1930s.[4]

What did Kane learn from his round over *Agony in the Garden* (whether 1925 or 1926)? He repainted the work. When the subject resurfaces in the far right of *Touching Up 2* and in two known independent paintings, the garden is larger and three sleeping apostles have materialized in the foreground, borrowed from Pietro Perugino's *Agony in the Garden* (c. 1483–1493, Uffizi Gallery, Florence). In one version, the usual modest shaft of divine light has been transformed into an electrifying vision of the crucifixion, a startling deviation from standard Catholic iconography.[5] It might also be another example of Kane's fascination with mirror images, as Christ sees a vision of his crucified self.

Carnegie Institute's list of 1926 rejections includes a full-length (but not full-size) figure (*The Campbells are Coming*), a genre scene (*Expectation*), a religious subject (*Mother's Boy Found*), and a landscape (*Squirrel Hill Farm*)—his full range of subjects.[6] None is an outright copy, although *Expectation* is based on a photograph, and *Lost Boy Found* seems a pastiche of Old Master and Orientalist renderings of Christ found in the temple. It is the last traditional religious image Kane would submit to a Carnegie jury.

In 1927 Kane submitted two self-portraits, a genre scene, and a landscape (*The Girl I Left Behind Me, Before and After, Scene from the Scottish Highlands, Mount Mercy Academy*).[7] The presence of two self-portraits suggests that Kane had acquired a more sophisticated measure of artistic skill—he replaced recognizable copies of other artists with recognizable likenesses of himself. Dasburg awarded the glass slipper to *Scene from the Scottish Highlands*, and the rest, so to speak, is history, if not happily ever after.

Through 1930, the last year Carnegie Institute recorded rejected works, and probably in 1931 and 1933 as well, Kane submitted four paintings every year; a landscape found favor every time. He did not give up on figure painting without a fight, however. He submitted *Expectation* a second time in 1928, *Three Score and Ten* in 1929, and *Scotch Highlanders* and *Gran'ma* in 1930.[8] But as

result of the selection process, he comes across in the exhibition catalogs and critics' reviews as a landscape painter. O'Connor, who saw every submitted work year by year, concluded differently. "There were three realities for John Kane—God, nature, and himself."[9]

Kane visited Loch Lomond as a youth in Scotland; his much later painting of the view relied on memory and printed images such as this postcard. After Henry B. Wimbush. *Loch Lomond* (Picturesque Lochs), after 1910. Color postcard. Raphael Tuck & Sons, publisher. Author's collection.

· 20 ·

BEAUTY AND THE BEAST

BEAUTY AND THE BEAST IS THE FABLE OF A
monster saved by his love of beauty. It's also a basic story
line in *Sky Hooks* and subsequent criticism: brutish work-
man redeemed by his instinctual pursuit of beauty. Is it true? The
answer lies in John Kane's long engagement with landscape.

Was Kane a monster? Superficially, yes: physically, he was
large, powerful, intimidating, restless, a heavy drinker, and
notorious brawler. His Scotch-Irish-accented speech could be
difficult for some to understand, his wooden leg caused an awk-
ward gait. Marie McSwigan, describing her first meeting with
the artist, called him "It," as in, "It was tall and somewhat to the
lean side." She turns him into a man in the next paragraph and
dedicates much of her character study to making him less scary.[1]
The long-suffering Maggie Kane might be forgiven if she viewed
him at times as the husband from hell. The popular press and
art world elites identified him as a monster in the biological
sense of the term: a unique aberration from the era's artist and
worker stereotypes. As was Pablo Picasso. . . . Critics would argue
that under his rough exterior, Beast Kane hid a poet's soul. One
compared the effect of his paintings to the experience of reading
Emily Dickinson.[2]

Did John Kane love beauty? References to beauty in *Sky
Hooks* explain why Kane painted landscapes long before he found
a market for them.[3] Among the sights he considered beautiful
are:

the Scottish countryside and Edinburgh landmarks
natural scenery in Alabama, seen from hilltops
the beauty and colors of nature
an empty farm lot on Steubenville Pike near Akron
the countryside in Dauphin County, Pennsylvania
views from Pittsburgh cemeteries
old Pittsburgh

Every single one is a landscape. Sky, hills, and water are common to most. Many he viewed from high ground surrounded by panoramic views and open sky—the top of the roof, in *Sky Hooks* terms. One can imagine that a man who worked in low-lying coal mines and industrial sites from the age of nine would find such places under "the big beautiful sky the way God made it" exhilarating. He could breathe clean air freely. His response to open landscape approaches religious awe. Kane's plots of land in Butler and Akron were beautiful for less visual reasons. He bought them as investments that he intended to develop as a family home and farm but never got around to fixing up. The Akron plot became the setting for genre subjects relating to his unfulfilled dreams of rural family life, such as *Mary's Pet* and *Her Boy's Return*.

Kane believed that every art student must paint outside in order to master light and color and space. Color excited him. "Finding" was part of the joy, too; finding a subject to paint seems to have satisfied the same wanderlust that sent him to distant parts pursuing jobs. "Finding" becomes the key to appreciating his paintings as well; the eye must wander, discover the subtle details, and put together the story just as Kane did. Most of Kane's paintings don't command the wall or scream for attention. Quietly, they reward the viewer committed to slow, patient observation of the kind he enjoyed. "Peaceful/mental/occupation" is inscribed on the back of a postcard that served as his model for a Juniata River landscape.[4] Kane repeatedly described beauty as something found that made him want to paint. "My ideal is to look for beauty and to paint it."[5] His landscape paintings represent his concept of beauty in its purest form. They also describe his escapes.

Conemaugh River, Johnstown, Pennsylvania, 1909. Color postcard. K-win & Co., publisher. Author's collection.

Beginning in 1926, Kane submitted six such quiet landscapes to Carnegie International juries, who rejected them all.[6] One subject stands out in this group because he painted it three times and submitted it twice. It exemplifies his idea of beauty. Coleman Hollow is a gap between two hills on the south side of the Allegheny River, just beyond Allegheny County's eastern boundary. Kane probably composed the scene from high ground above the Allegheny Railroad Company's track and adjacent to the Pennsylvania Water Company Pumping Station lot.[7] At the time, the land was empty; ironically and appropriately, it would become a cemetery later (Sunset Cemetery, now known as Riverview Memorial Park). Through the gap and across the river, the gently rolling hills of Blawnox and Aspinwall were visible. While the view is grand and expansive, the scenery was, and is, undistinguished. At least one of his small Kodak contact prints captures part of the

cluttered view. No mills, monuments, massive bridges, modern architecture; instead, a patchwork of fields and trees, small towns, clustered buildings, and scattered houses linked by roads and rail lines. Kane was attracted by the cemetery-like silence of his high vantage point and the contrast between the rough woods in the foreground, the human activities across the river, and the light on distant hills.

Kane submitted the first version, *Through Coleman Hollow up the Allegheny Valley*, to the jury for the 1929 Carnegie International. When the painting sold, he wrote it its owner, "Up to date the Allegheny Valley is my best painting. If an artist puts his soul in his work mine was there in the reflection of light on the hills on the left also the distane atmosphere with trains coming and going also steam-boats going dayly defieing me to paint them and believe me I took delight in doing so."[8] It was rejected. Perhaps in response to criticism, or after selling the first version, Kane painted another soon after. Essentially the same view, he titled it *Hills and Rivers, Steamboat at Sleepy Hollow*. The Sleepy Hollow reference adds literary depth and positions the landscape as epically American rather than regional. He reduced the format, stretched the scene horizontally, and enlarged buildings, steam-boat, and trains relative to the overall landscape. This version bustles. Trees cast reflections on water at river's edge, contours of fields and roads differ slightly, a few buildings move or disappear.[9] The jury for the 1930 Carnegie International rejected this version, too.

Although colorful trains and steamboat catch the viewer's eye, the central motif in all three paintings is the cluster of buildings just beyond the train tracks and road. The National Amusement Park opened in spring 1929 after a year of publicity stunts, and it thrived until a fire in the fall of 1930 devastated many of its buildings. Note the roller coasters. Kane loved amusement parks, having painted buildings at Luna Park in 1905, and frequenting Kennywood Park's Scotch and Irish days with dedication. Marie McSwigan plays up the Kennywood angle in *Sky Hooks*, but when Kane told her, "When I see the beautiful hills and valleys that surround this pleasure park, I see the hand of God," he might as easily have been talking about the National.[10]

John Kane, *Through Coleman Hollow up the Allegheny Valley*, c. 1928. Oil on canvas. Given anonymously, 400.1941. Digital Image © The Museum of Modern Art/Licensed by SCALA/Art Resource, NY.

In *Hills and Rivers*, down the road from the ephemeral pleasure park, on the right, a massive brick building, Warner Station Poor Farm, emerges from the trees. These two buildings, and the space between them, is the focus of the Kodak photograph mentioned above. This institution functioned as a tuberculosis hospital and county prison incarcerating Pittsburgh's poor by 1912. It occupies the western edge of a municipal complex incorporating the Allegheny City Poor House and the Allegheny County Workhouse and Inebriate Asylum, the hellish counterparts of the heavenly

John Kane, *View along the North Shore of the Allegheny River toward Blawnox*, c. 1928. Gelatin silver contact print. Collection of Mary McDonough.

pleasure park just down the way. Kane's view depicts the short path between a Pittsburgh workman's earthly success and failure, but its local, working-class symbolism would be lost on a jury of modernist painters from out of town. For Kane it's personal; his wife had committed him to similar institutions in 1899 and 1909, for which he could barely forgive her.[11] He would remember his stepfather's demise in the same institution a few years after Kane regained his freedom. In any case, the Coleman Hollow paintings reveal how Kane tells his story through landscape, and how some of its beauties are moral.

When he painted *Sunset, Coleman Hollow*, Kane compressed the view closer to a square format, reduced extraneous detail, and added an enigmatic setting sun at upper left. It showers rays of light on the distant hills. Leon Arkus described the sun as "Redon-like"—that is, a symbolist device that can be read simultaneously as natural (an unusual sunset) and transcendent (akin to the glowing eye on the American dollar bill, or the

The building appears at far right, across the river, in each of Kane's views through Coleman Hollow. Pittsburgh City Photographer. Warner Station Poor Farm, 1914. Identifier: 715.145.CP. University of Pittsburgh.

radiance surrounding the dove of the Holy Ghost). Arkus later opted for the meteorological interpretation, on the grounds that Kane did not use religious symbolism in his painting.[12] However, there is no indication in *Sky Hooks* or his art that atmospheric effects, on their own, interested Kane in the least. Given his frequent references to God as the maker of sky and earth and natural beauty, not to mention settings for pleasure parks, a divine luminous presence in this John Kane sky is not impossible.

Adding the setting sun completes and deepens the worker's story. A laborer on his life's journey might aim for the earthly

John Kane, *Sunset, Coleman Hollow*, c. 1930. Oil on Masonite. Carnegie Museum of Art, Pittsburgh: Gift of Sara M. Winokur and James L. Winokur, 76.55. Image courtesy Carnegie Museum of Art, Pittsburgh.

pleasure palace, the bright, exciting destination at the center of vision. Would the next turn end in shadowy disease, poverty, and prison? Streetcars and trains facilitate workers' access to these earthly ends. Or will it be a long, hard, lonely trek into the setting sun, radiant hills, and sky as God made them? Kane's

painting technique builds the moral message. God's landscape is composed of gently rolling forms, monumental, stable, richly painted and patterned. Humanity's superficial activities occur on the gingerly delineated top layer, as delicate and ephemeral as a laborer's life or a louse on a lady's bonnet. Even at the end of life, worn down by work, tuberculosis, and thirty years of exposure to lead paint, Kane would go toward the hills. As his three titles suggest, there he found nature, human stories, and divinity. In John Kane folklore, Beast finds Beauty.

In its effort to become "modern" Carnegie Institute repainted the art galleries from dark red to light grey and installed paintings on a line instead of tiers. Kane's work usually hung in a corner, the least conspicuous place in the room. *Across the Strip* in the Carnegie International 1930 installation photo. Image courtesy Carnegie Museum of Art Archives, Pittsburgh.

· 21 ·

RUMPELSTILTSKIN

J UST AS SIGNIFICANT FOR HIS CONCEPT OF "beauty" are the things John Kane didn't find beautiful. He considered Maggie Halloran, the future Mrs. Kane, to be "pretty" and the subjects of his monochrome drawings "interesting."[1] Things he never described as beautiful: modern cities, modern industry. He never painted scenes or memories of his working life, nor did he exploit subjects or methods characteristic of the highly marketable "industrial sublime." The paradox, of course, is that all six paintings selected by Carnegie International jurors after 1927 can be characterized as modern urban or industrial landscapes.[2] The 1929 jury rejected *Through Coleman Hollow* in favor of *Homestead*, which looks down on the dark mills and decrepit worker housing of Pittsburgh's most notorious industrial enclave, one Kane avoided in his working life. The 1930 jury rejected *Hills and Rivers* in favor of *Across the Strip*, which contrasts distant, modern, high-rise office buildings with Kane's regular environs, Pittsburgh's most notorious slum.

So, while it is possible to argue that the beauty of these works made Kane's career and reputation, they raise the question: whose beauty? Initially, not Kane's; urban/industrial landscapes form a very small part of his oeuvre overall and they are concentrated in his late years when he was painting for modern art competitions and sales. To describe the progression of subject matter in Kane's terms, one might say that Carnegie International juries rejected the landscapes God made in favor of those built by men, including Kane himself.

When exhibited in the 1928 Carnegie International, this painting would
have been surrounded by Pittsburgh art viewers in the traditional role of
mourners contemplating the portrait of a lost loved one. John Kane, *Gone but
Not Forgotten* [*Old Clinton Furnace*]. Private collection, Image courtesy Kallir
Research Institute, New York.

The industrial scene *Old Clinton Furnace* won Kane's second
round (depending on how you count) with International juries in
1928, a victory that would be as significant for his artistic future as
the more famous 1927 selection. The Clinton Furnace, constructed
in 1859, was Pittsburgh's first coke-fueled steel mill, the foundation
of its industrial wealth. It closed down for good in 1927; the paint-
ing's inscription, "Gone but not forgotting" [*sic*], usually appears on
tombstones in eighteenth- and nineteenth-century mourning scenes.
In the twenty-first century it seems eerily prescient; at the time it

seemed nostalgic. Kane's death portrait of Old Clinton Furnace would do for Pittsburgh industrialists what his mill worker portraits did for their families: memorialize a dead loved one.

The strategy worked. A possibly homesick Pittsburgher back from Harvard College bought it because it reminded him of watching the mills fire at night. "On a visit home during freshman year, [John] Walker made his first art acquisition—a painting by John Kane called *Old Clinton Furnace*. The asking price at the Carnegie International was fifteen hundred dollars; he offered seventy-five. The saleswoman at the catalog desk laughed in his face, but the next day she telephoned, chagrined, and said his offer had been accepted. Walker knew Kane slightly; the artist's wife had been his grandmother's cook. He also was well acquainted with the subject of the canvas; it was the blast furnace in central Pittsburgh that his grandfather owned."[3] John Walker III, scion of a wealthy Pittsburgh family, future director of the National Gallery, one of the most influential collector-connoisseurs of the twentieth century, bought Kane's art for the same reasons, in the same way, with the same emotions, that housewives and millworkers in Butler did.

In eighteenth- and nineteenth-century art, "gone but not forgotten" conventionally appeared on tombstones attended by grief-stricken mourners. John William Waterhouse, *Gone but Not Forgotten*, 1873. Private collection.

Crossing the Junction was the last Kane painting to appear in a Carnegie International. On August 1, 1934, still working on it, John asked Maggie to write down a title for the forthcoming catalogue; ten days later he died.[4] His Associated Press obituary reported, "Shortly before his death, he said he wished he had the strength to sign his name to his unfinished work, a panorama of industrial Pittsburgh."[5] The exhibition opened two months later. The "panorama" is one of his largest and most elaborate compositions. Like the Coleman Hollow series, this subject evolved over time and deepened in meaning with each iteration.

Crossing the Junction developed from a scratchy drawing featuring a metal bridge spanning the ravine between Pittsburgh's

John Kane, *Drawing for Bloomfield Bridge*, c. 1928. Graphite on paper. Carnegie Museum of Art, Pittsburgh, Purchase: Gift of Allegheny Foundation, 84.56.3. Image courtesy Carnegie Museum of Art, Pittsburgh.

Lawrenceville and Bloomfield neighborhoods.[6] The basic scheme resembles the Coleman Hollow view through a valley, but this time a bridge blocks visual access to remote hills. Kane paid meticulous attention to its construction, struts, and girders. He profiled the roofs and chimneys of houses below the left-hand span and industrial buildings rising on the slopes to the right. Railroad tracks flow through the flats below. In the foreground, another metal bridge-like structure supports signals controlling the trains. The subsequent painting follows the drawing's outlines for the most part, and "paves" it with blocks of trees, grass, dirt, railcars, and houses. Smoke issues from the trains and industrial building. The painting deviates from the drawing in one respect. The graceful

John Kane, *Bloomfield Bridge* [*Skunk Hollow*], c. 1930. oil on canvas. Carnegie Museum of Art, Pittsburgh: Gift of Mr. and Mrs. James H. Beal, 81.54.2. Image courtesy Carnegie Museum of Art, Pittsburgh.

and accurately drawn arc of the rail line in the sketch is bent into a sharp and dangerous curve in the painting. The change might be excused as artistic license to enable addition of the lengthy passenger train steaming across the foreground of the painting.

Kane called this version of the subject *Skunk Hollow* when he submitted it to a New York exhibition in 1931.[7] Skunk Hollow was one of Pittsburgh's most dreaded neighborhoods thanks to the 1908

Pittsburgh Survey. A landmark study of an industrial community, the *Survey* revealed to a horrified public the tumbledown shacks, open latrines, toxic air, crowded living quarters, filthy water supply, and hungry families that perched on unstable slopes above the hollow's railroad tracks, steel mill, gasoline plant, and waste incinerator. These would have been typical living conditions for most workers like Kane and his family up to World War I, and for many still decades later. When Kane visited the ravine with his pencil and paper following Pittsburgh's "city beautiful" renovations in the 1910s and 1920s, Skunk Hollow's lower hillsides had been cleared and terraced for the Bloomfield Bridge, carrying automobiles between city business district and country suburbs. As is often the case in Pittsburgh real estate, the heights belong to wealthy elites (flying over in their automobiles!) detached from the industrial zones below. While workers' housing had acquired some running water, and economic depression reduced ambient pollution, Skunk Hollow remained an isolated slum. Today this painting is named for the bridge, not the hollow.

Crossing the Junction differs from the drawing and previous painting in critical and related aspects. Critics who viewed the painting in the 1934 International disparaged the plunging hills and converging trains as imaginary until a *Pittsburgh Post-Gazette* photographer found Kane's original vantage point and snapped the scene.[8] The landscape is expanded on the left to incorporate Herron Hill and its radio antenna mast and step streets, and on the right to depict the worker community in Bloomfield. Kane returned to the spot to make detailed studies of the antenna mast and the perspective of the new electric lighting fixtures on the bridge.[9] The title *Crossing the Junction* draws our attention to four trains running in the foreground. The artist's intention has shifted from representing a famous slum to showing an action. Last but not least, he replaces the metal lattice structure supporting the signal system at the crossing (carefully delineated in drawing and first painting) with a blocky watch tower. Kane worked as a railroad crossing guard in McKeesport from 1891 to 1898. His job was to watch for, anticipate, and prevent disasters.

Why did the title matter so much to John Kane? Having stumbled over "sky hooks," one must ask what "crossing the junction" would mean to a railroad man. Specifically, a junction is where

These small studies filled in Kane's schematic composition design in the same way the right size stone blocks filled in sections of street pavement. (*Top left and right*) John Kane, Studies for *Crossing the Junction*. Pittsburgh, Pennsylvania, n.d. Pencil on lined cream notebook paper, 8 x 5 in. (*Bottom*) John Kane, Studies for the Bloomfield Bridge (double-sided). Pittsburgh, Pennsylvania, n.d. Pencil on lined cream notebook paper, 10 x 8 in., Collection American Folk Art Museum, New York, Gift of Michael Roland, Sean Roland, Timothy Roland, and Jacqueline C. Elder in loving memory of Margaret Kane Corbett, 2006.10.23 and 2006.10.22b. American Folk Art Museum / Art Resource, NY.

Baltimore & Ohio Boxcars after train wreck, 1913. Postcard. Author's collection.

railroad tracks operated by different companies cross "at grade," that is, on the same level. When competing companies failed to communicate or cooperate, as was common then and now, horrible disasters could and did occur. A famous collision between a Pennsylvania Railroad passenger train and two freight trains near Aberdeen, Maryland, in January 1929 might have stimulated Kane's first interest in the configuration of rails and signal systems in conveniently nearby Skunk Hollow (the painting shows three approaching trains). Then in 1930 Kane and his wife were seriously injured in separate accidents on a Railways Company streetcar line across the street from their house.[10] He memorialized those events in a painting known as *Old Saint Patrick's*, after the church on the left side of the composition. A critic noted that in the painting, Kane relocated his house to directly behind, and connected to, the church, facing the tracks. However, square in the center of the canvas are the streetcar tracks and oncoming streetcar that

A critic noted *Old St Patrick's Pittsburgh*'s extreme foreshortening, which compresses the distance (and shortens the reaction time) between the viewer and an oncoming streetcar. John Kane, *Old St Patrick's Pittsburgh*, 1930. Oil on canvas. Detroit Institute of Arts, 46.281. Photo © Detroit Institute of Arts, USA/Gift of Robert H. Tannahill/Bridgeman Images.

caused him so much pain and hardship in 1930–1931.[11] A street sign directs us to the catacombs (storage for dead bodies), which the Kanes had so narrowly avoided. This work, exhibited at the Associated Artists of Pittsburgh 1931 exhibition, anticipates the basic design and concept of *Crossing the Junction* four years later.

Two more national-news-scale disasters occurred on February 26, 1934. A Pennsylvania Railroad passenger train hit a frozen switch and derailed near Penn Station killing seven passengers and two enginemen; and a Pennsylvania Railroad express demolished a truck at a grade crossing in Delphos, Ohio, killing three people the same day. Is it a coincidence that Kane revisited the Skunk Hollow crossing that year? His decision to paint four trains rushing to a single point suggests that the real subject of this painting might be train disasters. An alternate title for the composition, "Four Bridges," also puts the focus on crossings although only two bridges are visible in the painting.[12] In truth, a series of complex corporate mergers had finally unified ownership of the crossing tracks at Skunk Hollow with one company, the all-powerful Pennsylvania Railroad. It was no longer, technically speaking, a junction by 1924. A rail overpass obviated the risk of collision; east and westbound trains could speed safely above the north and southbound lines. So, the scene and its title constitute another Kane "gotcha" moment; despite the threat of imminent disaster, those who looked closely would realize that everything will be okay.

By stepping back to view the complex terrain and social landscape surrounding the junction, Kane also widens the context and meaning of crossing it. In 1934 the Bloomfield Bridge carried expensive automobiles swiftly and safely above the vertiginous ravine and its deadly traffic. Trains moved safely and swiftly within it, as did their paying passengers. Who did not? The workers living on both wrong sides of the track. They rode trains by risking their lives to jump on slow-moving freighters, as Kane did in his tale about how he rode 130 miles on a mule in a single night. That sharp bend in the track where a train would slow as it approached the junction might have been a likely on-off spot. The poor traveling these lines risked arrest, violence, hunger, and the elements. They rode with animals, raw materials, and other industrial commodities.

Kane also shows us that in Skunk Hollow most roads were unpaved, and most workers walked. As the step streets on the left make clear, many would be crossing the tracks on foot to reach jobs in the mills, plants, and rail facilities every day. Kane knew

Bloomfield Bridge's large span and broad, well-lit roadway accommodated speedy automobiles, the hallmark of the modern city. Bloomfield Bridge, Connecting Grant Boulevard and Bloomfield District, Pittsburgh, Pennsylvania. Color postcard. Author's collection.

from bitter life experience that no one was looking out for them. Kane lost his leg trespassing on the tracks of the Baltimore & Ohio Railroad in 1890. His daughter Margaret's indelible child-hood memory—as a ten-year-old visiting her grandmother in Port Perry—consisted of watching a fourteen-year-old boy fall from a moving rail car and be dragged down the tracks until out of sight. "We walked over to the track and saw his little hand."[13] Kane's brother Patrick lost an arm on the Pennsylvania line in 1898. His brother Tom was killed by a freight train near Saint Paul, Minneso-ta, and his brother Simon was run over by a passing express while working on a coal train.

Crossing the Junction features four trains, one for each brother, from both companies and includes freights, locals, and expresses. In point of fact, only pedestrians were "crossing the junction" in

John Kane, *Crossing the Junction*, 1934. Oil on canvas. Gift of H. J. Heinz Co., 2013.112.1. Museum collection, Senator John Heinz History Center, Pittsburgh.

1934. Trains and cars had bridges to lift them above the dangers and most views of the area featured its massive concrete terraces, crisply engineered bridge supports, and speeding automobiles instead of the valley itself. In this respect, the organization of Pittsburgh's landscape, in real life as well as in Kane paintings, reflects the physical and social hierarchies found in John White Alexander's mural: laborers in the dark and dangerous bottoms, aspiring citizens climbing slowly up the hills, wealthy elites enjoying the privileges of sunlight and clean air along with the many gifts of labor.

RUMPELSTILTSKIN

If we follow a workman's route home from a job at the gasoline plant (another workman's hell) to lodgings in Lawrenceville or Herron Hill, he (most likely "he") would first cross the Pittsburgh Junction track for slow-moving trains outside the plant's entrance. In *Crossing the Junction*, it would be the lower track connecting foreground and background in the center of the painting. He would reach a narrow strip containing the rocky railbed and a steep terrace rising to multiple tracks for high-speed freight and passenger trains. The sharp turns and blind corners in this section would present as on-off opportunities for jumpers or dangerous blind spots for crossing pedestrians. A less strenuous but even more dangerous route might involve following the Pittsburgh Junction track through the underpass before crossing to climb the hillside.

Climbing the hillside becomes another story. Kane loved to climb hills and no one knew better than he that reaching the airy heights required sweat and shoe leather, not sky hooks. At the top of this one isn't just God's big, beautiful sky, clean air, or flying ladies bearing gifts; there is also a radio antenna mast. Commercial radio originated in Pittsburgh in the 1920s, and early programming consisted of musical performances broadcast live. A heavenly experience for a music lover like Kane? Or an allusion to his own, recent radio broadcast on WCAE? For the modern-minded, the antenna tower, erected by 1907, would be another example of Pittsburgh's leadership in innovation and technology. Like so many of Kane's views, it facilitates one reading by the elite, and another by the working class.

As its history makes clear, there are many reasons to believe that workers experienced Skunk Hollow as Pittsburgh's real-life Valley of the Shadow of Death, which Kane passed through one last time while painting *Crossing the Junction*.

"Beauty is to make things beautiful in any line of art," Kane told McSwigan.[14] Kane's paintings resemble fairy tales in that they present the hard truths of poor people's lives, especially his own, in entrancing, imaginative, subtle ways. He worked hard to make Pittsburgh's real places, as dark and dangerous as any haunted forest, comprehensible, beautiful, and interesting. He animates stark, ugly, industrial terrains with the people and activities that made a workman's life in the modern world beautiful and

meaningful—housewives shopping, friends meeting, laundry flapping, workers at train stations, nuns at church, millworkers' dwellings, children at play, merchants' wagons, laborers heading home. Slow, patient observation reveals their stories.

Of all the monsters and heroes of myth and legend, Rumpelstiltskin matches John Kane the best. They were dedicated craftsmen and indefatigable workers. Rumpelstiltskin secretly spun straw into gold the way John Kane transformed a mill girl's strawlike hair into movie-star metallic, or wove colored paints and mundane views into works of art. Their methods were mysteries because each worked alone. Both enjoyed short-lived, magical success. Later, driven by the rising expectations of greedy kings and ambitious maidens, their off-hours pastimes became full-time work. Status, wealth, and fame followed, but overreach brought retribution. Their stories are about the grind of work, the magic of craft, the invisible laborer's just reward, and the cruel punishments meted out to those who aspire for more.

CHRONOLOGY

THIS CHRONOLOGY ATTEMPTS TO ESTABLISH THE sequence and duration of events in Kane's life as mentioned in news articles, exhibition records, archival documents, and *Sky Hooks*. Births, deaths, marriage, and exhibition openings are among the few events that can be confidently associated with calendar dates. Tracking Kane's adventures before 1927 is complicated by variations in spellings (*Kane* or *Cain*) and the high frequency of both names in Ireland and Scotland and among American immigrant families at the turn of the century. Whenever possible, dates and events have been checked against immigration and census records, corporate, institutional, and local histories, and contemporaneous publications.

1860 August: John Kane is born in West Calder, Scotland, third child, second son of Barbara Coyne (born c. 1836) and Thomas Cain, laborer (born c. 1829; both born in Glanlusk, County Galway, Ireland); married c. 1853

1870 Draws scenes from Franco-Prussian War on slate at school; assists father with digging and harvesting jobs
 Thomas Cain dies, age forty-one, leaving widow Barbara and six living children: Patrick, Julia, John, Sarah, Tommy, Joe
 Shortly after father's death, begins work in shale mine (Old Number Nine Pit) in West Calder pulling shale cars ("lying bens") to assist older brother Patrick at ten pence per day
 At age ten or eleven visits Edinburgh with friend; spends night on the road; reunion with family; end of formal schooling

1872 Works making candles in Young's Paraffin Light and Mineral Oil Company in West Calder

1875 Barbara Cain marries Patrick Frazier, laborer (born in Ireland c. 1844), one son, Simon Frazier, born; family lives near Addiewell shale oil works in Happy Land worker community
 Works in shale mine with younger brother Tommy; starting pay 1 shilling, 3 pence per hour ($0.36), up to 45 shillings per week ($11.25) before emigrating
 Brother Patrick recruited for British Army, 42nd Highlanders Regiment, serves until 1879; John avoids recruitment in 50th Regiment

1875 At some time in 1870s, travels Scotland on holidays or during strikes; visits
 Calton Slap (Calton Hill, Edinburgh), Pentland Hills, Trossachs, Balmoral
 Castle, Stirling Castle

1879 Stepfather Patrick Frazier, brother Patrick Cain, and cousins Patrick Coyne
 and John Coyne emigrate on *Ethiopia* to New York City June 30; John be-
 comes head of household in Scotland
 November: Sees British prime minister William Gladstone speaking in West
 Calder

1880 April: Census records Patrick Frazer (b.1840/1844, married), Thomas
 Coyne (b. 1854), and Patrick Cain (b. 1859) working in pipe mill (prob-
 ably National Tube Works), lodging with Samuel Sanford, McKeesport,
 Pennsylvania, carpenter
 Emigrates with cousin (Tom Coyne?); travels from Glasgow to Larne, Ire-
 land, to United States on SS *State of Indiana*; joins stepfather and brother in
 Braddock, Pennsylvania; immigration record not found
 In McKeesport for first job in United States as gandy dancer/tie tamper
 working for Baltimore & Ohio Railroad; second job addressing stickers
 (cleaning out imperfections in pipes) for National Tube Company,
 McKeesport, lasts three months

1881 Moves to Connellsville Coke Region, Pennsylvania. With a cousin (probably
 Tom Coyne) works three jobs in three months including drawing coke and
 driving mules in Hecla Mine near Mount Pleasant; encounters Henry Clay
 Frick at Mullins' [Mullen?] Store in Bridgeport
 April: Barbara Frazier and brothers Joseph Cain and Simon Frazier arrive
 in New York City on *Anchoria* and join family in Braddock
 In early 1880s, joins Knights of Labor, national workers' organization;
 at unknown date also joins Amalgamated Association of Iron and Steel
 Workers

1882 Moves back to Braddock to join mother and brothers; laboring jobs in
 Braddock steel mills, digging foundations of new addition to Edgar Thomp-
 son Works; hauling steel rails to trains and boats, carrying hot metal in
 the furnace for $2.00 a day (approx. twelve months) and top-filling with
 brother Patrick at $1.75 a day
 Sister Sarah immigrates to United States
 Sister Julia immigrates to United States

1883 Maggie Halloran immigrates to United States from Scotland c. 1880–1883;
 in Pittsburgh learns to cook; works and lives in households belonging to
 wealthy families of future Kane collectors John Walker III and Duncan
 Phillips

1884 Recession, financial panic of 1884
 Cousin Pat Coyne immigrates to the United States
 Returns to Connellsville Coke Region to join cousin Pat Coyne, possibly at
 Mine Number 1, Hecla Coke Company, four miles out of Mount Pleasant
 "In early days as coal miner," experiments with heliographs, bromide prints

1885 Meets friend Joe Baker; with Baker, jumps trains from Cincinnati, Ohio,
 to Birmingham, Alabama; finds work in Warrior Coal Field mines; works
 in Drake Mine; makes drawings in hill country during time off

Digs coal in Alabama, Tennessee, and Harlan County, Kentucky; spars with boxer Jim Corbett in Glenmary, Tennessee; away from family for two years

1886 Snowbound near Jellico, Tennessee (Cumberland Mountains) looking for work; injures eye while "bearing in" with pickax at a mine in Jellico; returns to family in Braddock while eye heals

Returns to Connellsville when recovered, c. 1886–1888; with friend Sam Harry, sinking shafts with dynamite at Frick Coal and Coke Company, Leisenring Mine Shaft Number 3, Port Royal shaft in West Newton, Pennsylvania, living in Uniontown boarding house; joins Miners' Union; rescues Hungarian workers trapped in burning coal mine

Memorable boxing matches in Connellsville, 1886–1888

1888 "Hauling dirt and filling in" as laborer on foundations of new Westinghouse plant in Turtle Creek under construction from 1888

1890 Street paving job with John Callahan Company, Pittsburgh, in downtown, South Side, and McKeesport, earning five dollars per day; making pencil drawings of streets and surroundings

1891 Stays with sister [Sarah?] in Braddock; Barbara and Patrick Frazier away in Scotland; train accident on Baltimore & Ohio rails with cousins Tom and Patrick Coyne at age thirty-one, loses leg, spends seven to eight weeks in hospital; brief trip to Chicago on sleeping car, stays at Salvation Army; buys wooden leg for five dollars

Job as watchman with Baltimore & Ohio, McKeesport, c. 1891–1899; stationed at Riverton crossing and Walnut Street crossing, earns thirty-five dollars a month

1892 Homestead Strike at Carnegie Steel's Homestead Works led by Knights of Labor and Amalgamated American Iron and Steel Workers unions; observes Homestead strikers passing through McKeesport

1893 Meets Maggie Halloran at his sister's house in Braddock; begins four-year engagement despite warning from brother Patrick's wife Mary that both men are alcoholics; visits Maggie at houses where she works as a cook

First attempt to apply for naturalization and citizenship

Financial panic in the United States; unemployment peaks somewhere between 8 and 18 percent; economic depression or recession lasts into 1897

1897 March: Marries Maggie Halloran at Saint Mary of Mercy at corner of Third Avenue and Ferry Street, Pittsburgh; they set up housekeeping in Market Street, McKeesport, opposite Sisters of Mercy at Saint Peter's Convent, Market Street; joins the YMCA for exercise and education

Becomes American citizen (record not found)

1898 March: Daughter Mary born in McKeesport; doctor visiting to treat baby for pneumonia notices infection on John's amputated leg due to new, poorly fitting artificial leg; treated with poultices and drainage

Death of brother Simon Frazier, brakeman on Baltimore & Ohio, McKeesport, at age twenty-two, in train accident

1899 Brother Patrick Cain loses arm in accident on Pennsylvania Railroad tracks

Goes to work at Pressed Steel Car Company of Pittsburgh, newly expanded car works in McKees Rocks, Pennsylvania, looking for higher wages, paints

gondolas and box cars; retouches thirty to forty cars a day at ten cents per car

1899 Committed to Allegheny County Home for Poor, Hospital for the Insane and Tubercular (Woodville Hospital)

1900 US Census reports John Kane living in Stowe township, Allegheny County, with wife and daughter Mary; listed as day laborer, wife not working

US Census reports brother Patrick Cain living in North Versailles township with wife and six children, occupation laborer

Stepfather Patrick Frazier dies while an inmate of Woodville Hospital; "alien, no occupation, no family" according to US census

1901 Second daughter, Margaret, born in McKees Rocks

1902 US economic recession begins

Moves to jobs at Standard Steel Car Company, Butler, Pennsylvania, under construction April–September; first cars made in August; works there for a year or two more; multiple languages spoken by workers plus high production quotas contribute to accidents; buys lot on Butler Plank Road, possibly on land being developed by Lyndora Land Company for Standard Steel workers

Doctor visiting daughter Margaret for measles, sees signs of infection or gangrene in amputated leg, John resists treatment but doctor returns and removes dead bone from leg

1903 Enlarges and colors photos in Butler when jobs unavailable, earns four to five dollars per pastel, seven to ten dollars per oil; learns to make bromide prints

1904 February: Birth and death of son John on Saint Blaise's Day (February 3); initiates period of heavy drinking; jumps off Sixth Street Bridge in Pittsburgh in apparent suicide attempt

1905 Seven weeks of sleeping on floor in Salvation Army building on Seventh Street near Penn Avenue; first house-painting jobs

Spends summer painting buildings and rides at Luna Park in North Oakland neighborhood of Pittsburgh

November: Two receipts for work for W. J. Holland, director of Carnegie Museum of Natural History, at $1.75 per day

1906 Maggie takes job as cook for Convent of the Sisters of Mercy, Cresson, Cambria County, Pennsylvania, departs with daughters

1907 Spends spring painting at Coney Island amusement park on Neville Island, under construction until June 1907

Applies to John White Alexander for job with crew painting and installing *Apotheosis of Labor* murals at Carnegie Institute

First private sale of freehand painting: view of Steel Farm, Squirrel Hill, Pittsburgh, sold to farm's owner

1908 Maggie and daughters settle at 56 Lawn Street in South Oakland near Soho steel mills; Kane seeks work anywhere during financial panic of 1907–1908; visits family occasionally; family stories about drinking bouts including Maggie dragging him unconscious out of house during snowstorm, repenting and dragging him back in

Works for sign painter Walter Heathcock with studio on Fourth Avenue;

joins Heathcock's workshop on Penn Avenue near Seventh Street to produce Block House views for Pittsburgh 150th celebrations

Through employment agency, gets job as painter in Charleston, West Virginia, visits John Brown's Room in state capitol building and sees version of Thomas Hovenden's *Last Moments of John Brown*; second attempt to enter art school

1909 July: Admitted to the Pittsburgh City Farm Insane Asylum, South Fayette Township, Pennsylvania (known as Mayview or Marshalsea Hospital) as an indigent patient suffering from "toxic insanity" due to alcoholism. Order of admission records family's address as 308 54th Street, Pittsburgh, wife Margaret Cain as person to notify. Symptoms include hallucinations, delusions, suicidal impulses, bad memory, and digestive problems

Sees burning of Nixon Hotel, in Butler; paints interiors of new Nixon Hotel; crosses paths with estranged wife Maggie, who is visiting hotel with a friend

1910 Moves to Youngstown, Ohio; works as carpenter's apprentice

Census records Margaret Kane, head of household, living with daughters and brother Peter Halloran, boilermaker (b.1860, immigrated 1886) at 133 Carnegie Street, Pittsburgh (ward 10); numerous John Kanes recorded in Pittsburgh region and Ohio

1910 In Akron, Ohio, through c. 1912 for construction of second Firestone Tire and Rubber Company building, carpentering forms for concrete construction, built roof; while working for Cleveland contractor also builds and paints at Goodrich, Goodyear, and General Tire Companies

Buys property on Steubenville Pike near Akron for $375 (later part of Goodyear landing field), lets it go several years later undeveloped for $850

Name change from Cain to Kane; census records show wife and daughters also shift to Kane most of the time

Starts painting at night on beaver board scraps, carries art materials at all times, avoids bars

Brother Tom killed by a freight train near Saint Paul, Minnesota

Visits Star Junction in Perry Township, Fayette County, Pennsylvania, a coal town, to see old mining friends Sam Henry (Harry?) and Joe Baker

1912 Daughter Mary, age thirteen, visits Kane at Akron boarding house; Kane takes her back to Pittsburgh for his summer vacation

Cleveland contractor sends him to work in West Virginia, carpentry and painting

Daughter Margaret hurt in fall during neighborhood bridge repair in Lawn Street neighborhood; Kane returns to Pittsburgh from West Virginia

Cleveland contractor sends him to work in Dauphin County, Pennsylvania

Works as carpenter in Cambria Steel Works, Johnstown, also "building forms on houses"

Starts work on *Gettysburg Address* painting in Johnstown; Battle of Gettysburg fiftieth anniversary event

Gets job with John F. Casey Company as carpenter in daytime, driving work train at night for construction of Aspinwall filtration plant

1914 "Shipped to Cleveland" waterworks job for Casey, in Cleveland when war declared

Attempts to enter Cleveland School of Art

1917 Out of contact with family; working on the High Level Bridge, Pittsburgh, when Barbara Frazier (age eighty) dies in one-room shanty in Port Perry, Pennsylvania; siblings Sarah and Joe in steel business in Indiana

Attempts to enlist at Camp Sherman, Chillicothe, Ohio, when United States enters war; works as carpenter building barracks for recruits June–September, heavy drinking

Sent to Harrisburg to build government munitions storehouse (in charge of runways and lathes, power supply for their operations)

1918 Goes to Pittsburgh to make shells for Westinghouse Company in Garrison Alley plant (downtown Pittsburgh), loses job when Armistice treaty signed

December: Living in Lawn Street, Pittsburgh, with family; sentenced to ten days in jail after Maggie has him arrested for pouring whiskey on kitchen fire, setting fire to house; judge orders him to stay away from wife; Maggie and daughters move to Washington, DC, where daughters join war effort

After WWI price of artificial legs reaches $150–200, out of reach for workers; using third artificial leg

Brother Patrick Cain dies

1920 In Pittsburgh after war, holds one or two dozen jobs, painting and carpentry, over two years, "times were good," itinerant; settles in boarding house in slum neighborhood, Mrs. Miller's in Water Street near the Point at three dollars per week until c. 1921–1922; attends Saint Mary's Church; moves during Boulevard of the Allies construction

Census records Margaret Cain and daughter Mary Cain living with Margaret's brother Peter Hallaron [*sic*], boilermaker, in Alexandria, Virginia

Census records brother Patrick's widow Mary living with five adult children on Kirkpatrick Avenue, North Braddock

Prohibition begins

1922 Joins crew building Beechwood Boulevard Bridge (now called Greenfield Bridge, constructed 1921–1923) in Schenley Park, Pittsburgh

Seeks peace and solitude in Calvary and Homewood Cemeteries

After bridge job, works as carpenter in Homewood car barns (7310 Frankstown Avenue); family is unaware he is in Pittsburgh

Rents street-level storeroom at Fourteenth Street and Penn Avenue near Saint Patrick's School. Enough space to make large painting; while associated with Saint Patrick's he stops drinking

Works for two years painting offices at Sheet and Tin Plate works of the National Tube Company, McKeesport; enjoys the work; does not drink

1925 Works as painter for H. R. Roberts, real estate operator, in rapidly growing suburban community of Ingram, Pennsylvania

Possible first meeting with G. David Thompson, Pittsburgh industrialist and modern art collector, while peddling house portraits in wealthy Pittsburgh neighborhood; first sale to Thompson (according to Thompson)

First-time submission of painting for Carnegie International exhibition, rejected due to late arrival

1926 First formal submission, four paintings, for Carnegie International Exhibition; all rejected

1927 Living in rooms at 1711 Liberty Avenue in Pittsburgh's Strip District; slum

neighborhood house belongs to Saint Patrick's Church, inexpensive lodgings for indigent workers

October–December: First painting accepted for Carnegie International Exhibition; juror Andrew Dasburg buys *Scene from the Scottish Highlands* for fifty dollars; Carnegie Institute assistant director John O'Connor Jr. alerts local press about Kane; front-page article in *Pittsburgh Press* creates sensation

November: Maggie reads news stories and visits (briefly?) after ten-year absence; first grandchild, Lawrence Corbett, born to daughter Margaret in Alexandria

December: Kane advertises in *Pittsburgh Post-Gazette* for work, "anything in painting"

Has acquired portable Kodak box camera

1928 Interviewed by Mary Mullett for influential, nationally circulated *American Magazine* article published April 1928; Maggie is absent, living with daughters' families caring for grandchildren

Joins Associated Artists of Pittsburgh (AAP); reconnects with former employer (contractor) turned artist Walter Heathcock by 1932

February 10–March 9: AAP exhibition, exhibits six paintings, wins second prize with Turtle Creek view; probably meets Norwood MacGilvary, associate professor in painting and design at Carnegie Institute of Technology (now Carnegie Mellon University)

Attempts to enter art school when Carnegie Tech initiates fine arts courses

March: Exhibits with other AAP artists at Horne's Department Store, is present in galleries daily to meet the public

April: Advertises in *Pittsburgh Press* classifieds for "first class painter as partner"

Arrested by company police officers while drawing steel mill on Southside (probably J&L works or Clinton Furnace), they confiscate drawings before releasing him; ends his engagement with industrial subjects

October 11–December 9: Carnegie International, exhibits *Old Clinton Furnace*, asking price $1,500, sold to John Walker III for $75

Marie McSwigan feature article "Fame Fails to Bring Wealth to Painter," her first known article on Kane, published

1929 February 1–March 15: *Seen in the Mirror* and four other works exhibited in AAP annual exhibition at Carnegie Institute; AAP juror, artist Leon Kroll, buys *A Day of Rest*; critic Harvey Gaul recommends buying "Kane common" or "Kane preferred," cites self-portrait

May 16–June 17: Five works sent to Boston for the Harvard Society for Contemporary Art exhibition "Paintings by Nine Americans"

August: Onset of the Great Depression

October: Carnegie International jury rejects *Three Score and Ten* and *Through Coleman Hollow*; O'Connor sends them to an exhibition of "Painting and Sculpture by the School of New York, 1920–1930," organized by the Harvard Society for Contemporary Art, Boston

October 17–December 8: Exhibits one painting (*Homestead*) at Carnegie International Exhibition; first news report mentioning presence of Maggie living with husband

1930 Census records John and Margaret Kane living at 1711 Liberty Avenue, John listed as house and decorative painter; daughter Margaret in Alexandria City, Virginia, with husband Lawrence Corbett and three-year-old son Lawrence Jr.

February 13–March 13: Sends two paintings to AAP exhibition

June 1–August 31: Sends one painting to Toledo Annual Exhibition of Selected Contemporary Artists

October 16–December 7: Exhibits one painting (*Across the Strip*) at Carnegie International, sold to collector Duncan Phillips; handwritten list prices *Across the Strip* at $400, two landscapes at $300 each, and *Granma* at $200

October 17–November 1: Sends two paintings to Harvard Society for Contemporary Art for exhibition of Painting and Sculpture by the School of New York; John Dewey, head of faculty at Columbia University, buys one or two paintings

October–December: John and Maggie injured in separate streetcar accidents; he is hurt returning home from visit to Carnegie International; Kanes not aware of each other's injuries; following injury John resumes drinking

November: New York art critic Henry McBride describes Kane as a poet whose picture in 1930 Carnegie International "did give me that stir of the pulses that Emily Dickinson said is the true test of poetry"

December 2–January 20, 1931: Sends three paintings to Museum of Modern Art (MoMA) exhibition "Painting and Sculpture by Living Americans"; works selected and shipped by O'Connor, including group rejected from International; O'Connor assists MoMA with publicity

December: Rise in rent at 1711 Liberty from fifteen to twenty dollars per month causes hardship while Kane is unable to work due to injury and lack of jobs during Depression

1931 February 12–March 12: Exhibits two paintings at AAP annual exhibition

February: Moves to cheaper, more spacious lodgings in Pittsburgh's Soho/ Oakland neighborhood at Maggie's behest, 246 Ophelia Street, first floor

May 25–June 6: Sends approximately twenty-three paintings to solo exhibition at Junior League headquarters, two paintings exposed as painted-over photographs leads to scandal

New York dealer Valentine Dudensing drops one-man exhibition plan after Junior League scandal

Moves to 1700 Fifth Avenue above Nick's, an Italian shoemaker

October: In Saint Francis hospital with broken ribs after falling at home, reinjuring ribs broken in streetcar accident months previously

September 15–October 17: Exhibits twenty paintings at Contemporary Arts Gallery, New York

October 15–December 5: Exhibits one painting (*Monongahela Valley*) at Carnegie International

Visits daughter Margaret and family in Alexandria for ten days

1932 January 24–March 13: Exhibits two paintings at Pennsylvania Academy of the Fine Arts (PAFA) Annual Exhibition in Philadelphia

February 12–March 11: Shows two paintings in AAP annual exhibition

March 26–April 15: One-man exhibition at Gallery 144, New York, including fifteen to twenty paintings dealer Manfred Schwartz bought in 1931

April: Responds to letter from Homer Saint-Gaudens about paintings for future display; mentions possibility of moving again and need to "keep pot boiling for Mrs. Kane"

Maggie invites McSwigan to collaborate on magazine article that will eventually morph into *Sky Hooks*

May 18–June 19: Sends three paintings to Carnegie Institute exhibition of Pittsburgh artists

September: Preparing three paintings for Corcoran exhibition

Carnegie International canceled

October 8–December 1: One painting on view in exhibition at Addison Gallery of American Art, Andover, Massachusetts

October 27–January 2, 1933: One work in Chicago Art Institute Annual Exhibition

November 22–January 5, 1933: One work in first Whitney Biennial, New York City

First signs of active tuberculosis

1933 January–February: AAP exhibition, awarded second prize for *Liberty Bridge*; John and Maggie attend opening; controversy over prize winners follows in Pittsburgh newspapers

February: Edward Hopper defends jury award selections for AAP exhibition, appreciates Kane as artist with something to say

Kane excited about repeal of Prohibition

October–December: Exhibits one painting (*Industry's Increase*) at Carnegie International Exhibition

October 20: Delivers scripted radio address over WCAE radio from editorial rooms of *Pittsburgh Sun-Telegraph*

1934 January 20–February 10: Ten paintings on view at solo exhibition, Gallery 144, New York

Schwartz closes Gallery 144, sells Kane stock to Valentine Galleries, New York

January 28–February 25: Sends one painting to PAFA Annual Exhibition, Philadelphia

February 8–March 8: Sends two paintings to AAP exhibition

Summer shortly before death, repaints *Seen in the Mirror* with grinning expression in watercolor, possibly to please Maggie

August: Sent to Mercy Hospital, Pittsburgh, in final illness; returns home where he is besieged by press; dies of tuberculosis and infected throat at Tuberculosis League Hospital. Funeral at Epiphany Church, buried at Calvary Cemetery in section managed by Saint Vincent de Paul Society for the Poor (on the spot he stood to paint views, according to Maggie). No will, $4,380 in bank account (number varies from different sources); funeral attended by O'Connor, Edward Duff Balken, Schwartz, Thompson, Saint-Gaudens

August: Maggie hopes to sell forty-four paintings from estate, move to live with daughter Margaret in Alexandria

1934 Pittsburgh collector (possibly Thompson?) values sixty paintings in estate for sixty dollars total or fifty to sixty dollars each (news accounts vary)

October 18–December 9: *Crossing the Junction*, incomplete and unsigned, on view at Carnegie International Exhibition

November: McSwigan final interview with Maggie; McSwigan is considering a novel and a movie about the artist

1935 January: US Department of Labor John Kane exhibition, Washington, DC, includes fifteen paintings

January 26–February 16: Twenty-eight paintings on view in memorial exhibition at Valentine Gallery, New York, with strong sales

April: John Boling writes scathing article in *Art Front*, attacks Pittsburgh critics and biographer McSwigan, New York dealers and collectors as speculators

1936 April 9–May 14: Forty-six paintings on view at Carnegie Institute Memorial exhibition, organized by Valentine Gallery; paintings sell for up to five thousand dollars each

April 12: Douglas Naylor article in *Pittsburgh Press* describes Thompson as leading Kane collector in Pittsburgh, McSwigan as "official biographer"

1938 *Sky Hooks: The Autobiography of John Kane* published

NOTES

Prologue

 1. All quotes by John Kane are from *Sky Hooks: The Autobiography of John Kane*, introduction by Frank Crowninshield, postscript by Marie McSwigan (Philadelphia: J. B. Lippincott, 1938) unless otherwise indicated.

Chapter 3. Making Steel

 1. Charles McCollester, *The Point of Pittsburgh: Production and Struggle at the Forks of the Ohio* (Pittsburgh: Battle of Homestead Foundation, 2008), 131.

 2. McCollester, *Point of Pittsburgh*, 153.

 3. McCollester, *Point of Pittsburgh*, 134.

 4. Les Standiford, *Meet You in Hell: Andrew Carnegie, Henry Clay Frick, and the Bitter Partnership That Changed America* (New York: Crown, 2005), 97.

 5. Kenneth Warren, *Big Steel: The First Century of the United States Steel Corporation, 1901–2001* (Pittsburgh: University of Pittsburgh Press, 2001), 107, 108, 111.

 6. S. J. Kleinberg, *The Shadow of the Mills: Working-Class Families in Pittsburgh, 1870–1907* (Pittsburgh: University of Pittsburgh Press, 1989), 27.

 7. Kleinberg, *Shadow of the Mills*, 30.

 8. Kleinberg, *Shadow of the Mills*, 39.

 9. Kenneth J. Kobus, *City of Steel: How Pittsburgh Became the World's Steelmaking Capital During the Carnegie Era* (Lanham, MD: Rowman & Littlefield, 2015), 205.

Chapter 4. A Ranging and Restless Spirit

 1. Kleinberg, *Shadow of the Mills*, 9–10.

 2. Kobus, *City of Steel*, 47.

Chapter 5. Trouble Comes

 1. Mark Aldrich, *Death Rode the Rails: American Railroad Accidents and Safety, 1828–1965* (Baltimore: Johns Hopkins University Press, 2006), 1.

 2. Aldrich, *Death Rode the Rails*, 123, 161.

Chapter 6. Paint

 1. Kleinberg, *Shadow of the Mills*, 105.

 2. Marie McSwigan, Notebook 1, interview dated March 3, 1933, Leon A. Arkus Collection of John Kane, Carnegie Library of Pittsburgh.

Chapter 7. The Artist as Nomad

 1. Kleinberg, *Shadow of the Mills*, 121.

 2. Leon Anthony Arkus, *John Kane, Painter* (Pittsburgh: University of Pittsburgh Press, 1971), 3, 4.

 3. Jane Kallir, *John Kane: Modern America's First Folk Painter* (New York: Galerie St. Etienne, 1984), 19.

 4. Kallir, *John Kane*, 12.

Chapter 9. Acclaim

1. Marie McSwigan, Notebook 3, interview dated March 3, 1933.

Chapter 10. And Controversy

1. Quoted in Arkus, *John Kane, Painter*, 92.

Chapter 11. Legacy

1. Frank Crowninshield, foreword to Kane, *Sky Hooks*.

2. Henry Adams, foreword to Kallir, *John Kane*.

3. Katherine Jentleson, *Gatecrashers: The Rise of the Self-Taught Artist in America* (Berkeley: University of California Press, 2020), 5.

4. Kallir, *John Kane*, 6.

5. Jentleson, *Gatecrashers*, 15.

6. Arkus, *John Kane, Painter*, 4.

7. Jentleson, *Gatecrashers*, 47.

8. Crowninshield, foreword to Kane, *Sky Hooks*.

9. Kallir, *John Kane*, 20.

Chapter 12. Kissing the Blarney Stone

1. Mary B. Mullett, "Maybe It's All I'll Ever Get, but It's Worthwhile," *American Magazine*, April 1928, 148.

2. Mullett, "Maybe It's All I'll Ever Get," 19, 142–48.

3. Penelope Redd, "The Man Who Was Two Painters," *Pittsburgh Sun-Telegraph*, August 11, 1934. Kane posed with the boat for the *Sun-Telegraph* photographer in summer 1930 or 1931, while the boat was docked near Aspinwall.

4. Margaret Corbett enclosed photocopies of the card recto and verso in an undated letter to Leon Arkus, probably June/August 1988. Arkus's correspondence regarding John Kane, c. 1987–2007, with Jane Arkus, Pittsburgh [cited hereafter as Arkus Correspondence].

5. Marie McSwigan, Notebook 1 (1931–1932), collection of Mary McDonough. Marie McSwigan, Notebook 3 (1933), n.p., series 2, box D [cited hereafter as McSwigan, Notebook 3], Leon A. Arkus Collection of John Kane, Carnegie Library, Pittsburgh [cited hereafter as CLP Arkus Collection]; Margaret Corbett to Leon Arkus, May 30, 1988, Arkus Correspondence.

6. Marie McSwigan, series 2, box D, CLP Arkus Collection, contains the questionnaires, notebooks, and radio script that formed the basis of *Sky Hooks*.

7. McSwigan, postscript to Kane, *Sky Hooks*, 187.

8. The photograph is preserved in the John Kane artist file, Carnegie Museum of Art Archives. Caption on verso identifies John Kane, Maggie Kane, and daughter Mary Edwards, WCAE radio, and the editorial rooms of the *Pittsburgh Sun-Telegraph*.

9. Carbon copies of undated draft book contract between McSwigan and John Kane, series 2, box F, folder 5, CLP Arkus Collection.

10. McSwigan, Notebook 4 (1933–1934), n.p., series 2, box D, folder 2, CLP Arkus Collection. Notebook 4, with Mickey Mouse on its cover, includes interviews and notes from late 1933 through 1935.

11. John Boling, "A Perfectly Honorable Business," *Art Front* 1, no. 4 (April 1935): n.p.

12. Scrapbook, series 2, box 4, CLP Arkus Collection. Two copies of "Exalteth the Lowly" are tucked in the back of the scrapbook.

13. McSwigan to Viola Cooper, November 3, 1937, series 2, box F, file 6, CLP Arkus Collection.

14. McSwigan to Viola Cooper, September 21, 1937, series 2, box F, file 6, CLP Arkus Collection.

15. Frank Crowninshield to Marie McSwigan, January 20, 1938, series 2, box F, file 6, CLP Arkus Collection.

16. "Associated Art Show Opens with Full House," *Pittsburgh Press*, February 10, 1933, 24.

17. McSwigan, postscript to Kane, *Sky Hooks*, 195; Jentleson, *Gatecrashers*, 34.

18. "The Way of My Life Is the Title of Marie McSwigan's Book on John Kane," in "About Books," *Pittsburgh Sun-Telegraph*, December 12, 1937, 60.

19. McSwigan, Notebook 3, and McSwigan, postscript to Kane, *Sky Hooks*, 192–95.

20. Kane, *Sky Hooks*, 112. When heavy lift helicopters and high-tech parachute and rock-climbing equipment were developed later in the twentieth century, many were branded "sky hooks." See, for example, A. W. Rudge, "Sky Hooks, Fish-Warmers and Hub-Caps: Milestones in Satellite Communications," *IEE Proceedings F—Communications* 132, no. 1 (February 1985). The website TalkingScot (www.talkingscot.com) gives examples of the phrase's use in British factories since the Industrial Revolution; recently it served as the title of a novel of working-class life in Manchester, England. Neil Campbell, *Sky Hooks* (Cromer, Norfolk, UK: Salt, 2016).

21. John Slagle, *The Epistemological Skyhook: Determinism, Naturalism, and Self-Defeat* (New York: Routledge, 2016), 4–6.

22. *Bartlett's Familiar Quotations*, 18th ed. (New York: Little, Brown, 2012), 309.

23. Edward Hopper, "Judge Defends Art Exhibit Awards," *Pittsburgh Sun-Telegraph*, February 20, 1933, 17.

24. Diana Strazdes, *American Paintings and Sculpture to 1945 in the Carnegie Museum of Art* (New York: Hudson Hills Press in association with Carnegie Museum of Art, 1992), 401.

Chapter 13. Modernist Mythologies

1. Leon Arkus, introduction to ACA Galleries, *Four American Primitives: Edward Hicks, John Kane, Anna Mary Roberston Moses, Horace Pippin* (New York: ACA Galleries, 1972), n.p.

2. Margaret Corbett to Leon Arkus, October 27, 1987, Arkus Correspondence.

Chapter 14. Tests of Virtue

1. Kallir, *John Kane*, n.p. n8.

2. This was true regarding the Carnegie Museum of Art collection due to the excellent research published in Strazdes, *American Paintings and Sculpture to 1945*, 280–92.

3. Jentleson, *Gatecrashers*, 27.

4. For example, Lynne Cooke, *Outliers and American Vanguard Art* (Washington, DC: National Gallery of Art, 2018); Jentleson, *Gatecrashers*. See also Holland Cotter, "Will the Renovated MoMA Let Folk Art Back In?" *New York Times*, June 6, 2019.

Chapter 15. Hero's Quest

1. McSwigan, postscript to Kane, *Sky Hooks*, 192; overdue notice from Carnegie Library of Pittsburgh, July 30, 1934, with typed annotation by Marie McSwigan (collection of Mary McDonough).

2. Holograph inscription in John Kane's handwriting on undated sketchbook sheet, American Folk Art Museum, New York, acc. no. 2006.10.12 verso

3. Kane, *Sky Hooks*, 181.

4. Kane, *Sky Hooks*, 116–17.

5. Kane, *Sky Hooks*, 40, 79, 97.

6. Kane, *Sky Hooks*, 183.

7. Kane, *Sky Hooks*, 82.

8. Kane, *Sky Hooks*, 110.

9. Kane, *Sky Hooks*, 101.

10. "Novelty Wins Over Technique in Art Exhibit Prize Awards," *Pittsburgh Sun-Telegraph*, February 10, 1933, 21.

11. Mullett, "Maybe It's All I'll Ever Get," 146.

12. Kane, *Sky Hooks*, 107.

13. Kane, *Sky Hooks*, 107–8.

14. Notebook 1, interview dated March 3, 1933. Emphasis in the original.

15. Arkus catalog nos. 115 and 116; the third version is in the Leon Arkus Archive at Carnegie Library of Pittsburgh.

16. Collection of Mary McDonough.

17. Batches 15 and 42. Identifiable compositions correspond to Arkus, catalog nos. 47, 68 or 73, 89, possibly 109, 110, 113. Unknown paintings include a third version of Arkus catalog nos. 44 and 45, where the sledding child is replaced by a portly fallen female figure, and three scenes of putti tending a vineyard likely inspired by a Roman or Renaissance prototype.

18. Marie McSwigan, "Crafton Claims Largest Elm Tree," *Pittsburgh Press*, October 6, 1928, 7. Batches A20, 32 (collection of Mary McDonough). The painting is *The Old Elm*, Arkus, catalogue no. 97.

19. Batch A20. Collection of Mary McDonough. Paintings that can be associated with some confidence include Arkus catalog nos. 92, 93, 94, 97, 110, 112, 128, 129, 130, 131, 133, 134, 135, all landscapes dating from late 1928–1933.

20. The signed receipts are preserved in the archives of the Westmoreland Museum of American Art, Greensburg, Pennsylvania, and the collection of Pat McArdle, Pittsburgh.

21. Douglas Naylor, "Artist Talks Over Old Times with His Former Odd Jobs Boss," *Pittsburgh Press*, December 22, 1932, clipping in John Kane artist file, Carnegie Museum of Art Archives.

Chapter 16. Comedy and Tragedy

1. "Exhibition of Paintings by Pittsburgh Artists Begins Today . . . ," advertisement for Horne's Department store, *Pittsburgh Press*, March 19, 1928, 13; "Wanted—First Class Painter . . ." classified ad by John Kane, *Pittsburgh Press*, April 22, 1928, 30; Douglas Naylor, "Simplicity of Kane's Style May Have Been Intentional," *Pittsburgh Press*, April 12, 1936, 14.

2. "Kane to Miss Art Exhibit; Rib Broken," *Pittsburgh Sun-Telegraph*, October 14, 1931, clipping preserved in John Kane artist file, Carnegie Library of Pittsburgh archives.

3. Pat Codyre, Museum of Modern Art, to John O'Connor, December 11, [1930], John Kane artist file, Carnegie Museum of Art Archives.

4. Marie McSwigan, "Fame Fails to Bring Wealth to Painter," *Pittsburgh Press*, October 28, 1928, 13.

5. Harvey Gaul, "21st Exhibition Opened by Local Artists," *Pittsburgh Post-Gazette*, February 13, 1931, 22; "Some of Kane's Paintings Merely Painted-Up Photos," *Pittsburgh Post-Gazette*, June 5, 1931, 17.

6. Marie McSwigan, "Kane Ready to Show His First Nude," *Pittsburgh Press*, May 22, 1931, 34; "A House Painter Turns Artist," *Bulletin Index*, February 22, 1931, n.p.

7. John Kane to Homer Saint-Gaudens, April 12, 1932, typescript copy of letter, John Kane artist file, Carnegie Museum of Art Archives.

8. Jane Kallir describes the role of copying in standard art training, cites other artists' reliance on photographic models throughout the twentieth century, and reconstructs Kane's artistic practice through careful examination of original works. Kallir demonstrates how Kane's work is original by most recent standards, even when the underlying inspiration or support might have been a photographic image. Kallir. *John Kane*, n.p. n8.

Chapter 17. Mirror, Mirror

1. Kane, *Sky Hooks*, 183. A slightly different version of the conversation is recorded in McSwigan's Notebook 2, Mary McDonough Collection.

2. Peter H. Falk, ed., *Record of the Carnegie Institute's International Exhibitions, 1896–1996* (Madison, CT: Sound View, 1998), 175.

3. Arkus, catalog nos. 49, 144.

4. Arkus, catalog no. 144, plate 2.

5. Judith E. Stein, "John Kane," in *Self-Taught Artists of the 20th Century* (San Francisco: Chronicle, 1998), published in conjunction with a traveling exhibition of the same title, organized by the Museum of American Folk Art, New York, 50.

6. Marie McSwigan, "Kane Ready to Show His First Nude," *Pittsburgh Press*, May 22, 1931, 34; Arkus, catalog no. 11.

7. Mullett, "Maybe It's All I'll Ever Get," 19.

8. Douglas Naylor, "Art Lags in Old Year," *Pittsburgh Press*, December 30, 1934, 38.

9. McSwigan, Notebook 1, interview of October 16, 1932, Mary McDonough Collection.

10. Arkus, catalogue no. 144.

11. Arkus, catalog nos. 116, 48, 106, 74.

12. Arkus, catalog no. 48.

13. Harvey Gaul, "Associated Artists Gone Modernist in Tonic Show," *Pittsburgh Post-Gazette*, February 14, 1930, 23.

14. The 1900 census lists Patrick Frazier as an inmate in the Clarion County workhouse. According to Kane, *Sky Hooks*, 105, he died c. 1900–1902.

15. Kane recalled painting two, a small one while employed at the Cambria Steel Works in Johnstown, Pennsylvania (Arkus 143, c. 1912–13, location unknown), and a larger version c. 1925 when he was based in McKeesport's Sheet and Tin Plate Works (Kane, *Sky Hooks*, 130, 150; probably lost). Nevertheless, three versions are known today: Arkus 81 (which Arkus at first believed to be the Johnstown original), another version recently discovered on the back of a farm scene (Arkus 156; Carnegie Museum of Art, acc. no. 2005.66.1.B), and a third version not recorded in Arkus (Kallir 14, Alexandre Gallery, New York, in 2020). Similar in size, these versions differ in their lettering and supports: a canvas, a Masonite board, and cardboard. Arkus 81 and

Kallir 14 remained in Kane's estate, but the farm scene (Arkus 156, Carnegie Museum of Art, acc. no. 2005.66.1.A) was exhibited in 1931 and acquired by the McGivern family (friends of the artist). *Lincoln's Gettysburg Address* hitched along undetected until the painting arrived at the Carnegie. Louise Lippincott is grateful to Akemi May and Costas Karakatsanis of Carnegie Museum of Art for providing essential information on the museum's Kane collection.

16. Kane, *Sky Hooks*, 130–33.

17. Kane, *Sky Hooks*, 63.

Chapter 18. Soul of a Champion

1. Patricia Lowry, "How a Frown Wiped Away a Smile in John Kane's Self-Portrait," *Pittsburgh Press*, April 26, 1985, series 3, box G, newspaper clippings II, CLP Arkus Collection.

2. Marie McSwigan, "Fame Fails to Bring Wealth to Painter," *Pittsburgh Press*, October 28, 1928, 13.

3. For example, Hans Wolfgang Singer, *Drawings of Albrecht Dürer* (London: George Newnes, 1906) or Lionel Cust, *The Paintings and Drawings of Albrecht Dürer* (1897), in possession of the Carnegie Library.

4. M. Therese Southgate, "On the Cover [Self-Portrait of John Kane]," *Journal of the American Medical Association* 291, no. 2 (January 14, 2004): 159; Jentleson, *Gatecrashers*, 29.

5. Peter R. Shergold, *Working-Class Life: The "American Standard" in Comparative Perspective, 1899–1913* (Pittsburgh: University of Pittsburgh Press, 1982), 225.

6. Knights of Labor, *"Adelphon Kruptos": The Full, Illustrated Ritual Including the "Unwritten Work" and an Historical Sketch of the Order* (Chicago: Ezra A. Cook, 1886), 23, 33.

7. "Art: Men Are Square," *Time Magazine*, September 17, 1923.

8. Arkus incorrectly assigned the title *Three Score and Ten* to a small painting of two aged graybeards conversing (Arkus catalog no. 54); the proper title for that work is probably *Auld Lang Syne* rejected from the 1928 International and miscatalogued as a lost work (Arkus catalog no. 153).

9. Marie McSwigan, "Wielder of Paint Brush on Houses Again Wins Signal Honor as Artist," *Pittsburgh Press*, October 14, 1929, 21.

10. A. J. Philpott, "Harvard Society's Exhibition of Paintings and Sculpture," *Boston Globe*, October 29, 1929, 8. Italics added.

11. "Kane, House Painter, Ceases to Be a Joke," *Art Digest*, November 1, 1929, 18; William Pfarr, "The Side Walks of Pittsburgh," *Pittsburgh Sun-Telegraph*, November 19, 1929, 21.

12. Marie McSwigan, "Facing Eviction, Strip Artist Gets New Glory but No Cash," *Pittsburgh Press*, December 1, 1930, 40; Penelope Redd, "Art Circles Awaiting Awards on September 23 of International Jury," *Pittsburgh Sun-Telegraph*, September 7, 1930, 42.

13. According to McSwigan, Notebook 3, Kane's first artificial leg, long out of use by 1929, did have leather straps over his shoulder, like suspenders.

14. Louise Lippincott expresses her gratitude to Mark Lewis, paintings conservator, and Kimberli Gant, McKinnon Curator of Modern and Contemporary Art at the Chrysler Museum of Art. Despite pandemic lockdowns they carried out a detailed study of the painting and shared their findings via photographs, email, and numerous phone conversations.

15. *United States Life Expectancy 1860–2020*, accessed August 31, 2019, http://www.Statista.com/society/historical.

16. McSwigan, "Wielder of Paint Brush on Houses"; the verse comes from *As You Like It*, act 2, scene 3. Kane quoted the second half of the verse, which reads in full: "Though I look old, yet I am strong and lusty; / For in my youth I never did apply / Hot and rebellious liquors in my blood, / Nor with unbashful forehead woo / The ways of weakness and debility; / Therefore my age is as a lusty winter, / Frosty but kindly." McSwigan removed the quote from its original context when she reused it in *Sky Hooks*. She appends it to Kane's story of a snowy night in the hills of Tennessee in the 1880s and morphs it into "Scotch winter" for the section about Kane's art career and old age. Kane, *Sky Hooks*, 68, 153.

17. Arkus, catalog no. 19, collection of Mary McDonough.

18. Scottish actor and comedian Billy Connolly explains the term *bubbly jock* by describing the connection between name and noise in Scottish vernacular in an interview for NPR. "Billy Connolly's Funny, but Not Clever, Comedy," NPR, November 22, 2012, transcript, https://www.npr.org/transcripts/165727164.

19. Arkus, catalog nos. 69–73, 153–155.

20. Harvey Gaul, "Associated Artists Open Big Annual Show," *Pittsburgh Post-Gazette*, February 10, 1933, 24. Arkus 71?

21. Kane, *Sky Hooks*, 172.

22. "When It Rains, He's an Artist," *Pittsburgh Sun-Telegraph*, October 21, 1929, 18.

23. Kane, *Sky Hooks*, 21.

24. Kane, *Sky Hooks*, 107.

25. "John Kane Died 'Poor Artist,' Had Fortune," *Pittsburgh Sun-Telegraph*, August 12, 1934, 18.

26. Margaret Corbett to Leon Arkus, October 16, 1987, Arkus Correspondence.

Chapter 19. Cinderella Story?

1. "John Kane," unsigned, undated typescript attributed here to John O'Connor, c. 1931, John Kane artist file, Carnegie Museum of Art Archives.

2. "Art Jury Row Made John Kane Famous," *Pittsburgh Sun-Telegraph*, August 12, 1934, 11.

3. Kane, *Sky Hooks*, 154.

4. Margaret Corbett to Leon Arkus, n.d. [probably June–August 1988], Arkus Correspondence.

5. Traditional images depict Christ's vision as a glowing chalice, some versions include an angel bearing a cross. Arkus, catalog no. 74.

6. Arkus, catalog nos. 64, 26, 76, 104.

7. Arkus, catalog nos. 69, 115.

8. Arkus, catalog no. 26, no number, no number, catalog no. 8.

9. John O'Connor Jr., "The Kane Memorial Exhibition," *Carnegie Magazine*, April 1936, 21.

Chapter 20. Beauty and the Beast

1. McSwigan, postscript to *Sky Hooks*, 186.

2. Penelope Redd, quoting art critic Henry McBride, in "Rare Honors Await Kane, 'Strip' Picture Painter," *Pittsburgh Sun-Telegraph*, November 21, 1930, 1.

3. Kane, *Sky Hooks*, 30, 40, 60, 102, 125, 129, 130, 143, 181.

4. The postcard was collected by Marie McSwigan and is preserved in the collection of Mary McDonough. Kane made two versions of the painting: Arkus, catalog nos. 82, 83.

5. Kane, *Sky Hooks*, 177.

6. Arkus, catalog nos. 104, 115, 151, 107?, 92, 93.

7. G. M. Hopkins & Co. 1915 plat map of Penn Hills, Homewood North, plate 33, ID no. 20091022-hopkins-0039, University of Pittsburgh archives, www.historic pittsburgh.org.

8. Crowninshield, foreword to *Sky Hooks*, 17. The Museum of Modern Art dates the painting to c. 1928, but the amusement park depicted in the scene did not open until May 1929.

9. A photograph of the river's edge c. 1900 shows the trees reflecting in the water in identical fashion. Allegheny River and Pumping Station, Carnegie Museum of Art acc. No. 1999.34.8, www.historicpittsburgh.org. Louise Lippincott would like to thank Barbara Jones, Doug Evans, and Anne Kraybill of the Westmoreland Museum of American Art, Greensburg, Pennsylvania, for providing access to the Kane paintings in the collection, including *Hills and Rivers, Steamboat at Sleepy Hollow*, acc. no. 2015.4.

10. Kane, *Sky Hooks*, 181.

11. Margaret Corbett to Leon Arkus, May 30, 1988, Arkus Correspondence.

12. Strazdes, *American Paintings and Sculpture to 1945*, 286.

Chapter 21. Rumpelstiltskin

1. Kane, *Sky Hooks*, 94.

2. Arkus, catalog nos. 132, 126, 121, 130, 136, 124.

3. Nicholas Fox-Weber, *Patron Saints: Five Rebels Who Opened America to New Art, 1928–1943* (New York: Knopf Doubleday, 2014).

4. McSwigan, postscript to Kane, *Sky Hooks*, 195.

5. "John Kane, Artist, Dies at Pittsburgh," *La Crosse (WI) Tribune*, August 11, 1934. Thanks to Allison Russell for sharing the information. Louise Lippincott also offers her thanks to Anne Madarasz and the staff at the Heinz History Center, Pittsburgh, for allowing special access to *Crossing the Junction*.

6. Strazdes, *American Paintings and Sculpture to 1945*, 287.

7. Strazdes, *American Paintings and Sculpture to 1945*, 286.

8. "Kane's Last Picture Faithful to Local Scene," *Pittsburgh Post-Gazette*, October 9, 1935, series 3, box G, newspaper clippings II, Arkus Collection.

9. Kallir, *John Kane*, nos. 24, 25, 26, illustrated.

10. Arkus, catalog no. 117; thanks to Allison Russell for checking the 1930 census record on ancestry.com.

11. "John Kane Quits the Strip, Tells Fib in Oils," *Pittsburgh Press*, February 13, 1931, 2.

12. The alternate title is mentioned in "John Kane's Studio, and the Artist, Dead at 74," *Pittsburgh Post-Gazette*, August 11, 1934, 1.

13. Margaret Corbett to Leon Arkus, October 14, 1987, Arkus Correspondence.

14. Kane, *Sky Hooks*, 177.

SOURCES

Archival Sources

Leon A. Arkus Collection of John Kane. Carnegie Library, Pittsburgh. Within the collection, series 1 contains materials related to Arkus's *John Kane, Painter.* Series 2 consists of Marie McSwigan's Notebooks 3 and 4 (1933–1935), correspondence, scrapbooks, and miscellaneous loose notes accumulated from 1932 to c. 1940 pertaining to *Sky Hooks.* Series 3 includes miscellaneous materials belonging to John Kane: his flute and tin whistle, miscellaneous drawings, letters, and postcards acquired from the Kane family c. 1987.

Arkus, Leon. Correspondence regarding John Kane, c. 1987–2007. In the possession of Jane Arkus, Pittsburgh. Primarily correspondence with John Kane's daughter Margaret Corbett around a possible new biography of Kane, as well as inquiries from collectors and scholars.

Artist files, Carnegie Museum of Art, Pittsburgh. News clippings, photographs, ephemera relating to artists represented in the museum's collections or its International exhibitions, 1896–present.

Local artist files, reference collections, Carnegie Library, Pittsburgh. News clippings and ephemera pertaining to Southwestern Pennsylvania artists from c. 1920 to the present.

Mary McDonough Collection, Pittsburgh. Materials inherited from Marie McSwigan, including Notebooks 1 and 2 (c. 1931–1933); an envelope containing eighty black and white contact photographic prints by John Kane (c. 1928–1933); a transverse tin flute; numerous news clippings pertaining to John Kane or *Sky Hooks*; five paintings by John Kane (Arkus, catalog nos. 13, 19, 72, 116, 140).

Published Sources

"About Books." *Pittsburgh Sun-Telegraph*, December 12, 1937, 60.

ACA Galleries. *Four American Primitives: Edward Hicks, John Kane, Anna Mary Robertson Moses, Horace Pippin.* Introduction by Andrew Crispo. New York: ACA Galleries, 1972.

Aldrich, Mark. *Death Rode the Rails: American Railroad Accidents and Safety, 1828–1965.* Baltimore, MD: Johns Hopkins University Press, 2006.

Alzo, Lisa A. *Pittsburgh's Immigrants.* With the Carnegie Library of Pittsburgh. Charleston, SC: Arcadia, 2006.

Anthony, Leon Arkus. *An Accidental Life: The Memoirs of Leon A. Arkus (1915–1999), 5th Director of the Carnegie Museum of Art, Pittsburgh (1969–1980).* Edited by Jane Callomon Arkus. Self-published by the editor, 360 Digital Books, 2012.

Anthony, Leon Arkus. *John Kane, Painter.* Pittsburgh: University of Pittsburgh Press, 1971.

"Art Award to House Painter." *Des Moines Register,* March 10, 1929, 69.

"Art Jury Row Made John Kane Famous." *Pittsburgh Sun-Telegraph,* August 12, 1934, 11.

"Art. Rising Kane." *Bulletin Index* 106, no. 8 (February 21, 1935): 1.

"Art: Men are Square." *Time,* September 17, 1923.

"Artist Confesses Exhibiting Photos He Had Colored." *Indianapolis Star,* June 5, 1931, 18.

"Associated Art Show Opens with Full House." *Pittsburgh Press,* February 10, 1933, 24.

Bauman, John F., and Edward K. Muller. *Before Renaissance: Planning in Pittsburgh, 1889–1943.* Pittsburgh: University of Pittsburgh Press, 2006.

Boling, John. "A Perfectly Honorable Business." *Art Front* 1, no. 4 (April 1935): n.p.

Burns, Daniel J. *Pittsburgh's Rivers.* With the Carnegie Library of Pittsburgh. Charleston, SC: Arcadia, 2006.

Bush, Perry. "A Neighborhood, a Hollow, and the Bloomfield Bridge: The Relationship between Community and Infrastructure." *Pittsburgh History,* Winter 1991, 160–72.

Cannadine, David. *Mellon: An American Life.* New York: Knopf, 2006.

"Church and Kane Hail Free-For-All Art Exhibition." *Pittsburgh Press,* September 23, 1932, 24.

Cloud, Joseph J. "An Artist Who Paints 'Dream Houses.'" *Pittsburgh Press,* December 7, 1930, 65.

"Combines Art and Trade!" *New York Daily News,* October 21, 1927, 32.

"Combines Art and Trade!" *Wilkes-Barre Record,* October 22, 1927, 1.

Cooke, Lynne. *Outliers and American Vanguard Art.* Washington, DC: National Gallery of Art, 2018.

Cooper, Douglas. *Knowing and Seeing: Reflections on Fifty Years of Drawing Cities.* Pittsburgh: University of Pittsburgh Press, 2019.

Danver, Charles. "Pittsburghesque, Things That Get in an Artist's Hair." *Pittsburgh Post-Gazette,* October 18, 1930, 6.

"Dewey Buys Art of House Painter." *New York Daily News,* December 29, 1930, 191.

Dolan, Leo V. "Portraits at Exhibit Painted Photographs. Heated Controversy over Discovery Works of John Kane Are Unethical." *Times-Tribune* (Scranton, PA), June 4, 1931, 23.

Elliott, Bruce. *The Baltimore & Ohio Railroad's Pittsburgh Division.* Charleston, SC: Arcadia, 2016.

Falk, Peter H., ed. *Record of the Carnegie Institute's International Exhibitions, 1896–1996.* Madison, CT: Sound View, 1998.

Fox-Weber, Nicholas. *Patron Saints: Five Rebels Who Opened America to a New Art, 1928–1943.* New York: Knopf Doubleday, 2014.

"Frenchman Wins Art Prize." *Pittsburgh Sun-Telegraph,* October 14, 1927, 2.

Gaul, Harvey. "21st Exhibition Opened by Local Artists." *Pittsburgh Post-Gazette,* February 13, 1931, 22.

Gaul, Harvey. "Associated Artists Gone Modernist in Tonic Show." *Pittsburgh Post-Gazette,* February 14, 1930, 23.

Gaul, Harvey. "Associated Artists Open Big Annual Show." *Pittsburgh Post-Gazette,* February 10, 1933, 24.

Gaul, Harvey. "Associated Artists Open 19th Exhibition." *Pittsburgh Post-Gazette*, February 15, 1929.

Hopper, Edward. "Judge Defends Art Exhibit Awards." *Pittsburgh Sun-Telegraph*, February 20, 1933, 17.

[Horne's Department Store]. "Exhibition of Paintings by Pittsburgh Artists Begins Today . . ." Advertisement. *Pittsburgh Press*, March 19, 1928, 13.

"House Painter Also Is Artist." *Oakland (CA) Tribune*, December 11, 1930, 19.

"House Painter Is Now Distinguished Artist." *Morning Call* (Allentown, PA), December 18, 1927, 43.

"House Painter Wins Art Honors." *Courier-Express* (DuBois, PA), October 25, 1927, 3.

"House Painter, 61, Again Wins Prize at Carnegie Show." *Wilkes-Barre Times Leader*, February 11, 1928, 20.

Jentleson, Katherine. *Gatecrashers: The Rise of the Self-Taught Artist in America*. Berkeley: University of California Press, 2019.

"John Kane Died 'Poor Artist,' Had a Fortune." *Pittsburgh Sun-Telegraph*, August 12, 1934, 11.

"John Kane Quits the Strip, Tells Fib in Oils." *Pittsburgh Press*, February 13, 1931, 2.

"John Kane, Artist, Dies." *Pittsburgh Sun-Telegraph*, August 10, 1934, 1.

"John Kane's Studio, and the Artist, Dead at 74." *Pittsburgh Post-Gazette*, August 11, 1934, 1, 20.

Kallir, Jane. *John Kane: Modern America's First Folk Painter*. New York: Galerie St. Etienne, 1984.

"Kane to Miss Art Exhibit; Rib Broken." *Pittsburgh Sun-Telegraph*, October 14, 1931.

"Kane, House Painter, Ceases to Be a Joke." *Art Digest*, November 1, 1929, 18.

"Kane's Last Picture Faithful to Local Scene." *Pittsburgh Post-Gazette*, October 9, 1934.

Kane, John. *Sky Hooks: The Autobiography of John Kane*. Introduction by Frank Crowninshield. Postscript by Marie McSwigan. Philadelphia: J. B. Lippincott, 1938.

Kleinberg, S. J. *The Shadow of the Mills: Working-Class Families in Pittsburgh, 1870–1907*. Pittsburgh: University of Pittsburgh Press, 1989.

Knights of Labor. *"Adelphon Kruptos": The Full, Illustrated Ritual Including the "Unwritten Work" and an Historical Sketch of the Order*. Chicago: Ezra A. Cook, 1886.

Kobus, Kenneth J. *City of Steel: How Pittsburgh Became the World's Steelmaking Capital during the Carnegie Era*. Lanham, MD: Rowman & Littlefield, 2015.

Lee, Ann. "Only Pittsburgher Admitted to International Is a House Painter." *Pittsburgh Press*, October 16, 1927, 1.

Lowry, Patricia. "Art." *Pittsburgh Press*, November 27, 1987, 33.

Lowry, Patricia. "How a Frown Wiped Away a Smile in John Kane's Self-Portrait." *Pittsburgh Press*, April 26, 1985.

McCollester, Charles. *The Point of Pittsburgh: Production and Struggle at the Forks of the Ohio*. Pittsburgh: Battle of Homestead Foundation, 2008.

McSwigan, Marie. "'—and Exalteth the Lowly.' How America's Number One Primitive Was Branded a Faker, a Painter over Photographs." Unpublished typescript, c. 1937–1938, Leon A. Arkus Collection, series 2, Box E (scrapbook), Carnegie Library, Pittsburgh.

McSwigan, Marie. "Crafton Claims Largest Elm Tree." *Pittsburgh Press*, October 6, 1928, 7.

McSwigan, Marie. "Dean of Pittsburgh Painters Has Odd Hobby . . . Socialism." *Pittsburgh Press*, October 24, 1931.

McSwigan, Marie. "Facing Eviction, Strip Artist Gets New Glory but No Cash." *Pittsburgh Press*, December 1, 1930, 40.

McSwigan, Marie. "Fame Fails to Bring Wealth to Painter." *Pittsburgh Press*, October 28, 1928, 13.

McSwigan, Marie. "Kane Ready to Show His First Nude." *Pittsburgh Press*, May 22, 1931, 34.

McSwigan, Marie. "Limerick, Old South Side District, Once Real Bee Hive of Industry." *Pittsburgh Press*, July 25, 1929, 25.

McSwigan, Marie. "Wielder of Paint Brush on Houses Again Wins Signal Honor as Artist." *Pittsburgh Press*, October 14, 1929, 21.

McSwigan, Marie. "Works of Women Painters Shown." *Pittsburgh Press*, May 25, 1932, 20.

Moore, Sarah J. *John White Alexander and the Construction of National Identity: Cosmopolitan American Art, 1880–1915*. Newark: University of Delaware Press, 2003.

Muller, Edward K., and Joel Tarr, eds. *Making Industrial Pittsburgh Modern: Environment, Landscape, Transportation, and Planning*. Pittsburgh: University of Pittsburgh Press, 2019.

Mullett, Mary B. "Maybe It's All I'll Ever Get, but It's Worthwhile." *American Magazine*, April 1928, 19, 142–48.

National Park Service. "The Birth of Camp Sherman." Last updated November 6, 2017. https://www.nps.gov/articles/the-birth-of-camp-sherman.htm.

Naylor, Douglas. "Art Lags in Old Year." *Pittsburgh Press*, December 30, 1934, 38.

Naylor, Douglas. "Artist Talks Over Old Times with His Former Odd Jobs Boss." *Pittsburgh Press*, December 22, 1932.

Naylor, Douglas. "Hint of Art 'Price Fixing' Brings Storm of Protests." *Pittsburgh Press*, April 27, 1936, 16.

Naylor, Douglas. "Painter as Art Critic, John Kane Tells What He Likes in Work of Others." *Pittsburgh Press*, October 29, 1933, 36.

Naylor, Douglas. "Simplicity of Kane's Style May Have Been Intentional." *Pittsburgh Press*, April 12, 1936, 14.

The New Encyclopaedia Britannica. 15th ed. 32 vols. Chicago: Encyclopaedia Britannica, 2010. Final print version. Continued online, as *Encyclopaedia Britannica*, at https://www.britannica.com/.

"Novelty Wins over Technique in Art Exhibit Prize Awards." *Pittsburgh Sun-Telegraph*, February 10, 1933, 21.

O'Connor, John, Jr. "The Apotheosis of John Kane." *Carnegie Magazine*, January 1955, 19–24.

[O'Connor, John, Jr.] "John Kane." Typescript memorandum c. 1930–1931. John Kane artist file, archives, Carnegie Museum of Art.

O'Connor, John, Jr. "The Kane Memorial Exhibition." *Carnegie Magazine*, April 1936, 19–24.

"Painter Wants Work . . ." Classified advertisement by John Kane. *Pittsburgh Post-Gazette*, December 5, 1927, 23.

"Painting in the Rain." *Pittsburgh Press*, June 1, 1930, 16.

Pfarr, William. "Side Walks of Pittsburgh." *Pittsburgh Sun-Telegraph*, November 19, 1929, 21.

Philpott, A. J. "Harvard Society's Exhibition of Paintings and Sculpture." *Boston Globe*, October 29, 1929, 8.

Piccolomini, Marion M. *Southwestern Pennsylvania's Coal Region*. Charleston, SC: Arcadia, 2016.

"Pittsburgh Turned House Painter John Kane into a Major U.S. Artist." *Life*, May 17, 1937, 44.

"Public Art Ideas Differ from Opinion of Judges." *Pittsburgh Post-Gazette*, November 28, 1927, 13.

Redd, Penelope. "Art Circles Awaiting Awards on September 23 of International Jury." *Pittsburgh Sun-Telegraph*, September 7, 1930, 42.

Redd, Penelope. "Artists Meet as John Kane Paints Capt. Menke's Famous Showboat." *Pittsburgh Sun-Telegraph*, summer 1930 or summer 1931. Undated news clipping, John Kane artist file, archives, Carnegie Museum of Art.

Redd, Penelope. "House Painter Turns Artist, Success Puzzles Colleagues." *Pittsburgh Sun-Telegraph*, October 21, 1929, 18.

Redd, Penelope. "Rare Honors Await Kane, 'Strip' Picture Painter." *Pittsburgh Sun-Telegraph*, November 21, 1930, 1.

Redd, Penelope. "The Man Who Was Two Painters: He Used Canvas on Rainy Days." *Pittsburgh Sun-Telegraph*, August 11, 1934.

Romig, Walter. *The Book of Catholic Authors*. 6th series. Published by the author, 1960.

Rouvalis, Christina. "Pittsburgh's Painter." *Carnegie Magazine*, spring 2018.

Shergold, Peter R. *Working-Class Life: The "American Standard" in Comparative Perspective, 1899–1913*. Pittsburgh: University of Pittsburgh Press, 1982.

Slagle, Jim. *The Epistemological Skyhook: Determinism, Naturalism, and Self-Defeat*. New York: Routledge, 2016.

"Some of Kane's Paintings Merely Painted-Up Photos." *Pittsburgh Post-Gazette*, June 5, 1931, 17.

Standiford, Les. *Meet You in Hell: Andrew Carnegie, Henry Clay Frick, and the Bitter Partnership That Changed America*. New York: Crown, 2005.

Stein, Judith E. "John Kane." In *Self-Taught Artists of the 20th Century: An American Anthology*, 48–51. San Francisco: Chronicle, 1998. Published in conjunction with a traveling exhibition of the same title, organized by the Museum of American Folk Art, New York.

Strazdes, Diana, et al. *American Paintings and Sculpture to 1945 in the Carnegie Museum of Art*. New York: Hudson Hills Press in association with Carnegie Museum of Art, 1992.

"Studio and Paintings of Pittsburgher Who Was Laborer for 40 Years." *Pittsburgh Press*, undated clipping [c. August 11–15, 1934], series 3, box G, folder V (oversize), Leon A. Arkus Collection, Carnegie Library, Pittsburgh.

Therese Southgate, M. "On the Cover [Self-Portrait of John Kane]." *Journal of the American Medical Association* 291, no. 2 (2004): 159.

Thompson, G. David. "John Kane." Unpublished typescript [probably August 1934], John Kane artist file, archives, Carnegie Museum of Art.

"Through Pain, Poverty John Kane Toiled to Art's Highest Hill and on a Hill Death Found Him." *Pittsburgh Sun-Telegraph*, August 11, 1934.

Wajda, Shirley. "'A poster should be a sermon in lines and colors': Gerrit A. Beneker's World War I-Era Posters of Laborers." *Shirley Wajda* (blog), February 5, 2019, https://shirleywajda.com/2019/02/05/sure-well-finish-the-job-and-fight-bolshevism-too/.

"Wanted—first class painter . . ." Classified advertisement by John Kane. *Pittsburgh Press*, April 22, 1928, 30.

Warren, Kenneth. *The American Steel Industry, 1850–1970: A Geographical Interpretation*. Pittsburgh: University of Pittsburgh Press, 1989.

Warren, Kenneth. *Big Steel: The First Century of the United States Steel Corporation, 1901–2001*. Pittsburgh: University of Pittsburgh Press, 2008.

Weir, Robert E. *Beyond Labor's Veil: The Culture of the Knights of Labor*. University Park: Pennsylvania State University Press, 1996.

Wheeler, Monroe. *20th century Portraits*. New York: Museum of Modern Art, 1942.

"Widow Careful in Handling Kane's Art for First Time." *Pittsburgh Press*, August 21, 1934, 2.

"Widow Huddles in Rain as Grave Claims John Kane." *Pittsburgh Sun-Telegraph*, August 13, 1934, 3.

INDEX

Scotland, 19–20, 78–79, 188, 215; family and, 52, 57, 61; wages in, 14, 23; boyhood in, 3, 10–11, 13, 40, 81, 138, 187, 232; nostalgia for, 14, 40, 78–79, 81, 93, 102, 106–7, 187–88, 213–14, 232. *See also* West Calder, Scotland

self-portraits, 170, 179, 182–83, 185–90, 193, 199, 200–201, 209, 211, 213, 215, 218–20; late, 163; most ambitious, 179; rejected, 114; retrospective, 164. *See also under* Kane, John, works of, by title

self-taught artist, the, 81, 88, 104, 112, 116–17, 147

Skunk Hollow, 247, 248, 250, 252, 255. *See also under* Kane, John, works of, by title

Sky Hooks: The Autobiography of John Kane, 96, 104–6, 115, 135, 137–44, 146, 182, 226; Arkus and, 147, 152; John Kane in, 16, 127, 185, 196, 217, 233; Maggie Kane and, 110; title misinterprets a joke, 106, 269n20

"Stingy Jack." *See under* Ireland

streetcars, 139, 161–62, 179, 214, 240, 250–51

street paving, 46, 47, 161, 162

Strip District, Pittsburgh, 41, 95, 104

Sullivan, John L., 39, 202

Thompson, G. David, 149–50, 180

U.S. Steel Corporation, 21, 101

unions, 29, 53; Miners Union, 40; Sons of Vulcan, 206; Union Trust Co., 27. *See also* Amalgamated Association of Iron and Steel Workers; Knights of Labor

Valentine Gallery, New York, 125, 149, 150, 200

Vesta Coal Mine complex, Washington County, 42–43

wages, 13–14, 20, 23, 40, 74; Carnegie and, 30, 56, 57, 101; Kane and, 36, 46, 77, 96; labor movement and, 42, 64

Wall, William C., 18, 84

Walter, Christian, 84, 176

Warhol, Andy, 131, 151; Andy Warhol Museum, 152

Warner Station Poor Farm, 237, 239

West Calder, Scotland, 3, 8, 10, 12, 13–14, 60

Westinghouse, George, 19, 29; Electric Corporation, 93

Whitney Museum of American Art, New York, 6, 125

writers: Emily Dickinson, 233; Ernest Hemingway, 208; Samuel Johnson, 143; D. H. Lawrence, 208; James Parton, 27; Les Standiford, 30; Gertrude Stein, 102

Young's Paraffin Light and Mineral Oil Company, Scotland, 12–13